Turning Points

Turning
Points

Turning Points

RESPONSIVE PEDAGOGIES IN STUDIO ART EDUCATION

EDITED BY RICHARD JOCHUM, JUDITH M. BURTON, AND JASON WATSON

TEACHERS COLLEGE PRESS

TEACHERS COLLEGE | COLUMBIA UNIVERSITY
NEW YORK AND LONDON

Published by Teachers College Press,® 1234 Amsterdam Avenue, New York, NY 10027

Front cover and interior design by Carolina Rojas. Photo by Efe Kurnaz vis Unsplash.

Library of Congress Cataloging-in-Publication Data

Names: Jochum, Richard, 1967– editor. | Burton, Judith M., editor. | Watson, Jason (Art educator), editor.
Title: Turning points : responsive pedagogies in studio art education / edited by Richard Jochum, Judith M. Burton, Jason Watson.
Other titles: Turning points (Teachers College Press)
Description: New York : Teachers College Press, [2023] | Includes bibliographical references and index.
Identifiers: LCCN 2023023332 (print) | LCCN 2023023333 (ebook) | ISBN 9780807768723 (paperback) | ISBN 9780807768730 (hardcover) | ISBN 9780807781913 (epub)
Subjects: LCSH: Art—Study and teaching (Higher) | College teaching—Methodology.
Classification: LCC N345 .T87 2023 (print) | LCC N345 (ebook) | DDC 700.71/1—dc23/eng/20230808

LC record available at https://lccn.loc.gov/2023023332
LC ebook record available at https://lccn.loc.gov/2023023333

ISBN 978-0-8077-6872-3 (paper)
ISBN 978-0-8077-6873-0 (hardcover)
ISBN 978-0-8077-8191-3 (ebook)

Printed on acid-free paper
Manufactured in the United States of America

Contents

Contents

Contents

Preface

We need no reminding that we live in complex and difficult times. Many of us in the intertwined worlds of the arts and education feel overwhelmed by changes long in the making and exacerbated by recent events. Yet the sense of crisis is urging imaginative and dynamic action, providing opportunities to rethink and open up pathways to new professional practices. Artists and art educators alike are challenging past practices and opening new and imaginative ways of thinking about the dynamics of creativity and the kinds of pedagogy we need for the future. As we find in the following pages of this richly endowed text, *Turnings Points: Responsive Pedagogies in Studio Art Education,* artist-educators are forging new spaces more sensitive to the voices of students, the broader needs of community, the incursions of technology, and the kinds of expertise needed to reshape our sociocultural worlds. These explorer-researcher-practitioners also have an eye on the long term as they embrace this transitional moment of growth, challenging long-held icons of skill by introducing competencies more deeply calibrated to the complexities of our time.

We face this volatile reality of challenge and change on a global scale and need to recognize that we can learn much from each other. To this end, the faculty of the Art and Art Education Program of Teachers College invited colleagues from the Maryland Institute College of Art to participate in a joint symposium—"Art School Pedagogy 2.0"—in April 2021 to consider issues undergirding the professional education and practices of artist teachers. Together, faculty colleagues reached out across the globe, inviting artists-educators from different cultures to share new pedagogies and ways of thinking, considering the diverse contextual demands these will make on supports for their challenging work. The papers in this text are the outgrowth of this symposium. Taken together, they offer imaginative examples of teaching and learning, exploring new options and possibilities, and affirming why the education of the artist is such a profound necessity for the ways in which we live our social and cultural lives. Cumulatively they provide a critique of the status quo, revealing with clarity just why transformative growth is essential to our ability to live within our complex world as agents of hope.

—Judith M. Burton, Macy Professor of Education
Teachers College Columbia University
January 2023

Part I: Studio Teaching During a Pandemic

Introduction

RICHARD JOCHUM
JASON WATSON

1 | The Pandemic as a Turning Point

The beginning of the 2020 COVID-19 pandemic left educators stranded on a digital life raft. From their laptops and monitors, teachers from across the education ecosystem used whatever creative resources were at hand to continue what had been so abruptly interrupted—the collaborative learning process. Art educators, attached perhaps more than most to the specific materials and tools of their discipline, found themselves reconsidering every assumption of what an art class might be. What is the nature of painting when it can only be shared through online photographs? How do we re-create the energy and urgency of a group critique when communication technology is distributed unevenly? How do we foster community-based experiences when social distancing forces us to rethink the very idea of community? How do we teach printmaking without a press, life drawing without a live model, ceramics without clay?

The following academic years were unprecedented. Art educators never escaped that life raft but instead settled in, exploring an extended digital landscape for both communicating and making, reshaping their understanding of what it means to teach and learn studio art along the way. The particular problems of living with COVID-19, and the social and political upheaval that the lockdowns unleashed, called for more than just coping through another crisis; they instigated an opportunity to reassess the very foundations of the discipline.

Indeed, for the past several decades, there have been ardent calls to reform studio art education, to address changes brought on by the hybridization of the art object and loss of media-specificity by the influx of technology and, perhaps more urgently, to tackle inequalities promoted by elitist, racist, misogynist, and homophobic systems, the same systems deeply embedded in the broader societies that support

and shape our cultural and educational institutions. COVID-19 became the match that lit a fire igniting these issues anew, insisting on a reevaluation of the motives, priorities, and anticipated outcomes that constitute contemporary studio art pedagogy.

It is important to note the exact conditions, specific to art education, that sparked this new climate of reflection and reevaluation. Distance learning protocols meant adapting new communication technologies to simulate the traditional forms of instruction and dialogue that animate the majority of studio art education discourse, including seminars, critiques, and instructional demonstrations, as well as the unique co-learning environment of the shared studio. Traditional studio materials and ways of making were tested, when translated through digital media, as never before. Many of the qualities previously prized in physical materials—their specific weight and texture, the embodied sensation of scale, the solidity of form in space—were rendered mute through the numbing, flattening effects of enforced digital isolation.

But the estrangement artists felt toward physical materials and traditional ways of making, which had started long before the pandemic, was only the most obvious of distance learning challenges. Physical, emotional, and intellectual isolation were perhaps more pervasive and insidious. The COVID-19 pandemic was a disruption to the rhythms and routines of daily life; distance learning broke the flow of the daily rituals we had always taken for granted. This rupture reinforced a fundamental truth of all education: We learn best together, and the absence of a community comes at a cost. In the lack of physical contact and direct communication, social skills became stunted, and social development lagged. The fundamental relationships that sustain the social environment in which learning thrives were thrown into question; the roles of teachers, students, and administrators were reexamined in the absence of the daily contact that reinforces them.

Shared studios and galleries, the town squares of art academic institutions, were shuttered, leaving students and faculty responsible for adjusting their homes into whatever usable space they could muster. This blurring of boundaries between the domestic and the institutional paralleled the exhaustion many art educators felt while teaching online, a nagging sensation of feeling always "on" while depleting the basic reserves necessary to maintain self and family. As technologies enabled the further scrambling of work/life boundaries, art educators of all stripes reported burnout in record numbers. Burnout for art educators is nothing new; they have always operated under the weight of an endlessly expansive job description, one that expects a precarious balance of time and energy. Their limited personal resources must be allotted to various recipients: students, colleagues, and the institutions that employ them, and of course substantial time and energy must be continuously expended on maintaining their own

creative studio practices. As well, a culture of increasing accountability, which can manifest as a culture of surveillance, adds to the overall stress of all studio art teachers and professors. Nonetheless, the new "teach from home" paradigm heightened the collective intensity of these dilemmas, bringing the task of art education, for many, to the brink of unmanageability.

The principal support structures available at this moment were goodwill and solidarity. Art educators learned to navigate the ups and downs of distance teaching and learning by resourcing one another. This led to a new pattern in pandemic-era academic relationships, between faculty and students, students and their peers, and among faculty, inside the boundaries of their home institutions and beyond them. Older models of relating were recast to prioritize mental health and care. As we teleconferenced into each other's personal spaces, a new intimacy began to develop, instigated by both the technologies at hand and the precarious physical, mental, and social predicaments that have become synonymous with the pandemic era and its digital transformation.

So, in fits and starts, we adapted to the moment. Through radical disruption we carried on as best we could, trying to re-create the rich, layered experiences of familiar in-person studio art teaching and learning under compromised conditions. And while we understand that art making often thrives on constraints, teaching does not. It was perhaps the very nature of this rough translation, from the familiar to the unthinkable, that cast the tried-and-true pedagogies of studio art education in a new light. Indeed, as the months of distance teaching rolled on, many art educators felt the increasing need for a fundamental rethinking of the status quo. In this way, the pandemic brought about a moment of reckoning in studio art education, a significant turning point. It instigated a necessary reassessment of student needs and, more generally, brought into question the foundational assumptions that support our daily habits, the "invisible curriculum" so to speak.

Art educators began to ask one another: At what, and for whom, are traditional art education structures aimed? How does this orientation bear out at the elementary and secondary levels, in undergraduate education, in community spaces? How do we justify the disproportionate growth in graduate-level tuition increases? Who benefits from the current system of MFA programs, and what specifically should the goal of professional studies in studio art be? How do the institutions we work within meet the needs of the contemporary art students we serve? And, on a much more personal level, how can we rethink individual pedagogical models to meet the new and changing circumstances of a world in constant flux?

The conversation among art educators in online forums began to shift from the immediacy of the pandemic moment toward longer term goals anchored in deep foundational change. The conditions of

COVID-19 isolation unmasked a host of additional "pandemics" hiding in plain sight: racism, sexism, homophobia and transphobia, rampant income inequality, climate change, police brutality, and growing antidemocratic political movements around the world. Art educators began to insist on a reevaluation of what and how they teach against this societal landscape, realizing that both their students' and their own well-being depended on it.

2 | The Structure of the Book

It was this deeper yearning for substantial change, based not just in the immediate effects of the pandemic, but in how those effects continually ripple through culture, politics, environmental issues, and social justice movements, that animated the discourse around studio art pedagogy at Teachers College, Columbia University in spring 2021. That year's version of the annual Art and Art Education Symposium, "Art School Pedagogy 2.0," sought to gather reports from educators from across the field, not only to share their experiences of pandemic teaching and learning but to begin thinking forward to the kind of practice we wished to shape in the aftermath of the still looming health emergency. Over a month-long online forum, art educators from around the world explored and debated what this future might be. This book springs from that discourse in both style and content. It is the manifestation of our desire to keep the conversation going by providing a solid platform (a published book) from which future conversations about studio art pedagogy might take root and grow.

We envisioned creating a publication that would echo the chorus of diverse voices that had emerged in the symposium, one that sustained the tone of practitioners in dialogue with fellow practitioners: honest, concise, reflective, and favoring practical application over heavy theoretical argument. *Turning Points* is the anchor we offer for that purpose, a launching pad for future-facing discourse around studio art pedagogy, a tool to think with and through as we collectively consider how the future of art education might look and feel.

The structure of our book promotes two primary goals: to document a sample of reflections on studio art teaching and learning during the first years of the pandemic, before they dissolve into the digital ether, and to build from these reflections a starting point for considering art education's potential future directions. Part I, "Studio Teaching During a Pandemic," addresses this first goal through four distinct but intertwined themes. Chapter 1, "Pedagogy as Mentorship," looks deeply at the primary shift in the student–faculty relationship over this period, driven by the new norms of technological communication while simultaneously encouraged by the need to manage the societal and cultural trauma the pandemic wrought on individual lives. Chapter 2,

"Materials and Processes," illuminates the particular problems of translating traditional media-based instruction through digital tools and delves deeply into the daily work of managing studio art production in pandemic isolation. Chapter 3, "Community and Relationships," gathers the experience of community-based arts educators, relating the care of self to the care of others (and, by extension, the broader culture) through arts-based methods. And Chapter 4, "International Perspectives," seeks to sample the wide range of voices from art educators around the world, finding solidarity in their common concerns while subsequently highlighting the unique cultural differences that have made pandemic teaching in certain areas specifically challenging or rewarding.

In "Studio Teaching During a Pandemic," several themes emerge from the common challenges shared by studio art instructors during the peak of the global health crisis. Several writers reflected on the shifting nature of their relationships with colleagues, administrators, and students. As one might expect, a more personal, intimate tone colored all our correspondence during the early days of the pandemic, a time when asking a simple "How are you today?" might trigger responses far beyond conventional courtesy. In this moment, art educators reported increased feelings of deep concern for their students' well-being. This concern translated into a responsibility far beyond pre-pandemic expectations. For high school teacher Jess Perry Martin, this meant sustaining her students over Zoom calls even while managing her own health challenges. University instructor Iman Djouini focused on mentoring and supporting her students who were also women of color and mothers, building from their shared experience. And for teachers like Linnea Poole, hand-delivering art supplies to students who would otherwise go without became just one of many ways to manifest social justice during pandemic lockdowns.

Given that the health emergency confined many to their homes and effectively shut down school and university buildings, the negotiation of space for teaching and learning became charged with a new immediacy. By working from home, art educators blurred the boundaries between domestic space and institutional space as never before. By learning from home, students brought into question the accessibility of the classrooms, workshops, and collective studios they could no longer activate. As well, the strangely intimate Zoom rooms that replaced classroom studios revealed the gross inequalities in living spaces across the board, casting a fresh critique on our inequitable economic reality. Bill Gaskins expands this critique to encompass a radical rethinking of our entire university studio art system, citing Dr. Nicole Fleetwood's notion of "carceral aesthetics" as a template for imagining how programs might be restructured in the post-pandemic era. Meanwhile, Sarah Schneckloth finds positive potential in the online spaces that replaced the physical space of her undergraduate

drawing classes, reporting a heightened energy among her students as they shared their work processes on camera.

But whereas a drawing class might lend itself to immediate translation through online modalities, other media and materials presented more fundamental challenges. In teaching students without access to clay, ceramics instructor Aimée Ehrman shifted her entire curricular outlook. Within this extreme limitation, she discovered a window of potentiality, opening up form and process for herself and her students. Painting professor Jun Gao saw the shift to distance learning as an invitation to imagine new studio models with emergent virtual and augmented reality technologies. And Carlos Arturo Gonzalez Barrios altered his filmmaking courses to embrace whatever materials were immediately at hand, a pedagogical premise neatly encapsulated in his short animation *A Pencil Is All You Need*.

Yet despite these common pedagogical strategies, the short reflections in Part I reveal distinctions along national, cultural, racial, gendered, and economic lines. Although we all experienced the pandemic from that same technologically mediated life raft, the conditions of the waters in which we sailed were not the same for all. For example, leading an online critique from an art and design university in Saudi Arabia, where cultural norms made the use of laptop cameras untenable (as recounted in the essay by Dina Lutfi), proved a different challenge than engaging with students online in technologically saturated Seoul, South Korea (as described by Sangbin IM). In this way, our collection of reflections aims to satisfy multiple goals: to link art educators across common pedagogical themes while simultaneously highlighting individual experiences during a time of shared crisis in the discipline.

Following Part I, a conversation between Judith M. Burton of Teachers College and Samuel Hoi of Maryland Institute College of Art enriches this discourse. Drawing from their leadership experiences in college art teaching, Burton and Hoi place the shifting nature of studio art pedagogy within the broader context of dialogic relationships. Anchoring future studio art pedagogies in mentorship, they favor new approaches that pair students and teachers as co-learners over traditional models that follow an outdated "master/apprentice" template.

Part II, "Road Maps for the Future," takes up the themes that emerged from Part I and applies them to imagine future directions for the discipline. This series of essays offers readers a spectrum of viewpoints on where we've been and where we're headed from prominent thinkers in the field of art and art education, including those of Ernesto Pujol, Seph Rodney, Kaitlin Pomerantz, Steven Henry Madoff, and Mick Wilson. Although by no means comprehensive, this collection is intended to serve as a foundation for future thought and action. It outlines key problems, leading questions, and potential solutions that will shape the landscape of art education in a post-pandemic world.

Our Conclusion, by Stacey Salazar, sums up the dilemmas and opportunities that await art educators, leaving us with a call to renew studio art pedagogy for a challenging time. And our Afterword, by Søren Obed Madsen, looks outside the discipline, attaching the work of art educators to the broader renewal of society by equating cultural production and cultural education with a healthy immune system in a potent viral metaphor.

In an effort to expand the dialogue beyond the confines of these chapters, we feature thought-provoking quotes from artists, curators, and art educators whom we prompted for their unique perspectives on potential directions in post-pandemic studio art education throughout the book.

3 | A Pedagogy of Change

The reflections that make up Part I of this volume paint a picture of tenacity and resilience against immeasurable odds. Overall, the art educators we solicited for contributions rose to meet and surmount multiple challenges in studio art education as they unfolded in real time. However, we should resist the urge to organize these experiences into a tidy narrative that ends with the resumption of in-person classes and the gradual loosening of COVID-19 era health protocols. In fact, narrative closure around the events and experiences of the pandemic remains elusive, with lingering health, economic, environmental, and social justice issues complicating any sense of recovery. The return to our pre-pandemic routines is inextricably linked to the many challenges of our post-pandemic reality. New realities replace older notions of normalcy.

Nonetheless, the pandemic still represents a pivotal moment in the direction of art education, a distinct turning point more impactful than any other in living memory. Seeking a title for our book that would capture this moment's outsized impact on education, yet also emphasize a forward-looking approach, we decided on *Turning Points: Responsive Pedagogies in Studio Art Education.*

What COVID-19 and other recent crises have in common is that they require us not just to endure but also to transform. That transformational approach is central to understanding "responsive pedagogy" in a larger sense. The term refers to the type of teaching that so many of this book's authors address and display: a resilience-driven pedagogy that is flexible and student-centered; that encourages fluency, collaboration, and original thought; that provides strong structures to support students and their teachers with empathy yet is capable of "holding uncertainty." Essentially, responsive pedagogy not only reacts to change but also anticipates and embraces it.

Central to this book is the ongoing inquiry on how to teach and learn through radical societal shifts, to craft and implement responsive

pedagogies amidst dramatic change. It is exactly this emphasis on constant change, in the most general sense, that informs our writers' evolving stances on their teaching and learning practices, so much so that we describe this new way of thinking in art education as a *pedagogy of change*. Less a manifesto than a teaching-philosophy-in-progress, a pedagogy of change refers to a growing collection of teaching practices that center response to student needs in the wake of social, political, and environmental disruption, a shaping of the learning experience to directly address the events and circumstances that affect our lives within and beyond the classroom. This pedagogy of change often manifests as mentorship in a hyper-personalized learning environment, aided by rapidly developing communication technologies and animated through interactive, collaborative models of knowledge transformation. At its core, a pedagogy of change teaches flexibility and resilience, a willingness to adjust priorities in the face of compounding adversity. It is inherently optimistic, promoting a mindset of possibility, if not abundance, over the limitations of austerity. And it meets the challenges of an increasingly complicated present with dreams of a more equitable, sustainable future, built on the scaffolding of an inclusive social imaginary.

What does a pedagogy of change look like in practice? Perhaps the best examples come from our writers. Their teaching remained flexible to accommodate fast-moving changes in technology, culture, and the economy. They learned to shift back and forth between modalities of teaching (socially distanced in-person teaching, online teaching, and hybrids of the two), by drawing on one another and expanding their pedagogical repertoire, acquiring a collective digital fluency along the way. New capacities developed in learning how to learn; a new teaching skill set developed around stewardship and initiative in the absence of solid rules. However, this transformation was not seamless; some art educators met the limits of their patience with new technologies and distance teaching protocols and decided to go no further. Robert Storr's quote ("I stopped teaching at Yale after 6 months of experimenting with online classes in large part because I could no longer do it in good conscience.") clearly, and emphatically, articulates this point of view.

How do we extend and sustain a pedagogy of change in our discipline into an unknowable future? The answer seems to lie in what is most sorely lacking in many education spaces, consistent support structures that center the well-being of all stakeholders: students, teachers, staff, and administrators. Going forward, we require an art education learning environment that is increasingly diverse (for example, regarding race, gender, gender expression, and socioeconomic status as well as philosophical and aesthetic proclivities), that is fundamentally equitable to all who participate in it, and that is radically empathetic in its capacity to embrace the continual change that inevitably affects

all members of its community. We must pursue these requirements not only for our students and ourselves, but for the health of the very institutions that house us.

As many writers in this collection attest, art education cannot continue along its previous path; attempts to do so in the light of the COVID-19 pandemic and the societal crises it exacerbated are untenable. The demands on our collective mental health alone are adequate cause for radical reevaluation. We acknowledge that the work to meet these challenges is neither easy nor lies in our discipline alone. The contemporary, post-pandemic concerns of art education are the concerns of the broader societies that support it. A grander reevaluation is underway, one in which radical shifts in environmental, political, and economic realities are inexorably intertwined. This reevaluation has repercussions that not only affect the education of the artist but shape the imaginaries, themes, and approaches that contemporary artists choose as they reconcile new ways of making with the urgency of the moment.

Beyond this crucial reckoning, a pedagogy of change in art education holds a central promise: continued solidarity. The separation, isolation, and fragmentation of pandemic-era life engendered a universal recognition of unity as indispensable to the larger project of education. That unity might manifest as a casual hallway conversation, or extra time allotted for mentoring a student or colleague in need. It might show up through the research we embark on together, or the themes and ideas that rise up in our gallery exhibitions, conferences, and publications. Our shared time, attention, and physical presence matter, perhaps more now than before a global health crisis showed us the fragility of what we took for granted.

As Dorothea Lasky, another contributor to our collection, eloquently writes, "arts education classrooms now must be places of kindness, empathy, and pressurized time, where we push our students to do the work that really matters to them and to the future." This book is an open invitation to take up this call to kindness, by participating in a dialogue that has been collected in, but extends beyond, these pages. We began assembling *Turning Points* from peer-driven conversations about the issues that mattered most in studio art education; we hope that its dissemination among working art educators furthers this conversation and promotes action on these issues. If the life raft analogy holds as a potent symbol of isolated pandemic-era teaching and learning, then perhaps we might imagine a future in which continued solidarity offers a more expansive metaphor. The single life raft meets its neighbors at sea; they connect and expand their vessels beyond the size of the sunken ship they once supported. Emboldened by collective agency they sail on, toward whatever changes await beyond the horizon.

I think that Zoom teaching defrauds students and teachers alike in the areas that concern me professionally—painting and drawing. In other domains that are more text or image (that is to say "picture") oriented, one can achieve limited levels of exchange, but at the risk of talking about utterly different things with students who haven't been exposed to the complex visual and material dynamics ("aura") of art in space. I stopped teaching at Yale after 6 months of experimenting with online classes in large part because I could no longer do it in good conscience. I've no more to say.

—Robert Storr

Remarkably, we did a lot on Zoom while looking at little pictures on screens. Student's artwork kept growing, and gathering virtually was anchoring in the midst of so much dislocation. I saw a lot of expansion of form and technical agility as students made work to suit virtual space.
It's interesting that when visual art operates in virtual space, it joins text and moving image in its capacity to reach audiences anytime, anywhere. In the wake of the pandemic, and in the face of that ease, perhaps the patience required to value particular places and moments has sometimes grown a little thinner. I also see a lot of interest focused on bringing something of bodily experience into the virtual world.

—Jessica Stockholder

13

Retrospectively, we did a lot on Zoom
with looking at little pictures on
screens. Still one artwork kept
growing and gathering virtually was
anchored to the midst of so much
dislocation. I saw a lot of expansion of
form and regional agility as students
made work in surf virtual space.
It's interesting to see how visual art
operates in ... and joins text
and moving ... capacity to
reach audiences ... anywhere
in the wake of the pandemic, and
in the face of ... perhaps the
patience required to value particular
places and moments has sometimes
grown a little thinner. I also see a
lot of interest focused on bringing
new sliring of bodily experience into
the virtual world

Chapter 1: Pedagogy as Mentorship

Introduction

PAUL A. C. SPROLL

Initially invited to moderate the Pedagogy as Mentorship panel at the 2021 Teachers College Art School Pedagogy 2.0 Symposium, and here invited as chair to collect and respond to short essays where contributors were invited to take a reflective stance in the interrogation of their pedagogical practices, I need to preface my identification of what I detected as emergent themes surrounding any connection between pedagogy and mentorship in college art and design education within the collective's responses with a resounding statement of thanks to the contributors: Iman Djouini, Linnea Poole, Amanda Newman and Lynn Palewicz, Megan Irwin, Jessica Rohl, and Veronica Thomas.

While in my role as a virtual symposium panel moderator, I had met three of these essayists, the others were unknown to me prior to an initial Zoom meeting, where I invited contributors to gather and share preliminary thoughts about the theme and possible avenues of exploration for their statements. Further, during our first convening, I encouraged contributors to draw heavily in their writing from their lived experiences, anticipating the benefit to readers of observations, insights, and recommendations arrived at through the practical experience of several college professors, a faculty instructional consultant, a student unexpectedly entering, and another student exiting virtual graduate studio degree programs.

It is important to acknowledge that each writer's thoughtful response to their experiences is located and contextualized within a specific set of conditions, which legislates against generalizability. However, despite this, the true value of these statements resides in their very subjectivity, which permits direct access to writers' contemporaneous thinking as they unravel and make sense of their practice during an unprecedented time in higher education—a time and set of experiences all too familiar to this publication's readers.

My lens as reviewer is significantly informed by my own college teaching experience when abruptly, in March 2020, my graduate seminars crafted and fine-tuned for in-person delivery were required to pivot to a virtual modality. So, not unlike these essayists, I too experienced a level of uncertainty about my own ability to meet the needs of my graduate students while attempting to transfer, admittedly somewhat clumsily at first, my pedagogical practice to the virtual space while simultaneously acquiring and navigating a new set of digital tools for teaching and learning.

What I had not imagined in my role as this theme's chair was the steady deepening of my relationship with the contributors. I had invited them to share their work in progress with me, but what I had not anticipated was the enormous value I would find in these virtual conversations about shared experiences. Further, I came to recognize the rarity of such moments of exchange and reflection occurring as they did beyond any of our respective institutional mandates surrounding teaching and learning matters.

There is considerable consensus within the contributors' statements that the pandemic, while decidedly disruptive to the pre-pandemic ecological landscape of teaching and learning, has presented possibilities for future, altered pedagogical models. Such vivid models have emerged because they have been informed by the contributors' direct experiences while navigating the complexities of this new educational reality. It is particularly noteworthy that the contributors, while situated within the contextual frame of higher studio art education, for the most part in their essays move beyond concerns for disciplinary content to the identification and reflection about what one might characterize as being learner-centered pedagogical dispositions.

The essayists writing either from a faculty member or a graduate student perspective reflect upon practices and modifications to practice distinguished by increased attentiveness to the challenges many students face in their learning encounters, primarily when engaged in virtual modalities. Indeed, the central theme of these brief essays recognizes the significance within the contributors' pedagogical practice of enhanced consideration of the totality of students' lives, not just that circumscribed by academics.

It is not that these contributors disregarded such concerns for learners' experience during pre-pandemic times. However, the COVID-19 pandemic inescapably created intense anxiety levels for many students inside and outside the classroom that their teachers could not ignore. Iman Djouni speaks with candor about how the pandemic amplified longstanding inequities in the educational experiences of art students identifying as women of color and mothers and views mentorship as a critical opportunity to support these students as they negotiated their "intersectional identity." Furthermore, Jessica Rohl,

one of the graduate student contributors, claims that a pedagogy in which "instructors as mentors and their mentees fit into each other's lives" represented "a significant turning point in the educational space." Here, one senses the desire to shift pedagogical practice to one that is unabashedly inclusive of a commitment to mentorship. In their teaching, Lynn Palewicz and Amanda Newman-Godfrey "began to see these shifts in pedagogical practice as expanded forms of mentorship" and one "founded on empathy and trust."

While not explicitly articulated by the contributors, one might begin imagining pedagogy and mentorship not as distinctly separate acts but within a continuous Möbius loop where there is no perceptible divide between the two. Indeed, pedagogical practice viewed through the lens of mentorship acknowledges a willingness of these faculty to embrace a multiplicity of interconnected roles in their interactions with their students. In the literature on mentoring, the role of the mentor has been variously described as "that of adviser, agent, confidant, role model, sponsor and teacher" (Gotian, 2016, p. 2). It is not, therefore, unwarranted when framing pedagogy as mentorship that the role of a teacher should be more appropriately considered as being inclusive of all such roles but expanded to include that of a mentor. Graduate student Megan Irwin, for instance, refers to the multiple roles taken up by teachers as a "stretching relationship between student and faculty."

What is so inspiring about these contributors' reflections on their pandemic-situated practices is their generosity regarding their time, labor, and commitment to the concept of the learning encounter—formal and informal—as being essential and interdependent in their students' success. For instance, Linnea's sensitivity to the needs of students required to complete studio assignments in virtual classes led to an extraordinary act of care, taking it upon themself to make deliveries of art kits to students' homes, an action by an instructor one would agree would have been almost unthinkable during pre-pandemic times. Rather than narrowing their pedagogical practice, Lynn and Amanda expanded it during the COVID-19 pandemic and, through their "community-building efforts, opened up new spaces for mentorship to flourish." In Iman's openness to vulnerability in engaging outside regularly scheduled class time in one-on-one conversations with their students about shared experiences within the university, we see Iman as a mentor, yes, but far more accurately as a "cultural navigator" (Fries-Britt & Snider, 2015, p. 4).

Again, vulnerability—but in this instance, the degree to which it manifested itself in faculty charged by pandemic conditions to embrace online teaching—was a state that Veronica Thomas would face in their role as an instructional consultant and coach. However, what distinguishes Veronica's support of instructors entering what for a good many was new pedagogical territory was their commitment

at the outset "to cultivate a relationship with educators in which their vulnerability in not knowing was an opportunity rather than a liability." The effectiveness of Veronica's mentoring model would be dependent, as it may well also have been in the examples of the other contributors' practices, on the degree to which a trusting relationship had been established between consultant on the one hand and faculty/instructor/teacher on the other.

As I reflect on the essences within these brief essays, it is trust that emerges as pivotal to practices that blurred boundaries in these instances between pedagogy and mentorship. Indeed, I would argue that trust was central to pandemic practices where a new kind of intimacy had entered the educational forum. This intimacy led to greater levels of connection between teacher and student as both navigated the disruptive forces of COVID-19. Moreover, an ecology of teaching and learning and a pedagogy of care would surface in which empathy, agency, flexibility, the courage to rethink, the hyper-personalization of curricular goals, as well as the importance of community to the learning experience were significant characteristics of an evolving hybridity of pedagogy as mentorship. The recalibration of instructional practice exemplified by these essayists does, however, beg the critical question as to whether such customization of practice can be sustained in a post-pandemic pedagogy and whether faculty would be willing to continue to engage in the merged roles of teacher and mentor. In the face of the COVID-19 pandemic, higher education ironically was gifted extraordinary examples of innovative practices—glimpses of which have been described by these contributors. However, an arguably even more poignant question is whether such practices will remain sealed, undeveloped within a historical time capsule, or whether there exists the institutional will to carry these forward and to provide the support for an educational climate in which pedagogy as mentorship thrives.

References

Fries-Britt, S., & Snider, J. (2015). Mentoring outside the line: The importance of authenticity, transparency, and vulnerability in effective mentoring relationships. *New Directions for Higher Education, 2015*(171), 4. https://doi.org/10.1002/he.20137

Gotian, R. (2016). Mentoring the mentors: Just because you have the title doesn't mean you know what you are doing. *College Student Journal, 50*(1), 2.

COVID-19 and What Became Visible

IMAN DJOUINI

In public higher education, art students who identify as women of color, particularly mothers, have always stood within varying intersections of racial, gender, and economic barriers. As the COVID-19 pandemic contributed to increased inequalities for this student population, it is important to consider the role of effective mentorship in connection to student and faculty representation, how this has been shaped by the COVID-19 pandemic, and effectively how public universities can adapt more sustainable and robust intersectional diversity, equity, and inclusion (DEI) and antiracism strategies in a post-COVID context.

While data demonstrates that the pre-COVID U.S. college student population is more diverse than ever (Hussar & Bailey, 2023), art students who identify as women of color, and those who are mothers, continue to be the least represented in art higher education and art professional institutions. With this in mind, I would like to point to potential long-term negative outcomes this may have on diverse representation in art and cultural production, along with the negative long-term effects this may have in deepening racial and economic inequalities for both student and faculty populations in higher education.

As we know from the current literature, mentoring that takes place between faculty of color and students of color who share similar experiences like motherhood, cultural barriers, and challenges of difference leads to favorable outcomes in both educational and professional success (Taylor et al., n.d.). Providing effective mentorship for art students who identify as women of color directly correlates to this data. In this essay, through firsthand reflection and analysis, I highlight the unique challenges the COVID-19 era has presented to this population of art students, whom I mentored as we transitioned to working from home and adapted to online learning. I hope these reflections can provide insight into mentorship in contemporary educational practices specific to art education in public universities.

As a woman of color, a mother, and an educator, working with these student populations has inspired flexibility and creative problem-solving skills. These approaches have helped me develop different strategies, paving the way for new models of creative processes and

dialogues to emerge, facilitated further by digital technology, which instigated a new learning space within a virtual realm.

As the COVID-19 shutdown forced my teaching to move from the public classroom space and into the private home space, the computer camera lens revealed many unavoidable realities and personal challenges facing my students.

For my students of color who are mothers, the lack of child care has been one of the most difficult realities made visible in the online classroom. In the United States today, this issue is the biggest challenge facing mothers (Miller, 2021). While access to safe and affordable child care has always been a national crisis, the COVID-19 shutdown has forced many women to take on home schooling responsibilities for their children in addition to their in-home educational demands and professional workload. While attending online classes, these students' computer cameras and microphones revealed a window into their personal lives, which included children calling for attention, watching television, or sleeping in their arms. In effect, they balanced their attention between the virtual classroom and their children in real space. As such, these views made visible the "invisible labor" (Daniels, 1987) of parenthood, forcing me as an educator to rethink labor in art making and access to education and inclusion. These factors needed to be considered in order to ensure equity among my students. In my curriculum, I could no longer standardize art project assignments that required the same amount of labor from all students.

The impacts of the COVID-19 pandemic on my art have inspired me to revisit the issue of representation and what is ignored and excluded as a central theme in my pedagogical approach. *Light Elephant* is a site-specific and site-reflective public installation, where I placed a 16-foot inflatable white elephant in over a dozen strategic pop-up locations throughout the cities of Baltimore, Maryland and Santa Barbara, California. The elephant acts as a metaphorical linguistic prop for the idiom "the elephant in the room," which calls attention to the economic and political dynamics of what is ignored and excluded in cities with some of the highest income and racial inequalities in the nation. Positioning "the elephant in the room" throughout Santa Barbara in the context of the COVID-19 pandemic highlighted new social and economic inequalities that had become exacerbated.

At this point, my art metaphorically connected to my teaching practice. In one-on-one meetings with students of color who were mothers, we used our time to have more specific conversations about "the elephant in the room." We could no longer talk about art in the same way. The "elephant in the room" here referred to the challenges that we were facing that became visible on our Zoom screens; it was the context of our lives during COVID. These meetings also became a valuable time to reflect and assess the relationship between labor and

how it is experienced and negotiated in relationship to intersectional identities.

During this time, I have uncovered key strategies that have proven effective in fostering the growth of my mentees:

- Focusing on sustainable solutions for art making
- Providing a space to reset goals
- Narrowing the scope of projects
- Keeping the same project goals with extended deadlines

Encouraging the students to set their own boundaries has also been key, as well as reminding them to take full advantage of flexible work options.

Finally, talking about gender and intersectional bias that occurs when ignored invisible labor in realities of student lived experiences has been key. While equipping my students in these discussions with specific language to identify and highlight their unique perspectives based on their lived experiences as valuable and important, these discussions have also been important in avoiding biases that might occur in the development and assessment of standardized learning outcomes in courses.

More than 2 years into the pandemic we are finding that women of color who are mothers struggle disproportionately with continuing their studies in higher arts education. Understanding students' unique experiences and supporting them with effective mentorship is now more important than ever in helping to reduce the risk of losing future women leaders and unwinding years of painstaking progress toward intersectional gender diversity in the arts.

References

Daniels, A. K. (1987). Invisible work. *Social Problems, 34*(5), 403–415. https://doi .org/10.2307/800538

Hussar, W. J., & Bailey, T. M. (2016, April). Projections of Education Statistics of 2023. National Center for Education Statistics, U.S. Department of Education.

Miller, C. C., (2021, May 17). The pandemic created a child-care crisis. Mothers bore the burden, *The New York Times*, https://www.nytimes.com /interactive/2021/05/17/upshot/women-workforce-employment-covid .html

Taylor, A. L., Mitchell, D. A., Phillips, K. W., Gonzalez, R. L., Jr., Roberts, S. K., Goldman, L., Lapiner, C., Lassiter, S. L., & Brooks, A. B. (n.d.). Guide to best practices in faculty mentoring: A roadmap for departments, schools, mentors and mentees. https://graduatedivision.ucmerced.edu/sites /graduatedivision.ucmerced.edu/files/page/documents/mentoring_best _practices_columbia_university_-_office_of_the_provost.pdf

If We Speak, Do You Listen;
If You Hear, Will You Respond?

LINNEA POOLE

What does it mean for the role of educators to create a space where students are able not simply to learn but to be free to discuss grief, anger, and frustration, not just with our broken educational systems but with the lack of care for their very existence? This question arose from my experience as an art educator and parent during the first year of pandemic distance teaching and learning. Initially, neither educator nor student was prepared for what would become the standard of online learning. As artists, educators, and change makers, who would have thought that we would be reaching and teaching our students virtually? We had to quickly become proficient in online learning, adapting to limited Wi-Fi and slow systems, as well as managing being both parent and professor at the same time. With workshops and an overwhelming number of emails added to our workload, it was a challenge for us to get to class and somehow find the strength to engage with students, who were just as panicked and scared as we were.

Addressing this question of the essential labor of education during the pandemic starts with examining learning cultures and the ways in which institutions place conditions on students and teachers. We all continue to witness how the world makes divisions between race, class, and gender, but that has never quite been the ideal vision for freedom and justice. From sheltering in place to the anxiety of watching the news, things happening today have become more than just a slap in the face; they have become a sucker punch deep in the gut. Academic institutions seem to want to make a learning environment that gives way to curiosity. Course titles are different, and indeed faculty members as well, but the culture of neglect stays the same. The institution's need to perceive itself as a place of care and love falls short at every turn because the bottom line is the bottom line. The push for academic institutions to sustain themselves far outweighs their push to create rigorous learning environments, environments that help students construct, above all else, a sense of belonging, a space for questions, and a source of help.

Let's admit that now that we have a sense of normalcy back, some folks are doing fine retracting back to their daily lives while others are just taking things day by day; they are surviving after this wake-up call to the world. We all can agree that during the first year of the pandemic

we learned how to hold our families and children a little tighter at night. The world watched as many learning institutions scrambled from the immediate dismissal of students leaving campuses to not knowing how to support their students of color. I want to stress that I love all of my students, but in particular my BIPOC students needed an outlet to further process their feelings through art making, especially regarding the murders of George Floyd and Breonna Taylor, police brutality, and the international protests those events inspired. This does not exclude the horrible violence and unspeakable attacks that the Asian community also faced. There were many historical eye-openers during this first pandemic year that we must speak about, that we just cannot ignore.

Before the onset of the pandemic, I would never have thought that my pedagogy would be shifted, tested, and challenged within the blink of an eye. My teaching philosophy is inspired by the renowned philosopher bell hooks, who deeply expressed, throughout her research, how education is a practice of freedom. In terms of my own pedagogy, the classroom environment I create, whether virtual, hybrid, or in person, is a sanctuary, a home, a welcoming place with a few weekends off. My students are humans who are eager to embrace the newness of learning, new principles and techniques that will help them grow as artists creating, making, and building their practices. Whether it is through performance or foundation, I am their doula, motivator, and goal seeker. At times I am also a referee, and I do not mind stepping in as their second parent for comfort on occasion. But most importantly, I am their guide and mentor. Yes, teaching is my passion, but I am called to teach and to be at the forefront of art education as an ambassador through offering a creative, open learning environment.

Though I still honor this teaching philosophy, the conditions at the beginning of the pandemic required me to revisit it. My active teaching practice gave me a better insight to what my students specifically needed from me during that time. For example, there were times when I made visits to my students' homes to ensure that they had art supplies. The most interesting part about my art kit deliveries was that it combined my roles as art educator and parent; my young daughter came along and had the chance to witness and participate in what I called our "special gifts" just for our communities.

Indeed, we continue to learn from each other day to day. I always remind my students that we are always learning, that this is a growing semester that we will conquer together, like a fancy plant with plenty of sunlight. At the start of my classes, I now include a community check-in as a form of self-care that adds to my labor as an educator, but more importantly, it ignites my passion and my calling to be a teacher. One of my goals is to continue this practice in the years to come as my pedagogy research and studies continues.

This push of labor feeds our seeds in order for them to blossom! Let's aim as a community to go hard as educators and be the driving force behind our students so that they can succeed as creators and art makers. We all were once eager students that wanted so much, dreamed so big, and needed educational leaders to give us that extra push to meet our desires.

Indeed, our students need strong leaders more than ever as we move beyond the initial years of the pandemic. The shift in learning culture that the pandemic instigated is a wake-up call for our immediate future and even the next generation. Colleges and universities as a collective must take these matters seriously. This shift in learning must provoke a call to action; institutions must adjust, both for the sake of their students and for their own stability. Having made it through the first year of the pandemic, I can now say that educators and art practitioners have learned to be more open minded and diligent about their teaching pedagogy and practices. Institutions must do the same.

Barriers Broken and Lessons Learned in Pandemic-Era Art and Design Education

LYNN PALEWICZ
AMANDA NEWMAN-GODFREY

In the academic year of 2020–2021 of the COVID-19 pandemic, Moore College of Art & Design offered students the options of fully remote or on-campus learning. Courses were taught in one of two learning environments: (1) fully online (synchronous or asynchronous) or (2) HyFlex, a combination of on-campus and synchronously online experiences. These dichotomous learning environments presented challenges for us. While challenging, this moment afforded us opportunities to reevaluate the scope and importance of student interactions and different modes of mentorship.

Collectively, we feel the imperative "know your learner" frames the way we design courses and address student needs. The pandemic prompted us to seek a more comprehensive understanding of the challenges our students face. We anticipated engaging with learners with little to no online course experience, anxiety around what to expect, and questions about "the how" of everything. During our pandemic teaching we noted a number of issues that would reshape, and continue to reshape, our practices. Furthermore, we began to see these shifts in pedagogical practice as expanded forms of mentorship.

Mentorship as Highly Personalized Instruction

Pandemic-era learners are as diverse as pre-pandemic ones; however, course delivery dynamics during the pandemic necessitated shifts to expand mentorship opportunities. One example of such a shift centered on our ability to perceive and safely discuss our teaching and learning habits in these new classroom "spaces." Many pre-pandemic learners who consistently recognized and articulated their needs were "learning themselves" all over again in a virtual classroom. Concurrently, we too were learning ourselves all over again, given that online instruction was relatively new for us. Some students who previously handled in-person learning with minimal barriers found themselves struggling to stay engaged and timely. Other students blossomed in the virtual classroom by pacing their engagement throughout the week and

25

avoiding anxieties driven by in-person or real-time discussions and critiques.

Our go-to, in-person teaching strategies and tools had to be rethought and rebuilt for online environments. As professors and students collectively navigated new ways of teaching and learning without consistent face-to-face access, we all began to drop our guards and become more receptive and responsive to each other. Simply put, mentorship now became a more intentional and personalized shared journey.

Mentorship as Fostering Community

Without community, students did not feel safe asking questions, taking risks, volunteering answers, or offering critiques. We needed to seek creative ways to build community in fully online and HyFlex models. For our online learners, we fostered connections with their on-campus peers; in fully online environments, we facilitated similar comradery but solely via an online platform. Social media applications such as Slack and Discord allowed us to create online hubs for in-class and out-of-class chats. Online bulletin boards such as Padlet enabled students to post in-progress work for peer critique. With these community-building systems in place, students formed connections with one another.

The impact of these connections was immediate. Faculty now had a window into students' informal, community-oriented connections and could transform online posts into discussion points to enhance learning moments. Pandemic-era teaching reminded us that the role of educator (and mentor) goes far beyond delivering course content. We recognize, and have clear evidence of, how we play a critical role in setting the tone of the course, establishing values (i.e., trust, support, and encouragement), and facilitating peer-to-peer or student-to-professor communication. Our community-building efforts opened up new spaces for mentorship to flourish.

Mentorship as Intentionally Facilitating Mentorship

We believe that impactful teaching requires teacher–student interactions founded on empathy, trust, and the human need to support each other on a shared journey. Mentorship prioritizes these interactions, with the goal that lessons learned foster and strengthen self-directed skills essential for successful college and career experiences. During our pandemic teaching, we found that the need for one-on-one connections (and mentorship) was heightened and required a higher level of engagement with students outside of regular course hours. The

structure of fixed office hours no longer met student needs. We both found that our use of social media and online share points significantly increased the time we each spent one-on-one with students addressing their learning needs.

As such, building these mentorship opportunities became a key component of our teaching practice. While these increased connection points required more time, they proved to be a fruitful investment that led to increased levels of student confidence and engagement. The strong bonds of mentorship established during individual meetings encouraged trust, empathy, and shared goal setting. During these unprecedented times in higher education, we began to see each other as humans navigating a host of superhuman challenges together.

A New Normal

As we consider our roles as professors informed by our observations of and reflections on our pedagogical practices during the pandemic, we wonder about the "new normal" and speculate about its impact on higher education. We believe we became stronger educators from both the challenges we navigated and the lessons we learned. We have identified three practices in particular that we plan to incorporate into our updated pedagogy and from which we are confident our students will benefit:

1. We intentionally increased personalized instruction that resulted from both professors and students navigating new ways of teaching and learning online.
2. The role of community is critical to student learning as it instills course values and reminds us that learning is also a group experience.
3. Mentorship opportunities lead to growth in learner confidence and engagement, which impacts student development of transferable self-guided learning skills critical for careers in art and design.

Regardless of all the lessons learned and those yet to be learned from teaching art and design in these new learning spaces, we strongly feel that layering in intentional moments and avenues for mentorship had positive and lasting effects on our pedagogical practices and student outcomes.

Hyper-Personalized Mentorship as Essential Work

MEGAN IRWIN

After 14 years of working as a graphic designer, I applied to graduate school in January 2020 with the goal of shifting my professional practice and transitioning to design education. Not only did the onset of COVID-19 complicate the decision-making process for pursuing graduate studies, but the pandemic continued to derail and challenge my expectations for what graduate education might be.

As we headed into virtual learning with a collective weight on our shoulders, it became clear that everyone had less margin for the level of productivity that typically would be expected of us as graduate students. During the required isolation of the pandemic, the whole world was realizing the need to distill our busy lives down to the *most necessary* things. This was not only required of us in order to stay inside the safety of our homes, but also for our own mental health as we worked to manage the additional burden and stress that lockdowns thrust upon us. There was a quote going around on social media from Austin Kleon that said, "Creative people need time to just sit around and do nothing." At the same time, everyone around me was reading Jenny Odell's book *How to Do Nothing* (Odell, 2019). I started thinking about the idea of "nothing" and how suddenly we had the opportunity to embrace the "nothingness" forced upon us in our isolation and respective cancellations. We had the chance to reset the unreasonable expectations we had all been living under before the pandemic.

This simplification happened in art education as well. I witnessed instructors asking the question "What is necessary?" in regard to the learning and development of their students operating under this collective burden. This often meant revising a broader range of skills and learning outcomes in order to truly deepen students' knowledge and skills of the essentials. Instructors became more strategic in their use of class time, utilizing individual meetings or smaller group sessions that provided greater degrees of autonomy and individualized instruction. These more concise and intentional blocks of time allowed instructors more opportunities to adapt and guide students toward their individual growth trajectories. From my perspective, this specialized instruction has led to the evolution of the instructor role into something more like that of mentor or guide. I often heard the phrase, "How could I be most helpful to you today?" or, "What would

you like to focus on during our time?" You could feel an empathetic and considerate shift from instructors to meet students' specific needs. The instructors' increased concern for individualization within their pedagogy resulted in students focusing on their most essential work toward the development of their own personal practice.

This focus on "the necessary" has brought about a heightened awareness to what was previously required in pre-pandemic times in terms of productivity and output. It is evident that the last two years have led to a reevaluation of standards and expectations placed on students. Guidelines have been adaptable, deadlines have been flexible, expectations have been more feasible and sustainable. Additionally, I noticed a significant shift in instructors' pedagogical practices, away from final outcomes and toward an embrace of nonlinear creative processes. Indeed, the learning along the way has become far more critical to my development than finishing my creative work on a certain timeline. I have seen many instructors within the virtual educational landscape adjust deliverables or redefine what constitutes "finished." Some of these changes were due to limits on resources for production. But they are also due to a shift in instructional practices to directed mentorship, where each student's individual process and artistic journey is increasingly considered and valued. Frequent offers of Zoom meetings provided opportunities for students to talk about new ideas, show work in process, or just receive encouragement when stuck. And it is here in these raw, vulnerable, and unpolished stages of the creative process that meaningful mentorship becomes even more crucial.

I am imagining these pandemic-induced shifts in mentorship (hyper-personalized approaches to students' development, adaptable timelines and deliverables, and a focus on process over product) may now have cemented themselves into the pedagogical approaches of many studio faculty. If that is indeed the case, I believe that art and design students will certainly benefit from these changes for years to come.

Reference

Odell, J. (2019). *How to do nothing*. Melville House.

The Adventures of a Pandemic Graduate Student

JESSICA ROHL

At the beginning of my second semester of graduate school, I was faced with a dilemma: either stay in Baltimore, the place that I had called my home for the past 6 months, or pack whatever I could into my Corolla and drive 6 hours north to Buffalo. I knew that all the buildings would be closed since we were informed that classes would be online for the foreseeable future and the school moved all students out of their dorms. I loved the house I was living in, but life in lockdown with four roommates seemed daunting. If I stayed in Baltimore and didn't go back to Buffalo, every possible scenario with endless outcomes whirled around in my head. I finally decided to drive north. I had three days before all my graduate program classes, the class where I was a teaching assistant, and my two jobs at the graduate tech lab would all be online. I went from only using a computer to write an occasional paper to staring at a Zoom screen for up to 8 hours or more a day. Those first few months of the pandemic were some of the most challenging days of my life.

Online classes meant the loss of the physical presence of my classmates and teachers. But it also meant learning a good deal more about those individuals' lives. Strangely, a new level of intimacy was established in the virtual classroom that wasn't present before as I was transported into their homes. This was the first significant shift that I saw in education. While I was a teaching assistant in an alternative processing undergraduate course, I noticed the content change in students' projects from friends they went to school with to images of siblings or parents. Images of the campus and the City of Baltimore were replaced with photographs of students' backyards and neighborhoods.

The second significant shift in my education involved my relationship with my graduate school mentor, Professor Bill Gaskins. I can say without a doubt that my thesis development was contingent on two primary factors: the pandemic and Bill's guidance. In terms of that guidance, it was the break from meeting face to face, the separation of teacher and student, rather than the shift to virtual learning that made the difference. I found that some of the best learning I accomplished was when Bill would step back and just let me figure something out for myself. I would work through a problem, answer pivotal questions I needed, and then return to him, seeking guidance on how to expand

my idea. He might then challenge me as to whether I had pushed my ideas far enough.

During the third semester of my MFA, I traveled around to national parks, living out of my car over the 2-week journey. Bill's encouragement paved the path for me to do so. I would have never even considered doing such a thing while in school before the pandemic, but in the online learning space, in which students all around the globe took courses virtually, there seemed no reason not to incorporate travel into my own learning. Bill agreed, but he took it a step further and allowed me a break entirely from the class schedule so that while on the trip, I could more fully devote my time to building my thesis. He prepared me before I left with the kinds of research questions I should be asking and made sure I had a good idea of what I wanted to be documenting. And on my return, Bill listened to my new ideas and how they completely altered the direction of my thesis.

The experience I had on the trip created room for a necessary shift in my creative process. I also felt that the mentorship that Bill provided before and after the trip was very different than the mentorship he provided during the trip. Before the trip, Bill offered questions and advice. But during my journey, he stepped back and allowed me to breathe, go off and see and do what I had to while always remaining available to help problem solve in those moments when I most needed his support. I was working on a project that I thought would be a film, but it quickly turned digital and shifted from black and white to color, from national park histories to translating abstract landscapes into music.

Once I returned home and reentered the digital classroom, my dialogue with Bill continued, which is when I finally informed him that I had found my thesis topic: abstract photographs representing memories associated with music. The path of my project only happened because Bill believed in my vision sufficiently to allow me to go out and search for it.

Mentorship practices should not be confined to the walls of a brick-and-mortar classroom or the constraints of a Zoom call. Mentorship is broader; it reaches further. Sometimes this looks like the mentor stepping back to allow the mentee space to figure it out. Bill gave me the space I needed to learn, grow, and find my voice, which I eventually discovered in music. My thesis project continued to develop as I looked at artists creating work in similar conversations and as I listened to old songs that evoke strong memories. My undergraduate school permitted me to use a small campus gallery to hang up my work to see it full size, though again, due to pandemic protocols, I could only share the physical presentation of my work with my best friend and my parents. I graduated in my parents' backyard with close family members and friends on hand, as the words of Valerie Maynard and Amy Sherald filled the space from the TV speakers.

It has been my privilege to see and experience what I consider a significant turning point in art education. Pedagogy has changed, specifically in the way mentors and mentees acknowledge and fit into one another's personal and intellectual lives. I know that as I continue to grow as an artist, educator, and learner, I will pass on the lessons of the pandemic years to my own future students. And I can now see, more vividly than ever, the importance of truly knowing one's students and the totality of their whole lives. Doing so will allow them to break free and find their own voice, as it did for me.

Mentoring as Pedagogy

VERONICA THOMAS

The pandemic year of 2020 reminded us all of our fragility. This recognition, however, did not lead me to futility, but instead engendered humility. I had never considered myself a particularly prideful person when it came to my work in higher education guiding educators through the frontier of teaching online; nevertheless, as the months of COVID-19 lockdown stretched into years, I began to examine my "why." Why was being the executive director of digital learning so important to me? Why was I so driven to help educators? These "why" questions led me to ask the ultimate "what" question: "What really matters to me?"

When it comes to my profession, what really matters is what I can do from a place of authenticity to help and inspire others to *become*. This is the guiding principle behind my work in mentoring educators in online course development and in continuously iterating on my mentoring model.

My credo for support and development through mentorship has at its core a four-letter word: help. But when it comes to working with educators, what is "help" on a practical and philosophical level?

From my perspective, help is fundamentally values in action. Figure 1.1 provides a visualization of the core "actioned values" in my mentoring model. These values are arranged in a cyclical, dynamic, and flexible process consisting of eight actions in which I persist: See, Validate, Expose, Connect, Stretch, Wait, Separate, and Revise.

SEE Their Teaching Style

To "see" someone is to look through the veil of their performance. People eventually reveal who they are if you take the time to see

Figure 1.1. SEE the Educators for Who They Are and What They Need

them. In my work with educators, I have typically seen several general teaching mindsets or approaches:

- Transmitter: "Learning is listening."
- Synthesizer: "How do they make sense of it all?"
- Taskmaster: "It's my way or the highway."
- Facilitator: "What can they learn from the group?"
- Collaborator: "What can we learn together?"
- Provocateur: "Just for the sake of argument. . . ."
- Curator: "You might find this interesting."
- Practitioner: "This is what you need to know in the real world."
- Explorer: "Let's try it."
- Researcher: "Where's the evidence?"
- Clinician: "What's the diagnosis and solution?"

Although a few educators will have a combination of these teaching approaches, most will generally have a dominant teaching style. My task is to determine each educator's teaching philosophy and adapt my mentoring approach to their level of readiness. For example, if a professor places an emphasis on transmitting information, I'm not going to easily convince them to be as spontaneous in their teaching style as an educator who is an explorer. Conversely, if an educator is an explorer, it will be a challenge to get them to plan ahead for teaching an asynchronous online course. They may also need help focusing, staying on task, and meeting deadlines.

VALIDATE Their Feelings About Teaching Online

The emergency move to teaching online in 2020 left many teachers feeling as though they were novice instructors again. The strategies and techniques many had perfected over dozens of years and hundreds of students were no longer reliable or feasible in online settings. No matter their teaching approach, however, online instruction required every instructor to learn how to teach at a distance through technology. My task was to cultivate a relationship with educators in which their vulnerability in not knowing was an opportunity rather than a liability. I did this by being a technology pragmatist as opposed to a technology evangelist. A technology evangelist pushes technology while turning a blind eye to its imperfections and discomfiting consequences. Their rationale for the utilization of technology is often "because we can." As a technology pragmatist, I'm not content with "because we can" as a rationale for doing anything. I don't believe that everything we *can* do, we *should* do. Therefore, before I adopt or recommend a new instructional technology, I consider three things: (1) its intended

purpose, (2) whether it will help an educator accomplish a specific teaching and learning objective, and (3) its downsides. In their zeal to be modern, many technology evangelists will ignore or not at least pause to ask what the unintended consequences of using a particular technology might be. While it would not be advisable to avoid the unknown simply because it is unknown, discounting the potential cost before embarking upon a new frontier and failing to prepare for "just-in-case" scenarios would be reckless.

In counting the cost for using any educational technology, I evaluate the pros and cons from the perspective of the educator and the student: what works well with the technology; what doesn't work well; what level of technical proficiency may be required to create or to engage with the technology; could the learning objective be accomplished without the technology or with an alternative technology the instructor already knows how to use? I try to be transparent with educators about a technology's pros and cons, even if it is one that I personally use. I find that this transparent and pragmatic approach—liberally peppered with humor—often helps educators feel less self-conscious about what they don't know. They feel validated in their feelings of anxiety but grow increasingly confident knowing they have a partner in their journey of learning.

EXPOSE Them to New Ideas to Consider in Their Teaching Practices

When trying to encourage an educator to try something new or to even think about teaching in a new way, it helps to have examples from other people who have been successful at using the tool, strategy, or technique. This requires me to have a "satchel of samples," which I keep updated so that when the opportunity presents itself to expose an educator to a technology or technique that is new to them, I will be ready to show, tell, and hopefully, encourage them to try.

CONNECT Them to Curated Resources

What distinguishes curated resources from samples is that while samples provide *examples* of what someone was able to accomplish with an instructional technology, curated resources provide *tutorials to explain how to use* the technology to accomplish specific tasks. I emphasize *curated* resources because educators are often overwhelmed with technology options. This is where a mentoring approach scaffolds the instructional-technology-curation process not only by pointing the educator to relevant resources that can help them accomplish a task but also by modeling how the search was made to discover the resource so that the educator feels equipped to curate resources for themselves.

STRETCH Their Capacities by Inviting Them to Try Something New

I've explained the importance of exposing educators to new ideas. Even a good idea, however, is meaningless until it is tried, tested, and refined. The "trying" stage is where anxiety levels are at their peak. Educators, like anyone else, want to make their mistakes in private. The thought of their students seeing them fumble with technology when teaching online is a factor that leads many instructors to dread or despise online instruction. This is why I always try to get educators to experiment with a new instructional technology in the safety of a virtual cocoon that is limited to just the two of us or to a few of their trusted colleagues. This can be accomplished in a one-on-one tutorial session or a small group workshop.

WAIT Until They Have Processed New Information and Are Ready for More

In my work with educators, I have learned that their learning must be at their speed, not mine. Learning requires waiting. Despite buzzwords like "accelerated learning" or "learning at scale," human beings are not machines. Learning is not a factory process in which thinking, feeling, and growing human beings can be manufactured from relentless mechanized procedures. Learning through mentoring is a painstaking process that expects the person being mentored to keep moving forward but also knows when to wait and allow time for them to pause and reflect. When mentoring educators to teach online, I have to give them time to synthesize new information before introducing a new concept or guide them to the "trying" stage.

SEPARATE My Ego from Their Success or Failures

Although mentorship is personal, it still requires a degree of neutrality and objectivity; otherwise I can find myself making excuses for the person I'm guiding rather than holding them accountable for owning their learning. It stands to reason that I can't do the learning for the person I'm guiding; however, when my ego creeps into the process, I might be tempted to take credit or blame for their successes or failures. Mentoring requires humility. My goal as a mentor is not for the educators to become like me, but to guide them through their own journeys of becoming their best teaching selves whether online or in person. Separating my ego may at times require me to admit when there is a mentoring mismatch. Mentoring is mutual, and both the mentor and mentee must choose to participate in the process. Sometimes an educator, for whatever reason, may absolutely not be ready for

mentoring or to be mentored by me. Here's where ego mitigation is especially crucial, and I then have to do my best not to allow any feelings of offense to lead me to abandon the educator but to try to connect them with someone to whom they will listen.

REVISE My Mentoring Approach as Needed for Each Educator

Earlier, I listed the different types of teaching styles I've encountered. Each of these teaching styles requires a different approach or entry point in the mentoring cycle. For example, if an educator is a transmitter, I may have to wait until they signal that they are ready to try something new before suggesting a different way of presenting. If an educator is a practitioner, I may have to first curate resources to help them refine their teaching techniques. If an educator is researcher, I may have to provide evidence from reputable resources to back up my suggestions. I should also expect that they will also investigate the research for themselves. The point is that mentoring is not a one-size-fits-all process. What may work to help one educator get over hurdles they have encountered in teaching online will not always be effective with another educator. I constantly have to experiment and adapt my mentoring approach to meet the needs of each educator.

Mentoring educators continues to be one of the most challenging yet fulfilling pursuits of my life. It is my life's practice that began before the pandemic, was refined by the pandemic, and, as long as I am able to do so, will continue after the pandemic with increasing insight, wisdom, understanding, and compassion. Some might ask how I measure the effectiveness or return on investment of my mentoring pedagogy in a world that revolves around scalable consumption. I don't think scalability ever belongs in the same sentence as teaching, learning, or mentoring. Scalability is for reducing per unit costs to generate more profit. There are costs to mentoring not measured in dollars and cents but in time, commitment, and persistence. The profits, however, increase as the educators become better teachers in the classroom or in virtual settings and touch dozens, hundreds, or thousands of students. These students will themselves go on to touch dozens, hundreds, or thousands of other lives. Who knows? In developing a pedagogy of mentorship, I am certain of only one thing—it's bigger than me.

Chapter 2: Materials and Processes

Introduction

AIMÉE EHRMAN

I approach ceramics from many roles: artist, educator, and researcher. From these intertwined perspectives, I consider the vast materials, techniques, and processes that are embedded in the act of making with clay. This abundance of options is not limited to ceramics, but it feels that within this medium, the possibilities are endless. Clay bodies are designed with properties that suit our needs. Raw materials are used in combinations that enable us to obtain colors and textures on the clay surface. Both analog and digital equipment aid with building and creating forms of all kinds. Kilns fire both by electric computer programs and by hand, including manually stoking a kiln with wood, to bring the clay to its vitrifying temperatures. These are just a few of the vast materials and options available when working with clay, yet all can be considered essential to learning ceramics. At least that is how I felt prior to teaching during the pandemic.

With the forced shift to online learning, I will admit, along with my students, I highly lamented the loss of the ceramic studio and classroom. I missed the feel of the clay, its smell, the dialogue that I had built with it over the years. I missed the excitement of physically experiencing my students building their own personal dialogue with clay in their own ways. I missed seeing many of them, for the first time, touch and activate the material in their hands, experimenting freely with the clay as a way of making sense. I missed the feeling of the community that forms in a class when working together in the studio: the shared experiences of investigation and intrigue, and of challenge and frustration, intermixed with conversations about daily life.

However, as my students and I embarked into this uncertain space and new territory of ceramics *online*, I came to realize that clay is and can be more than what I had previously known. While my time teaching ceramics online was limited to 6 months, what perhaps resonated most was that teaching and working with clay is about more than working

with the material itself. During the initial switch to remote learning, with the loss of access to the ceramic studio, materials, and equipment, I decided to approach learning about and teaching clay through what we had at our fingertips: our environment and our computers. We were able to explore form and content removed from a specific medium and allow other environmental stimuli to inform our discussions. We spent sessions discussing the idea of the vessel, an idea with thousands of years of history and tradition. We chose to move beyond the oft repeated narratives that have pervaded ceramic education and move beyond what, even prior to the pandemic, had started to feel like constraints. We imagined, wrote, photographed, and made drawings about what the vessel can and might be and what containment encompasses.

We took deep dives into research online, looking at works by ceramicists and artists in other mediums to build discussions about identity, race, personal expression, fear, and sadness, among many other topics. We considered how one might utilize these concepts and feelings to build vocabularies for personal expression. We explored and learned from the physical environment that we had within reach. We engaged with our senses, smelling, seeing, touching, hearing, and sometimes tasting objects, and pondered how these textures, colors, and shapes *might* inspire ceramic forms some day in the future. We discussed what we *might* make if we had unlimited access to materials and technology, factors we had not taken the time to consider with the clay directly in front of us.

What we discovered, or for some of us rediscovered, was the idea of unlimited possibilities in clay. We challenged ourselves to use our imaginations, to lean into the notion of asking the questions, *what if* and *what happens when?* We put into action the words of ceramic artist-educator Paulus Berensohn (1968), "The thing is, I'm learning that if you ask *What if?* often enough, you begin not only to believe it but to know that it is possible to play again (*playing* can be very serious indeed), to make things that aren't happening for you, happen. . . . The thing is, our clay can take and support the shape of our questions. The fact is, it needs them" (p. 90). Students embraced the freedom to play with their ideas and push the boundaries of what they knew clay could be without having it in their hands. As an educator, I too embraced the idea of pushing the boundaries of what clay could be and how I could teach clay. This idea of unlimited possibility stayed with me as I formulated an online version of ceramics and hybrid versions of ceramic studio courses that would follow in the semesters to come.

When I think about ceramics now, as an artist, educator, and researcher, I still think of the vast materials, techniques, and processes that are a part of making with clay. But this concept of unlimited possibility has expanded my approach. I now feel that working with clay

is about seeing, feeling, and engaging with material, our immediate environment, and the world around us. It is about developing a dialogue that enables students to build their own vocabularies within the medium and that can take shape in forms we have yet to imagine. Working with clay does not have to be prescriptive. It can be learner centered. It can address issues of access and inclusivity. It can involve experimentation and personal expression without being limited to the ceramic studio or equipment.

I would be remiss if I did not say that personally, I *do* feel that we need clay. At some point we need to touch it, to experience it, and to learn from it. I love the sometimes-crucial processes that accompany working with clay—the very materiality, the specific qualities inherent in the firing process. But I continue to question what we can do with the clay. What can making with clay encompass? Do we even need to fire our clay? How can we use clay with technology to say something new? How can we continue to draw from the world around us as we make with clay? I must admit that some of these ideas had already started to permeate my studio and teaching practices before the shift to online learning accelerated this new way of thinking, practices of making with, and teaching ceramics. I was previously interested in challenging how I, and other educators, teach clay, but I had not given myself the permission to fully lean in to those challenges. The pandemic enabled me to reflect and reenvision my practice and to embrace the unlimited possibilities of what working with clay might be.

What follows are statements by five fellow artist-educators, also contemplating the most significant ways that the pandemic has shaped and altered the ways we teach specific media and materials, both physical and digital. These educators reflect on how the pandemic has affected student learning and consider how teaching and learning in this new climate has changed their relationship to their individual disciplines and to art education more broadly.

In his statement, "Dismissing the Myth of Scarcity in the Land of Plenty," Bill Gaskins outlines the multiple factors that have altered his approach to directing a digital photography and media program during this time. For Gaskins, among student contention over tuition, access, tools, and against the broader landscape of graduate art education, his encounter with the research of Dr. Nicole Fleetwood in "carceral aesthetics" was a defining moment. Her work helped to clarify his personal role in guiding a graduate cohort through a remote curriculum that "relied upon dismissing the narrative of scarcity in a state of relative plenty." This new consideration prompts Gaskin to present to us with a call to action of sorts. Borrowing from Toni Morrison, he states *"this is precisely the time* to open new doors through thinking and making in new ways."

Sara Schneckloth gives us insight into teaching drawing through distance learning, as well as student experiences in online learning

spaces. In "Pandemic Drawing: Marking in Public and Private," Schneckloth speaks of online studio drawing with reverence. She asserts that even with all the associated limitations, at a base level, online drawing can offer "consistency and reliability of format in the face of uncertainty and change." During this time, drawing together with her students online became a place for personal and group discovery, invention, and idea exchange.

Emma Quintana reflects on the FabLab (Fabrication Lab) experience as it shifted into a remote learning environment. Anticipating the logistical concerns that would come when teaching object making and manufacturing through distance learning, Quintana first speaks to access and tools. The pandemic highlighted many aspects of accessibility, "how making outside of an educational institution can be framed, taught, and planned for," and how learners outside of the institution are deprived of these making experiences. However, what became most revelatory for Quintana was the importance of socioemotional engagement in the classroom. She discusses how the digital classroom evolved to include behavioral, emotional, and cognitive engagement in concert with and to enhance the digital and remote studio experience.

Kate O'Connor echoes these experiences as she reflects on the first-year design studio curriculum in the online learning space. In her statement, "High Touch Practices in First-Year Design Studio Education During COVID-19," O'Connor highlights how both students and instructors worked to overcome the limitations of traditional methods of instruction and outcome delivery. She demonstrates how the "implementation of an innovative virtual platform" was able to positively affect design education by encouraging critical thought and creative problem-solving strategies.

In his statement, "If Studio Art Education Could be Otherwise," Jun Gao considers the "ontological essence of virtual studio art education." Gao argues that our virtual teaching practices, which already include tools such as Zoom, Google Classroom, Miro, and the Meeting Owl video technology, do not provide the full immersive experience that virtual learning could provide. Learners, isolated in individual physical space and only receiving visual and audio stimulation through screens and speakers, miss the sensory experience of materials and the shared surrounding environment. Gao takes a leap to the near future and describes what a virtual painting studio course might look like. With the addition of artificial intelligence (AI) and virtual reality (VR) tools, extended reality (XR) technology and haptic equipment, the virtual painting course becomes a fully immersive experience, engaging all senses over a 3-hour session. Students engage in a holistic, embodied, multisensory experience that they can then bring back to their physical moments of making.

What is clear in the writings from these contributors is that we all share common feelings of struggle and frustration at the speed with which we shifted to distance learning. Maintaining a steadfast and thoughtful approach to accommodating the vast uncertainties of the pandemic era was and is not easy. Yet, what is perhaps more importantly apparent is that our reflections share a common sentiment of resilience and hope and, might I even say, excitement. We are energized by the challenges of the pandemic and eager for the teaching evolution to come. Indeed, with the pandemic creatively forcing our hands and minds, we have all, in some ways, already taken Gaskins's call to 'think and make in new ways' to heart. These short statement papers are a testament to our collective willingness to creatively push studio teaching forward, to lean into new digital possibilities, and rethink our media and materials from a decidedly student-centered approach. By continually modifying our relationships to traditional materials, methods, and processes, we engage with the evolution of studio art pedagogy as it unfolds right in front of us.

Reference

Berensohn, P. (1968). *Finding one's way with clay: Pinched pottery and the color of clay*. Simon and Schuster.

Dismissing the Myth of Scarcity in the Land of Plenty

BILL GASKINS

In the first week of August 2020, Maryland Institute College of Art (MICA) announced the college would go to a remote learning model for the semester despite the best efforts to avoid this path. The incoming first-year cohort in our program were prepared for and agreed to online learning following my decision to pursue this path one month before. None of the students asked for tuition discounts. One of the students turned down an offer for a tuition-paid scholarship at a state university to be part of the cohort of an MFA program transitioning from the former program in Photographic and Electronic Media to Photography + Media & Society @ MICA.

However, in the face of the clear and present danger of the deadly virus that had reached the pandemic stage, most faculty and students were in angst over the prospect of a semester with limited access to tools and campus facilities. Students asked questions about tuition and what it paid for. Indeed, access to facilities and tools is a portion of each tuition dollar, but the contention over the lack of ideal access to these facilities and tools led to executive and existential questions about graduate education in art and design school. Is this not the moment for MFA programs to stop marketing facilities and tools? Are MFA programs no more than high-priced maker spaces?

Multiple, intersectional factors changed my approach to studio teaching during the pandemic. Many of the elements impacting my practice were years in the making in a pre-COVID era. 2020 was also the year the United States faced another racial tipping point in its story. On a global scale, attention and outrage followed the videotaped, state-sponsored murder of George Floyd at the hands of police in the city of St. Paul, Minnesota, during the administration of the 45th president of the United States. So, creating a curricular path that would raise the social and scholarly literacies of every entering cohort at the intersection of race, gender, and visual culture became more urgent.

One defining moment guided my response to the student contention over facilities and tools, as well as my approach to teaching graduate studio during the pandemic—and after. The book *Marking Time: Art in the Age of Mass Incarceration*, a 10-year research project by Dr. Nicole Fleetwood, was published in April 2020. *Marking Time* focuses on "carceral aesthetics" visual and material artistic practices of people

in American prisons working within and beyond the limits of "penal space, penal time, and penal matter."

These persons, as "property of the state," are engaged with the production of visual and material culture that pursues freedom for all through dismantling the values that build and maintain penal space, penal time, and penal matter—by any means necessary. "Many of them (the works) are reflections of the material limitations and scarcity of art supplies inside, constraints that some transform into innovative experiments with found objects, ephemera, and state property."

My encounter with "carceral aesthetics" through *Marking Time* clarified my role in guiding the manipulation of materials and processes among my graduate cohort through a remote curriculum that relied upon dismissing the narrative of scarcity in a state of relative plenty. The role of networks, community, and collaboration is a critical feature in the production of visual and material culture through carceral aesthetics. So, students working within the boundaries of pandemic conditions must establish networks of community and collaboration to produce and progress.

In a 2015 essay for *The Nation* titled "No Place for Self-Pity, No Room for Fear," writer Toni Morrison wrote the following: "This is precisely the time when artists go to work. There is no time for despair, no place for self-pity, no need for silence, no room for fear. We speak, we write, we do language. That is how civilizations heal" (Morrison, 2015).

The pandemic has exposed the pre-COVID state of art schools as a site where rebellion, radicality, and revolution amount to low-risk theater compared to the work of the artists Nicole Fleetwood has curated. Our students were not in what Fleetwood calls "punitive captivity" during this pandemic. Instead, far too many of them are trapped in the prison of group-think. Students may challenge theoretical ideas about art, art history, and form. Still, Western high art and culture's social, political, military, and economic values and traditions remain under-challenged—certainly with some exceptions. But this is where art school culture(s) play a role. The guard rails of safe space agreements provide paths for self-pity, despair, silence, fear—and stasis. For many students and faculty, the Morrison quote could be understood as a disruptive provocation, especially for those that require a trigger warning, as in many art schools.

The more we attempt to revive pre-COVID institutional and social conditions for our students during this pandemic, the more difficult it becomes for us to help them play a leading role in shaping a post-COVID state in art and design—and a post-COVID world into reality.

"This is precisely the time" to disrupt and expand what we call art supplies and maker spaces. Therefore, what is required now is a new literacy of materials. Students must develop ways of working with

inexpensive materials and processes that are (if not free) beyond the conventions of material fabrication and the readily available.

Some of the best lessons in this regard have come from David Hammons, Betty Saar, and others working within the Black radical tradition who do a great deal with relatively little. The Black radical tradition is engaged with the nonviolent, conceptual, aesthetic, creative, and philosophical visioning of the impossible in resistance to the limitations of the possible. These thought-leading artists, writers, playwrights, scholars, and workers remix and contest Enlightenment definitions of what lawmaking and law-breaking mean by troubling right and wrong, legal and illegal, black and white, man and woman, boy and girl. "That is how civilizations heal."

Exposing our students to the ideas and production of those artists working and living within carceral states that are solid—and porous—is a critical intervention at a crucial time in graduate education in art and the worlds beyond art schools.

What so many people are doing with less—less freedom of movement, less freedom of assembly, less access to tools and materials, all while making vital knowledge and meaningful visual culture—is shame-making in its depth and profundity. As faculty and students, we possess and have access to so much more, beyond our immediate campuses, tools, and facilities, than we lack. "This is precisely the time" to open new doors through thinking and making in new ways.

References

Fleetwood, N. (2000). Introduction. In *Marking time: Art in the age of mass incarceration* (p. 7). Harvard University Press.

Morrison T. (2015). No place for self-pity, no room for fear. *Nation 30*(14), *184–185.*

Pandemic Drawing: Marking in Public and Private

SARA SCHNECKLOTH

In a short video I sent to my drawing students at the University of South Carolina in March 2020, I advised that times of uncertainty lie ahead but, somehow, hopefully, we would adapt to working online for the rest of the term. Skepticism about the remote classroom ran in both directions. What I didn't know then is that we were at the outset of weaving together a network of satellite studios ripe for experimental image-making, enhanced ways of teaching and learning observational drawing, and elevated methods of presentation and critique. Drawing together online, students generated rich and accomplished bodies of work while providing generous insight and support to colleagues. They developed social relationships that have thrived well beyond final critiques, taking the form of weekly drawing groups and pop-up exhibitions. After a year of teaching fully online in AY 2020–2021, I returned to in-person teaching with a strong desire to develop online drawing courses for official delivery.

Looking back, I can now speak of online studio drawing classes with the tone of the converted, limitations and all. In my initial experience, the success of online studio drawing related most directly to everyone's comfort with the technology of course delivery, the students' ability to create viable remote drawing spaces, and the openness of all participants to the shared online process. Going forward, and parallel to logistical and technical considerations, I'm thinking more about the role of "osmotic learning" (Jones, 2021) or, in this case, how drawing skills and aesthetic judgements can be enhanced through casual peer interactions in a shared environment. I am also concerned with the ongoing implications of compressing home and classroom. What happens as the boundaries between public and private spaces of creative making are further blurred?

The university gave instructors their choice in teaching modality for AY 2020–2021, and I redesigned my Introductory, Intermediate, Advanced, BFA Capstone, and Graduate-level drawing courses for a fully online and synchronous format. Each of these courses mirrored the experience of a live studio drawing class, with demonstrations and hands-on experimentation, extended immersion in drawing exercises and individual project work, one-on-one feedback, and small- and large-group critiques. Undergraduates met twice weekly via Zoom for 2 to 2.5 hours, and cameras were expected to be kept on unless technical or

other difficulties prevented. The role of the camera and policies around class recording were presented within an extended discussion of online privacy and consent, revisited throughout the semester. I realize this is a point of controversy yet find that the visual connection between participants is vital to creating a thriving shared sudio space, whether online or in person. The "cameras on" approach doesn't replace the osmotic learning that happens in a traditional studio classroom but keeps channels of visual communication open. It bridges public and private in a way that can be both productive and fraught. An ongoing challenge for both instructor and student is to determine for themselves how much bridging between the spheres is acceptable and under what conditions.

Technology

Students were encouraged to use laptops versus phones or tablets, given the larger screen size and computing power. On the delivery side, I used two webcams, with one on a flexible tripod for down-shots on the work surface, two monitors, a full-feature Zoom account with unlimited meeting time, cloud recording, screen and camera sharing, on-screen annotation, and breakout rooms as well as a Basecamp account, which is free to educators and students at this time. The platform is intuitive, simple to use, and allows for easy posting in the moment.

Space

In the range of studio art practices, the materials and processes of drawing are some of the most portable, scalable, and nontoxic. Students were encouraged to set up for class in a space with good light, a decent Internet connection, and a functional work surface where they could draw with ease. Many students said that the momentum created by drawing together in the live online class took them into several more hours of post-class drawing without having to relocate, and this clearly showed in the work. Those who could set up viable and consistent spaces at home tended to produce bodies of work that reflected technical rigor and improvement, conceptual evolution and depth, and experimentation with diverse approaches to scale, dimension, and medium. Students who did not have a dedicated space for the synchronous sessions often had more difficulty in maintaining productivity and aptly noted how the physical classroom offered more space and focus than they would be able to find at home.

Shared Process

Zoom chats and breakout rooms enabled direct and personal sharing of ideas as students wrote and spoke comments, questions, and

suggestions with an ease and comfort that quickly evolved over the first weeks, and which ultimately surpassed what one would normally see in person. People became adept at sharing their images on Basecamp and closely seeing and reacting to colleagues' work. Drawing online together in small groups, with cameras on, for hours at a time enabled a camaraderie in which talking to and messaging each other enabled creative social bonds to develop and thrive. A comment in the chat box would often be the kernel of a larger conversation that would evolve over several classes.

Public/Private Vision

Osmotic learning takes a different form when working online, and the peripheral vision that is a hallmark of the studio classroom can cut both ways. When working remotely, students may develop images in a state of privacy in which they don't compare themselves to others. Ideas can be hatched and investigated without concern that what they're doing is "right" or "wrong" as judged by what they see their peers in the room doing. On the other hand, there isn't the same kind of positive absorption of technique gained by physically watching colleagues develop images. Incidental observation is replaced by episodic image-sharing and confronts the limitations of the screen. It is often difficult to assess scale, reflectivity, or texture of material, and the overall impact of the work can be diminished. The question remains of how teaching online can further adapt to this shift in peripheral vision and osmotic learning, when moving from a traditional classroom to satellite studios and the screens that connect them.

While I'm not alone in my newfound enthusiasm for teaching drawing online, I acknowledge the frustration and outright despair of those who feel no love for online studio pedagogy. At their foundation, the online courses offer consistency and reliability of format in the face of uncertainty and change. But in my experience, drawing together online became so much more, a site of public and private engagement with the materials and processes of drawing, conceptual discovery and invention, and open exchange of ideas.

Reference

Jones, A. (2021, October 5). The problem with losing 'osmosis learning.' *BBC*. https://www.bbc.com/worklife/article/20211004-the-problem-with -losing-osmosis-learning

Rediscovering the Z in an X and Y World

EMMA QUINTANA

At the onset of the pandemic, the biggest challenge for my digital fabrication course was finding a way to preserve the physical act of making over a digital learning platform from varied makeshift home studios. The magic of working in a digital fabrication laboratory (FabLab) is seeing how the digital and material aspects of a design come together through making and remaking. I typically work with upper-level graphic design students who have created exclusively in the X and Y for most of their academic careers. My FabLab course is their opportunity to combine their extensive digital design skills with physical fabrication processes and materials. The combination of digital and physical modes of making is at the heart of a true FabLab experience, but the wonder and joy of learning in such an environment often lies in the physical aspect of that equation.

I assumed going into remote learning that my most significant adjustments would be logistical. Transitioning to online learning while retaining the magic of the in-person experience forced me to reevaluate many of my assumptions about the classroom itself, which has revolutionized the way I think about my in-person coursework, professional persona, and pedagogical approach. While I will continue to use many of the logistical discoveries made during online learning, redefining socioemotional engagement in the classroom and preparing students for their post-degree making practices proved to be the most revelatory and important takeaways from my pandemic teaching experience.

Logistical Challenges and Solutions

One of the biggest appeals of the maker movement and the introduction of FabLabs within the education system is the democratization of object making and manufacturing (Gershenfeld, 2005). But as an educator in Fab Lab spaces, I am often faced with equitability issues related to gender (Carstensen, 2013), race, and other forms of access (Noel et al., 2021). The pandemic shed additional light on accessibility issues and how populations outside educational institutions are deprived of these making processes.

Confronting these challenges requires FabLab instructors to rethink how courses are framed, taught, and structured. Students must

have a better understanding of the limitations they may face in the real world if they choose to continue their digital fabrication practice. The distance learning experience of the pandemic allowed me to frame how students might continue their practice outside of the institution, whether at home, within a virtual environment, or working with a local and international making community. My goal was to impart an understanding of organic making and creating processes that empower them to use critical thinking skills to navigate challenges and develop novel solutions.

During the pandemic, many software companies offered students free licenses for various design programs to facilitate remote learning. I chose not to utilize these programs, however, due to concerns that subscription policies might be reinstated should the pandemic linger for more than a few months (which indeed proved to be the case). Instead, I turned to free, open-source, and browser-based programs to guarantee that my students could maintain our course pace with only an Internet connection. I consider myself fortunate that my students are beginner 3D modelers, so web apps such as TinkerCAD and Sketchup were versatile enough to meet their needs. In addition, we stayed in contact through the university's learning management system and with collaborative applications such as Google Workspace, Miro, and Cluster.

Engagement Challenges and Solutions

As we adapted to our technical challenges, the ideation and prototyping phase of each assignment became the focus of the course. In the typical art classroom, students receive class-wide feedback during the initial brainstorming activity for a project and once more during the final critique. Within my Fab Design course, I found that the limitations of remote learning led us to focus almost exclusively on the ideation and prototyping methodology. We used Google Slides for in-process critiques at the beginning of every class to discuss discoveries, triumphs, and disappointments in the space between the beginning and the end.

The new approach met three frequently elusive qualities that are present in every classroom: the issues of preciousness, the need for community feedback and connection, and the development of critical thinking. Focusing on ideation and prototyping allowed students to relinquish the preciousness of their initial ideas, which are often not the best vehicle for their intended purpose. As well, we had to address the feasibility of the materials and the software available to us. Within the process of making, revising, and adapting, the class thrived and came together as a remote community of makers. I witnessed a new level of engagement I would not have discovered within an in-person learning environment.

The circumstances of the pandemic forced students of all backgrounds to deal with high levels of stress, apathy, and frustration. Very quickly, I came to think of the missing Z-axis as the difficulty to connect within our virtually social landscapes. Student apathy can be addressed through a multidimensional approach to teaching methods and student engagement (Fredricks et al., 2004). Through various virtual learning and management tools, we were participating in a flexible and adaptive learning environment that called for a different approach than the traditional classroom. Creating and supporting our class community and allowing space for sharing and connection was paramount. To facilitate this, coursework deadlines became fluid, we implemented "share-time" to vent about pandemic frustrations in and out of the classroom, and we set aside time for self-reflection.

The pandemic pushed me to reconceptualize what student empowerment looks like within spaces supported by technologies, and I have seen the importance of redefining engagement across all learning spheres. Focusing on behavioral, social/emotional, and cognitive engagement greatly enhanced our new digital and remote studios. I shifted away from lecturing during class time because I saw so many disengaged faces when I looked at the squares on my laptop screen. While such disinterest may have been caused by a combination of different learning types and the fatigue of pandemic stresses, there was clearly a genuine need for social connection.

By utilizing a flipped classroom model that required students to complete course preparation ahead of meeting times, we were able to engage in social learning activities that fulfilled the need for meaningful interaction. I also incorporated pre– and post–self-assessments and self-reflection exercises into the class that increased engagement and allowed students to verbalize their problem-solving process, which increased class comradery (Wang, 2017).

Broadening the Definition of Engagement

During the pandemic, I reassessed what student engagement actually looks like within my classrooms and responded by learning and adopting new and dynamic teaching methodologies and processes. The experience has taught me that I need to broaden definition and conception of engagement. Behavioral, emotional, and cognitive engagement are equally essential within a healthy learning environment that promotes student achievement. They cannot be separated from one another, forming a multifaceted and ever-changing component of every classroom (Fredricks et al., 2004). This realization has led me to change how I present materials, demonstrate processes, and assess outcomes within my classroom. The shift has refocused my teaching methodologies toward the empathetic and adaptive nature

of personalized learning and the engagement opportunities afforded within the flipped classroom model.

References

Carstensen, T. (2013). Gendered FabLabs. In J. Walter-Herrmann & C. Büching (Eds.), *FabLab: Of machines, makers and inventors* (pp. 53–64). transcript Verlag. https://doi.org/10.1515/transcript.9783839423820.53

Fredricks, J. A., Blumenfeld, P. C., & Paris, A. (2004). School engagement: Potential of the concept: State of the evidence. *Review of Educational Research, 74*, 60–120.

Gershenfeld, N. A. (2005). *Fab: The coming revolution on your desktop—from personal computers to personal fabrication.* Basic Books.

Noel, V. A., Boeva, Y., & Dortdivanlioglu, H. (2021). The question of access: Toward an equitable future of computational design. *International Journal of Architectural Computing, 19*(4), 496–511. https://doi.org/10.1177/14780771211025311

Wang, F. H. (2017). An exploration of online behaviour engagement and achievement in flipped classroom supported by learning management system. *Computers & Education, 114*, 79–91. https://doi.org/10.1016/j.compedu.2017.06.012

High-Touch Practices in First-Year Design Studio Education During COVID-19

KATE O'CONNOR

First-year design studio holds a critical place in architectural education and creates a groundwork and basis for future study. The studio helps students form their general ideas about architecture and encourages an experimental and interactive ground for design experience, knowledge, and skills. This lays the groundwork for how the thought process and intensity of the process works not only in school but also in the profession. As the foundation coordinator, the curriculum is designed to have the studio component used as a laboratory for designing, testing, and exploring the efficacy of different materials, methods, and solutions. Design thinking is explored through the process, with a focus on the roles of observing, understanding, proposing, and crafting. Specifically, it introduces fundamental issues in the disciplines of architecture, including primary, formal, and spatial relationships between composition, operation, social relations, and tectonic elements.

Prior to the onset of COVID-19, our program specifically forbade digital manipulation in projects during the first semester of students' studio sequence. Our goal was to emphasize the value of materials in a design project's earliest stages. Teaching the beginning design studio, with its emphasis on abstraction and fundamentals, introduces students to a creative way of problem solving through new and innovative methods of graphic discovery and inquiry through the use of abstract representation. A typical project introduced a process to connect each exercise to earlier abstract studies. First, the space between objects is just as important as the objects themselves, and objects must be reconciled to their context. Second, simple everyday objects hold many lessons for designers, but only if they take the time and develop the tools for understanding them. Finally, the ability to move between 2D and 3D explorations is a key skill for the beginning design student.

To further the students' understanding of design development, in the second semester we introduce the use of digital platforms in the curriculum. The Digital Media I (DMI) class is the first course in the sequence, introducing two-dimensional methods of representation

utilizing digital programs, including AutoCAD, Illustrator, Photoshop, and InDesign. This course does not simply introduce students to a catalog of new tools, but instead teaches them to use a common language of representation. It is this language that later allows students to create their own means of expression within design projects.

With the onset of COVID-19 in March 2020, students were relegated to all virtual learning modalities, and the traditional haptic method of learning was introduced online. Both students and instructors overcame the limits of the traditional delivery methods with the implementation of an innovative virtual platform to positively affect design education. This platform encouraged critical thought and induced online creative problem-solving strategies.

The amended curriculum paired the DMI and Studio courses, where assignments were delivered primarily through synchronous sessions with supporting materials provided asynchronously. One of the primary reasons for collaboration was to create a high-touch environment for one of the most vulnerable groups on campus and to take advantage of how well versed the students are with the technology to maneuver digital platforms. The term "high-touch, high-tech (HTHT)" can be traced back to John Naisbitt's 1988 book, *High Tech High Touch: Technology and Our Search for Meaning*. HTHT speaks to the conscious integration of technology into our lives. Naisbitt characterizes it as "embracing technology that preserves our humanness and rejecting technology that intrudes upon it" (Naisbitt, 1988, p. 32). In other words, our relationship with technology must be one of balance. Inspired by the aforementioned mantra, this curricular model was designed to promote an equitable learning experience, meeting the needs of students of different abilities, including students with learning or attention disorders and students who may have varying abilities to access technology and Wi-Fi access, and providing flexibility for health issues, childcare, and job responsibilities. By consistently engaging students with similar content and feedback, we fought to reduce the projected national attrition average of 24.1% of this group (Hanson, 2022).

A comparison between in-person and digital delivery offers context. The "Bleacher Chat" (cleverly named because of the location!) is an in-person forum where all students (+/-70) physically gather at the beginning of studio classes to receive announcements and lessons before breaking into their own sections. This was established to maintain an equitable lens of didactic delivery and to emphasize the social comradery formulated through studio culture. With the pivot to online delivery, the Bleacher Chat tradition continued via Zoom, not only to honor its original intent but to serve as a platform for remote students to gather virtually in large and small groups, with and without an instructor in both an academic and social atmosphere.

To maintain curiosity and discovery, it was important to develop a way to reflect the same culture students experienced in person. MURAL, an online whiteboard application, was used to share student work in the way an in-person pin up review would be hosted. This software allowed students to collaborate, comment, and draw on each other's submissions to provide feedback and suggestions. Through these virtual critiques two improvements were identified to the traditional in-person model: the students were able to receive significantly more feedback from more reviewers, and the comments were written on "sticky notes," which gave them a resource to refer back to following the critique. Demonstrations were held using Zoom and often recorded for later access should a student want to reference a technique or had poor internet connection. At times students would opt to share their screens to show a particular challenge they were having with the software and would ask for help on how they might resolve the issue. Annotations were a great tool to offer guidance, and even shy students or students with weak Internet connection could participate synchronously.

The first half of this distance learning semester focused on creating tectonic constructs that captured light, with students reinforcing visual communication skills learned in the first semester. The second half was originally designed to create a physical context the construct would occupy. With the onset of COVID, a revised curriculum created a series of tessellated discoveries that slowly evolved into a habitable construct within a context.

Feedback from students enabled continued success from the first distance learning semester into the fall 2020 semester. The studio was restructured to embrace digital tools and empower students with technological strategies who were still suffering from the shellshock of an isolated environment as they entered college. The curriculum started with an in-person 2-week boot camp, introducing students to graphic conventions taught in foundation education paired with instruction to properly document their heuristic work and communicate through MURAL. It jumpstarted a didactic approach previously introduced incrementally throughout the year and strengthened learning outcomes by embracing the technical strengths of the students.

Additionally, I organized a mentorship program where upperclassmen were paired with new students to orient them to the academics and social ethos of the program. Students were warmly welcomed to a safe and supportive online atmosphere where they could virtually meet their peers and understand the intention of studio culture, empowering both groups—one through leadership and the other through acceptance.

This revised pedagogical model empowers students to create their design identity through applied and integrated tactile and digital

workflows and encourages peer interaction to further their academic and social encounters.

References

Hanson, M. (2022, June 17). *College dropout rates.* Retrieved from https://educationdata.org/college-dropout-rates

Naisbitt, J. N. N. (1988). *High tech high touch: Technology and our search for meaning.* Nicholas Brealy Publishing.

If Studio Art Education Could Be Otherwise

JUN GAO

Over the first year of the pandemic in 2020, the sudden migration from in-person to online teaching changed my view of studio art education in virtual reality, and I began to ponder if studio art education could be otherwise.

Online art education has gradually become an integral part of various art education programs since the early 2000s. Digitized studio art education became tangible when studio art courses switched to online mode since spring 2020. The abrupt migration from the physical to the digital forced art educators to explore and creatively utilize online platforms and tools to deliver teaching content that had otherwise always been presented in person.

Indeed, Internet connectivity did allow studio art teaching and learning to resume during the pandemic. A new frontier of virtual art education began, and instructors were required to translate familiar interactions with students into online modalities. Many traditional art instructors lamented this shift. However, based on my experience of delivering online studio instruction, I have come to think my virtual painting courses are actually not virtual *enough*. As it stands, tools such as Zoom, Meeting Owl, Google Classroom, and Miro lack sufficient immersive qualities that could fully engage students at the same level as face-to-face instruction.

My online painting studio teaching experiences in 2020 and 2021 and the terms of virtual art education brought up important questions for me. What is virtual art education? What are the essential attributes of virtual art education and its differences from physical studio art education? What are the educational merits, potentials, limitations, directions, and ethical and social challenges of virtual studio art teaching and learning?

Puzzles, Problems, Limitations, and *Aura*

The essence of virtual studio art education can be understood as a type of existence or experience of virtual reality. In the *Oxford English Dictionary*, "virtual reality" means "a computer-generated simulation of a lifelike environment that can be interacted with in a seemingly real or physical way by a person, especially by means of responsive hardware

such as a visor with screen or gloves with sensors; such environments or the associated technology as a medium of activity or field of study; cyberspace. Abbreviated VR" (*Oxford English Dictionary*, 2021).

In general online teaching practice, neither Zoom and Meeting Owl nor Google Classroom and Miro equivalently provide "simulation of a lifelike environment that can be interacted with in a seemingly real or physical way by a person" (*Oxford English Dictionary*, 2021). In current online painting classes, users are isolated in individual physical space; they can only receive visual and audio stimulation through screens and speakers. There is no touch of the texture, sense of weight, temperature, or smell of materials, medium, or environment. Online studio art education does not revive in-person studio art education's *aura*. The *aura* here is borrowed from Walter Benjamin's (1935/1968) assertion of the differences between original artwork and its mechanical reproductions, "its presence in time and pace, its unique existence at the place where it happens to be" (Benjamin, 1968, p. 220).

Virtual studio art education has its own *aura*. Its realization depends on integrating technologies, such as artificial intelligence (AI), virtual reality (VR), augmented reality (AR), mixed reality (MR), extended reality (XR), and kinesthetic communication (or haptic technology). Space and time rely on electricity in virtual studio art education, which is the fundamental difference between virtual space and time and their actual counterparts. Virtual space and time are digitized, generatable, alterable, manipulatable, replicable, erasable, deconstructable, and reconstructable. Opposed to the actual art studio, a virtual one is a studio of becoming, a space with *infinite possibilities*.

The overlapping area between virtual and in-person studio art education is time: subject's time. There are two parallel notions of time in virtual studio art education: the subject's time in the physical reality and the subject's perception of multiple-directional time in the virtual space. The non-fungible token (NFT) technology secures the authenticity or uniqueness of digital artwork in cyberspace and establishes confidence in extracting the aura of virtual studio art education.

Stepping Into a Dream: Exploring the Virtual Painting Course of the Future

AI and VR are perpetually changing our lives. What might my virtual painting course feel like in the future if my students have access to XR technology and haptic equipment? I had a dream about it and what happened in the dream felt vivid and tangible.

"It is 3 pm. The painting course portal is open. Your virtual class equipment is connected to the course. Enjoy!" An AI bot assists a

student, Aletheia, in joining a virtual painting studio class. As soon as she puts on a headset, haptic suit, and gloves, Aletheia enters Claude Monet's painting studio in Giverny. Her classmates and professor, appearing in the form of avatars, have already arrived. They stand in front of Monet's palette and discuss how Monet arranges his colors. The professor asks Aletheia to grab Monet's paintbrush from a big ceramic jar and use it to mix a color that matches a color in one of Monet's waterlily paintings. She feels the stickiness of the thick oil paint while mixing. A glass container of walnut oil sits next to the palette. She picks it up and carefully drips a few drops onto the heavy body paint; the twirling brush is diluting the paint, and her hands feel that the paint becomes a softer body. The motion of mixing with the paintbrush releases the subtle fragrance of the walnut oil, which is the smell Aletheia enjoys when using oil paint. "Do not add too much oil to it. Come and feel the impasto texture," her professor suggests. Aletheia lays her fingers on the surface of Monet's large-scale waterlily painting. "Coarse and grainy," she responds. Her professor then explains and demonstrates Monet's painting techniques and process. She nods with a smile because she grasps how Monet created this specific texture with heavy body paint.

"Would you like to join me for a stroll in my garden?" Monet stands by the door and offers an invitation to the class. While walking on the green Japanese bridge, Aletheia's eyelids dance with the reflections of the lily pond, and her face showers in the floral-scented breeze. Red cardinals and insects orchestrate a summer tune in the shades of roses, lilies, and rhododendrons; sunlight hugs her with warmth. A smile blooms on her face. She hopes she can come to visit often.

"If you want to explore further how Monet captured the interaction between the light and air, please feel free to stay and paint a landscape with him." The professor points at the pond bank where Monet is setting up his easel for a new painting. Some students decide to stay and begin setting up their easels around Monet. "If you want to continue exploring how other artists use impasto technique, our next stop is Lucian Freud's studio in London." Before their departure, the professor sets the sun's position at 10 am in early June on a tablet.

Three hours elapse. The class is over at 6 pm.

It was an exciting, enlightening, and productive lesson for Aletheia. With immersive observation and hands-on practice, Aletheia now understands different artists' painting materials, techniques, and processes. Besides studying how the artists paint, she also assisted an artist in stretching and priming a canvas in an atelier. Her arms are sore, the skin of her fingers burns from

stretching linen. Before exiting the virtual classroom, she wants to turn her two virtual works, a watercolor painting and a sculpture, into physical objects. She first uses AR mode to figure out the size and spots where she wants to place each work in her house, and then she outputs both pieces through a 3D printer. After taking off her haptic equipment, she feels tired but cannot wait to experiment and practice what she learned in the virtual class with her actual oil paint and install her digitally printed works.

Aletheia's virtual painting class may sound like just a dream now; however, this dream is swiftly becoming a reality given the fast development of virtual reality technologies, including some, mentioned previously, that are already at our fingertips. Realizing this dream of future studio art education is less an issue of VR development and more a matter of embracing these new technologies as they become increasingly available. During the recent transition to online teaching, I came to feel the imminence of holistic and multisensory experience, including visual, auditory, olfactory, tactile, and gustatory stimulations, as the path forward. It is time to have a bigger dream of virtual art education as if it could be otherwise; it's time to create curricula to embrace new possibilities.

References

Benjamin, W. (1968). The work of art in the age of mechanical reproduction. In H. Arendt (Ed.) & H. Zohn (Transl.), *Illuminations* (pp. 217–251). Harcourt, Brace & World. (Original work published in 1935).

Oxford English Dictionary. (2021). Virtual reality. In *Oxford English Dictionary*. https://www-oed-com.ezproxy.cul.columbia.edu/view/Entry /328583?redirectedFrom=Virtual+reality& (accessed June 15, 2023).

For my students, the pandemic opened up a simultaneously dark and fearful space, multiplying their anxieties about their future. At the same time, the unending lockdowns afforded an intimate, inward, and open time for the reconfiguring of their personal creative practices to their kitchen tables and bedroom floors. I began having much deeper conversations about home and neighborhood creative practices and practices for the self. My support manifested in tools for self-reflections, journaling, and research notebooks—ways to process the intense ambiguity of the time. There was a break from the constraints of the typical flow of life; instead, we were all searching for purpose. A time to breathe, a time to build a closer ring of essentials, and a time to make with what was right around us. I remember thinking; I hope these shifts last once this is over.

—Arzu Mistry

To put a finger on exactly what has shifted in art education pre- and post-pandemic is difficult as much seems unsettled. But I would point to two developments, both involve forms of materiality. Not only (as one might expect), did the digital life produce a craving and heightening of the meaningfulness of material—be it paint, metal, wood, etc.—but what was still somewhat taboo pre-pandemic, the speaking about material, or the attempts to, are now the very space where my students want to negotiate meaning. The names of pigments, the talk of tools and surfaces have a new caché. Matter matters to them. The second change—no doubt emerging from the limits of digital teaching and the constraint of masking in the classroom—is a new emphasis on and even a heightening of physical gesture. To use myself as an example, where I once mostly "spoke with my mouth," now not only do I also speak with my hands but my whole body is integrated into my pedagogy. Where will this new sensitivity of the expressivity of matter and embodiment lead us as artists?

—Jenn Mazza

Chapter 3: Community and Relationships

Introduction
RÉBECCA BOURGAULT

> Relationships may be likened to a meeting ground that holds understanding . . . Trust within the relationship becomes the invisible yet powerful force which is hand built by repeated actions such as showing up, responding predictably, telling the truth, being present, and finally, embracing.
>
> —Staikidis, 2020, p. 288

The body is inscribed with knowings and rememberings. We inhabit networks of nestled relationships. In an all-encompassing way, through resilience and adaptation, the pandemic years have highlighted how much community and relationships manifest a connected and holistic way of being in the world. We are not the isolated selves we often think we are, "we are more relationships than things" (Tonino, 2022, p. 14). As our reality confronted us with unfamiliar and deadly viruses, we were reminded of a relational ecology to which we are bound in a delicate balance of interconnected threads.

Human communities, neighborhoods, families, friends, sports teams, classroom cohorts, all perform collective practices that express how relationships are lived and encoded. Our most valued relational rituals involve our corporeal presence. When an unexpected event makes the continuance of these embodied and cultural traditions impossible to maintain, resistance, anxiety, fear, and pain follow.

Most of us have for decades now spent large portions of our lives immersed in digital media. We maintain hundreds of online relationships; we inhabit and travel through digital spaces; we belong to virtual communities, projecting imagined or existent likenesses of ourselves. As teachers, we are sometimes concerned about the time children and youth spend on social media. We collect data about their mental health, fragmented attention span, and uneasy sociality while calling for remedies that include in-person encounters and

"real" activities. Searching for equilibrium and a middle point, we find obvious advantages to virtual and physical relationships. The pandemic upset that sense of balance. The body became an uncertain site that needed to be isolated. Things that mattered such as celebrations with extended family, school, colleagues and peers, meetings with friends, public entertainment, all moved online or stopped. Relationships became confined to minds alone, our smiles and voices transmuted into numerical code.

As teaching and communications moved into an online mode; as the news media tallied numbers, constant reminders of upheaval, loss, and trauma; as the disarray brought a descent into silence, aloneness, or even a feeling of disappearance, we came to realize how much our daily measure of tangible encounters was essential to our emotional health, growth, stability, and social well-being. For art teachers, educators, and artists teaching in the community, what emerged as a gripping source of concern was how to keep *us* together. The urgent need to maintain our practices without physical studios or materials and to sustain emotional connections with students and community members preoccupied us day and night.

While these solutions highlighted the relational and social values of communal sites of learning, they also exacerbated our conditions of social inequity. As art studio activities and relational encounters required digital transmission, populations without consistent computer or online access were left stranded. Making art together became a luxury. In contrast, other groups were buoyed by the urgency of finding creative outlets, the energy of which emerged as silver linings to the lockdown and its dissociative effect. Online graduate art education students in an arts research course I teach turned their inquiry toward investigating new models of human connections or used their isolated conditions as a portal to an inner world where visual symbols and spirituality merged with poetry and dreams. Schools and community organizations went to great lengths to preserve their connections with art students. Energized by the necessity to care for their participants, they brought to life innovative online art projects and activities in a collaborative effort to sustain their community.

At times, it felt necessary to drop the curriculum and attend to the well-being of students through any means necessary, nurturing the teacher–student–community bond with the knowledge that no learning could be achieved before a sense of safety and stability was met. In her Los Angeles high school, art teacher Jess Perry-Martin met the challenge by attending to her students' essential needs, recognizing that the times called first and foremost for connection and support. Pressured by her own personal health concerns, she resolved to let go of the expectations she put on herself as an art teacher, making peace with the exigencies of online art instruction and focusing instead on

being fully present. Caring for her students meant maintaining contact through spontaneous and responsive choices of activities attuned to the daily and often traumatic realities of the youth in her classes. Her curriculum shifted to art project ideas that arose from the intensity of the times.

For artists and art education practitioners, isolating moments prompted a great variety of solutions as creative processes shifted. We read of artists who literally left the city, whose practice in isolation renewed the benefit of introspection. There was more time to breathe, to look around the studio and take stock. Tinkerers and makers of objects took over the house and made things with what was at hand, creativity spilling out in the kitchen, hunting in forgotten drawers, putting together treasures gathered on a daily walk to the park—if that alone was possible—transforming bits and pieces of artifacts of daily life in visual propositions that could then be exhibited on social media, reaching out to anonymous online audiences.

Others made things because the urge to reach out was so intense, they used the language of their medium to connect imaginatively and somewhat desperately with their community. In his reflection, Arturo Gonzalez-Barrios recalls how he discovered ways to reconnect with his students at a community youth art organization through his own need for self-care. The artistic process that gave him comfort became the pedagogy that rallied his former students, and together, they reinvented a way to turn their daily home time into visual narratives they could share. A personal practice equating art making with survival inspired a series of online tutorials. As a result, students performed with greater initiative than before; necessity led to inventiveness. Moreover, Gonzalez-Barrios discovered that the limitations of the teleconferencing medium offered unforeseen advantages. If during the pre-pandemic days, the voices of quiet students were overshadowed by their more loquacious peers, the configuration of online applications that demanded that participants mute their microphones created space for introverts who found themselves with an attentive audience and many stories to tell.

The discoveries of new pedagogical approaches to community rapprochement and care arose from inventiveness and urgency. Yet, the resulting distance of online education also served to emphasize the arbitrary boundaries that academic traditions maintain through their disciplinary structures. In his account, Neil Daigle Orians recalls how the hierarchy between non-art majors and officially recognized art students was suddenly made more apparent as communities were confined to online classes. Any possible physical mingling of students that, on campus, had blurred the demarcations between status and discipline disappeared, leaving a blaring view of departmental segregation that,

in Orians's eyes, supports a detrimental and unproductive dichotomic way of thinking. In his effort to expose his non-art-major students to the pleasures and promises of contemporary art, Orians uncovered how creative thinking and visual curiosity should be part of all students' curricula. His is an inclusive project of expanding artistic thinking to an entire community.

Living through personal family trauma distilled feelings of empathy, and art instructors understood that classwork expectations had to make room for community-building activities and spaces for students to support each other. Sabrina Marquez writes that the pandemic years inspired the creation of a team-taught course that offered students a blend of art instruction and mindful practice, a channel to happiness. Such pursuits provided students the opportunity to deepen their connection to artistic creativity through sensitive balancing exercises. Meditation and other techniques became tools for attentiveness, enhanced perception, and equanimity.

In her story, Marquez remembers how the pandemic inspired the creation of yet another course, this one focused on the concept of home. While home in isolation could feel alternately like a prison, a refuge, or a place of family communion, the course invited students to explore their attachment to the materials and memories that made home a multilayered, at times fragmented yet deeply meaningful place. Additionally, the concept of home and community resonated with conditions of eviction, loss, relocation, and migration. Students were encouraged to take their learning out into the community, where the compassion generated through sharing and listening could be extended to benefit others.

At the start of the pandemic, we needed to reinvent art education and became acutely aware that art communities and the relationships they foster are essential for maintaining our sense of belonging. We have since developed skills with online teaching technologies that eased into quotidian modes of encounter. Some of us developed a taste for solitude. We have slowly relearned our social skills. As art communities, we have begun a process of reemergence, and the urgencies of our moment now call for a deep renewal of our creative forces.

Reference

Staikidis, K. (2020). *Artistic mentoring as a decolonizing methodology*. Brill/ Sense.

Tonino, L. (2022, January). The desert within: Douglas Christie on the power of silence and contemplation. *The Sun*, 553, 4–15. https://www.thesunmagazine .org/issues/553/the-desert-within

Creating Community, Holding Space for Compassion in Times of Crisis

JESS PERRY MARTIN

At the beginning of the pandemic there was only fear: fear of getting sick, of infecting others, of losing people, of the unknown. Sitting at my pandemic-purchased folding desk writing about that time is an act of reliving that trauma: the uncertainty, the loneliness and isolation, the pain of compromising the things I thought were so essential in teaching. When my district resumed in-person instruction in fall 2021, I moved that desk into the corner of my house as an act of protest. I wanted to move away from that corner, into the physical spaces of joy, play, and noise within my art communities.

I regard my role of art teacher as a passionate advocate for the arts, helping students use art to build compassion for the world, to take artistic risks, and to lift voices in the fight for social justice. In a matter of a few pandemic weeks, many educators shifted our mode of instruction and our priorities. We quickly discovered that we had to accomplish all the goals of teaching while managing spotty Wi-Fi, overcrowded living spaces, family obligations, illness, hunger, and depression, without ever knowing who or what was on the other side of the computer screen. The lack of knowing how to address these issues raised serious questions.

What is the role and function of education (in a crisis)?

As an educator, should I focus more on instructing content or constructing communities so students know they are valued? The primary consideration that shaped my teaching at that time was the trauma of the moment, the desire to address that trauma, and how we might use art, through Internet connection only, to create in times of despair.

In Maslow's hierarchy, the baseline needs of physiology and safety must be met before love, belonging, and self-actualization can happen. In my school community, physiological needs are vast in any year. My district, Los Angeles Unified School District (LAUSD), is so large that it provided more than a million meals for pick up to families, as well as Chromebooks, hot spots, EBT cards for food, diapers, school supplies, and counseling services during the duration of school closures. I teach in a community where 81% of students qualify as Title I, and

multigenerational and cohoused families are norms. I learned through Zoom that many of my students lived in converted garages, some with more than one family. How could I expect students to have space to learn while attending virtual school on half a bunk bed?

Beyond addressing primal physical needs, my school has always been a caring community of educators who come together to support students and families. The pandemic amplified the needs, willingness, and creativity of the school community to offer support. Teachers at my site delivered instructional materials, medicine, food, and art supplies to students so that they were able to focus on learning. Our continued efforts were guided by a common sense of purpose: When the world is uncertain, we need to create and connect more than ever.

My husband likes to tease me that my favorite students are the underdogs because I admire how hard some young people struggle to overcome adversity. My advisory students during the pandemic became a particularly powerful underdog community, one carefully chosen at the beginning of online teaching as those who didn't connect with other teachers or students but connected with me or each other. Together we did yoga videos, meditated, played games, shared memes, told Dad jokes, made Jamboard drawings, wrote poetry, watched TedTalks, and occasionally turned our Zoom cameras on to check out our pandemic pets. We made time to talk or write in the Zoom chat about what was going on in our lives and participated in serious conversations about our challenges. When my student, R, got diagnosed with lupus as part of her long COVID illness, I reached out to her other teachers, asking for extended time on assignments so she could rest. When C's mom got a brain tumor and their family almost got evicted from their house while she awaited surgery, we did a GoFundMe to raise $3,485 to keep them housed. When M was hospitalized for her third suicide attempt, we sent flowers with online cards signed by her classmates reminding her that she is loved.

As the trauma circled into my own health, I began to see how interwoven our community was and how much I, too, needed connection and creativity, through my students, my sketchbook, and my colleagues. I had to leave after my first week of hybrid teaching to await surgery. Instead of making a Mother's Day card, one of my junior students, C. E., notorious for his challenging personality, made a card for me. It said, "Thank you for showing up for me, even when you were down." For C. E. and the rest of my Advisory students, surviving the trauma together was an act of love. "To know love we have to tell the truth to ourselves and to others" (hooks, 2018, p. 67). In sharing, teaching, Zooming, and living through the pandemic, we learned that love is showing up for one another, for being there on the other side of a screen, when so much else was beyond us. In this way, education in a crisis was a lifeboat keeping us from drowning.

As I tried to make art with students and effectively teach art online, at the beginning of the pandemic and later as I dealt with illness, I learned I had to let go. Every week was an exercise in altering expectations for myself and for the art we created in class, and a chance to create spaces for us to talk about art, make things with the tools and materials we had access to, and make peace with the challenges of depending on technology for our creative and communicative needs. In letting go, we made space to create, to listen, to share, and to exist in a community. I asked students what they wanted to create and designed lessons based on their interests. We drew our safest spaces (under the bed, in the bathtub, and on the corner of the couch), used old family photos to create protest narratives about our belief systems, and wrote comics about pet dramas. I pushed my advanced students to lean into the issues they cared about most. Many created powerful artworks about the struggles and isolation they experienced. When K. won the Congressional Art Award for her pandemic portrait of friendship, we saw how art illustrated our connections and gave us a reason to persevere.

Sitting at my pandemic-purchased folding desk again, I am reminded that we made virtual spaces to honor one another, to share experiences and to value each other that opened doors to artistic and academic success. When we returned to school in-person in fall 2021, many of my Advisory and pandemic art students became a much more tightly knit community of artists. These Advisory underdogs, the very ones who needed extra time, hospitalizations, home delivered art supplies, and GoFundMe's for rent, are the same people who graduated in 2022 despite incredible adversity, with several attending college and M. earning a full ride to study art and psychology, the two things that gave her a path forward. The pandemic changed us, challenged us, and gave us pause to consider what and who we value. We are working together toward reaching self-actualization knowing that at least in the art community we are loved and belong, just as we are.

Reference

hooks, bell. (2018). Honesty: Be true to love. In *All about love: New visions* (pp. 67–67). William Morrow.

I Am . . . I Create . . . We Connect . . .

CARLOS ARTURO GONZÁLEZ-BARRIOS

"To allow kids to be seen and heard" is the mission of Raw Art Works (RAW), a nonprofit youth arts organization rooted in art therapy. During the pandemic, the instructors pioneered ways to support students through remote learning.

RAW is located in Lynn, Massachusetts, a satellite community of Boston with a diverse population of natives and immigrants. Lynn faces many of the challenges of similar post-industrial cities: economic and racial inequality, precarious migratory status, lack of affordable housing, displacement from gentrification, over policing, and under policing. I was a member of this community and can speak from my own experiences as a nonimmigrant resident and citizen of México, often facing the same challenges as my students.

RAW offers free art classes. The objective is to use art as a canvas for social-emotional learning, self-discovery, and community building, while developing the students' confidence through skill acquisition. RAW has a film school program (Real to Reel), asking kids what is going on in their lives, giving them tools to create in unexpected ways and to envision new possibilities for their future.

Their motto of *Seen and Heard* attracted my interest as a conceptual artist and experimental animator. I graduated from the School of the Museum of Fine Arts at Tufts University in 2017 where I studied Film & Animation and benefited from a broad conceptual interdisciplinary arts curriculum. RAW's therapeutic approach to art making grounded my heady art-school idiosyncrasies, teaching me to trust the process and let go of control. There are no mistakes, just art at RAW.

There I created "Frame x Frame," an experimental animation class. In this course, students crafted films one frame at a time, by hand. The focus of the class is to take traditional art techniques and materials for a walk in the dimension of time. The lens of animation is the unlimited well of human emotion and imagination. In "Frame x Frame" students expressed themselves through the dynamic continuum of time-based experiences, creating motion and transformation with sequential images.

I lived abroad in the United States from 2013 until 2022, away from my loved ones in the city of Tampico, México. In the stillness of the

early pandemic, I realized how much my life had been devoted to my academic and professional pursuits. I wished I could fly away to my family, so I did it the only way I could during lockdown—with a no. 2 pencil and a stack of copy paper. I drew 147 frames of animation. I depicted a white heron taking flight, based on a picture my mother had just taken. The 20 second short I created, "A Pencil Is All You Need," addressed my explosive need to create and to communicate with the outside world. As I shared this message of hope and inspiration with my students, another RAW motto kept resonating with me: "I am . . . I create . . . We connect!"

As the weeks of isolation progressed, I began practicing yoga to ground myself in reality. My grandmother explained a few exercises over the phone. During the call, I tried to draw out these poses, but I couldn't picture them, so I tried them out physically. Flip Johnson, a former professor of experimental animation at SMFA, coined a term for this phenomenon: *kinetoviscerality*. This is the use of proprioception in proficient animation practice. In Flip's own words, "you gotta move your body to feel it in your guts. Act it out and then you can draw it."

I documented the process of turning these yoga poses into an animation and turned it into a video tutorial for my students. If my previous short was a breath of inspiration, this one was a call to move the body in search of the wellness of the mind. "Get up, do a physical exercise, then draw it as you feel it!" was the art directive I sent via email. Students sent back animations of themselves exercising. The positive student engagement that resulted from this tutorial helped us realize the potential of instructional videos.

While our leadership was setting up protocols for online learning, video tutorials fulfilled the need to communicate with students and inspired classes outside the film department to create short films. An example is the video created by WAMX, a public art group at RAW for self-identifying women and other nonbinary identities. In response to the racial unrest that followed the murder of George Floyd, the students of WAMX wanted to make a statement by creating large-scale portraits of female POC leaders in their community for display at the Lynn Arts Museum. They recorded personal statements calling for solidarity and social justice, which were edited with time-lapsed footage of their artistic process. The portraits they created at home were displayed on the windows of the Lynn Arts Museum. The video carried their voices reaching beyond their local community and overcame the fragmentation of collective grieving due to isolation.

Remote teaching via Zoom was piloted during the summer courses of 2020. Our way of teaching had to change since we could not share our studio spaces or our wealth of art materials. We were flexible but uncompromising when it came to giving students the proper tools. Different art materials evoke different emotional qualities through

their particular plasticities. Prior to the summer, we used simple domestic materials such as cardboard and sharpies. As we geared up toward summer classes, we made personalized art supply packages for each kid, expanding their tool kit of materials while still working from home.

Collaboration was the shaping force of this new remote format. Instead of imposing a new way of holding sessions, we took a step back and listened to our students' needs. What they wanted was a space for safe social interaction. The art became the excuse to meet each week, but the underlying goal was to catch up and check in with each other. The school year began remotely under the same premise. Refocusing on social interaction gave us flexibility but also new structures. My supervisor and film school co-teacher championed a flexible approach to filmmaking. Instead of focusing on short films as a professional product for our end-of-the-year exhibit, we encouraged students to go outside and shoot photos and video on their phones as "moments in time." We introduced closing the sessions with college-style formal critiques led by the students themselves.

At RAW we do not usually perform critiques because the therapeutic process of art making is the priority. But since fostering social interaction online had been elusive, critiques became an opportunity to get conversations going. A side effect of Zoom was that participants needed to take turns speaking, muting and unmuting. This leveled the playing field for introverts and extroverts alike. Verbal students realized that their quiet peers had a lot to say, and quiet students became confident in knowing that their voices were heard. They developed ways to talk about their artistic intent and to develop visual literacy and skills for appreciating others' artwork.

These distance learning challenges turned into positive assets and made students more self-sufficient. For example, prior to the pandemic, I digitally captured the students' physical drawings and compiled them into videos. Remotely, I had to teach them to photograph and compile the videos themselves on their phones and trust they would turn in their animations by the next online group meeting. I was pleasantly surprised with their patience and commitment. The critique model made students eager to show their work and hear what their peers had to say about it.

By mid-spring 2021 we went back to in-person classes. We dispelled initial concerns with strict safety protocols but had to revise our new emphasis on outreach and communication. We lost track of a few students during the transition, and attendance dropped. However, groups were steady throughout the year and consolidated in a renewed comradery. Many of the positive discoveries found during virtual classes remained, such as nonverbal students becoming more outspoken,

increased collaboration, and engagement through critiques. The school year concluded with a successful art exhibit, where students from the quietest to the most extroverted, spoke voluntarily about their pieces during an open mic Q&A. We were all in the room surprised by their insightfulness, wit, and sincerity.

The families we served needed time and space to find their footing in the middle of a worldwide crisis. We respected their needs by being mindful of our role, not only as an education institution but as a channel for our communities. We couldn't bring the students to RAW, but we brought RAW to each home, opening roads of communication that went inward and outward.

In conclusion, during the pandemic, RAW became more than a physical space; it expanded into a time at home to grieve, to feel validated, to joke, to cry, and laugh. We relied on our compassion, on our eyes and ears to see and listen, to rediscover the meaning of "I am . . . I create . . . I connect."

Empathy Over Gatekeeping: Redefining the Contemporary Arts Student

NEIL DAIGLE ORIANS

> Riot Grrrl was really influential in giving me permission to contribute and make art as opposed to just consuming it.
>
> —Allyson Mitchell (Yerba Buena Center for the Arts, 2014)

At some point in everyone's life, there is a moment where permission to be something is granted from another. This is especially true for artists under capitalism—we must constantly justify our existence and validation to create and make even when there is no financial gain to be made. This desire for validity has translated into a form of gatekeeping within academic art programs that defines who can and cannot be an "arts student," which I feel is detrimental to the entire field. Only those who pass a portfolio review or are enrolled with the right major are given permission to be arts students. The pandemic has amplified these concerns—physical distance now exacerbating the conceptual distance between programs, students, and the community from the arts. Indeed, digital spaces can be as exclusive as their physical counterparts.

The structure of art schools can be segregationist at best, and elitist at worst. There are unspoken hierarchies within them that deny some access to critical and creative intellectual exploration based on proclaimed major. The existence of studio courses for nonmajors should be evidence enough. Heaven forbid we allow non-art majors into our studio classrooms. While many of these classes exist with the primary purpose of welcoming a greater university population into arts programs, in my experience they're treated as nuisances or obligations. This hierarchy can even occur within departments themselves. I have experienced instructors treating art education majors as if they weren't as serious as their BFA-track counterparts.

I argue that we should radically redefine what constitutes an "arts student," and from there build a more inclusive means to integrate community both within and outside the realm of the academy. The pandemic has only further proven our cultural need for deepening creative and critical thinking, something that is inherent within the art

classroom. I offer my experience of working almost exclusively with non-majors in theory-based courses as evidence of the importance of welcoming all students into our world.

Prior to my current appointment, I stumbled into a career of teaching arts-related courses in programs or campuses that lacked a larger art program, starting with an adjunct position at UConn's Hartford Campus. Located right next door to the Wadsworth Atheneum Museum of Art, this campus has no formal art courses. Students interested in formal art instruction would most likely attend the Storrs campus, where the art department is housed. Teaching solely at the Hartford campus, I never encountered an art or art history major in any of my classes. Working only with general education students, I realized a significant language barrier existed between those who are fluent in art-speak and those who are not—in order to discuss contemporary art and feminist thought, I would need to also teach my students how to approach art from a critical standpoint.

This task was just as frustrating as it was exciting. At first, they were quiet and a bit shy—contemporary art, to the outside viewer, can seem daunting and pretentious. However, my students eventually opened up, offering the wildest takes and opinions. They sourced from their varied interests and backgrounds (consciously or otherwise), approaching art and analysis in ways I could not have anticipated.

This experience is what first made me consider redefining what constitutes an "arts student," and how we will only grow stronger through an inclusive approach regardless of program major or minor. All too often, art programs and schools are insular beasts. We intellectualize our world to prove that yes, we are academics too. This creates a form of elitist gatekeeping, where only the right kind of language or thinking may be present at the table. I found that when given permission, general education students were as capable as any fine arts majors to engage with complex, messy, and abstract concepts.

There already seems to be a push away from disciplinary modes of teaching studio art—recognizing the value of mastering basic studio techniques while simultaneously not limiting our students to only working within their chosen medium. MFA programs across the country have embraced this interdisciplinary approach, selecting cohorts of students who create strong work regardless of medium. Why should this multidisciplinary approach live and die in the art school?

My teaching philosophy is rooted in empathy and humanizing the academic process. Basic cultural competency requires we approach students contextually, being sensitive to how cultural differences can change understanding and interpretation. Embracing students from outside our programs (and even further, into the surrounding community itself) will only strengthen the importance of art programs both as assets to their respective institutions as well as within the

communities they inhabit. We have been confronted with how an individualist approach to living as cultural workers is not sustainable— we need community. We should be open to expanding what that community looks like, and it starts by redefining what it means to be an arts student.

This empathy must also extend beyond acknowledging the differences in this newly defined generation of arts students. We must also recognize the lasting impacts of the early pandemic in the psyche of our students for years to come. My first-year students effectively had their entire senior years of high school stripped from them— moments with substantial cultural weight (proms and homecomings, college visits and senior trips) were taken from them. They were then whisked into the college setting, many back to in-person for the fall 2021 semester for the first time in over a year and told that they were adults now and should start acting like it. We have no idea how the early pandemic will impact even younger students as they enter higher education. I feel solutions may be found through implementing pedagogy that centers empathy. By meeting students where they are, regardless of major or subject area, we can best serve them as educators and help them reach their potential through the pandemic and beyond.

Reference

Yerba Buena Center for the Arts. (2014, November 19). *Riot Grrrl activism through art and zines,* Alien She at YBCA [Video]. YouTube. https://www .youtube.com/watch?v=mp-VI9KUvBw

Home in/Is the Classroom: Building a Community of Artistic Citizens

SABRINA MARQUES

My memories of teaching during the COVID-19 lockdown in March 2020 are vivid and potent. I remember glancing over my shoulder as I taught, distracted by my kindergarten daughter's remote school obligations and the sobering uncertainty of the pandemic world. The past 2 years have presented numerous challenges for me as a professor in higher education. While the COVID-19 pandemic erupted, alongside natural disasters and escalating political tensions, faculty pivoted to remote instruction with little to no experience or training. This shift also had to contend with students' own often difficult personal circumstances. The abrupt movement to online teaching and learning blurred the boundaries between my professional and domestic life and has had a lasting effect on both.

Like the rest of the world, academia never functions under "normal" circumstances, and we must remember that. I couldn't reasonably expect myself or my students to complete the same course requirements as before. The beginning of the pandemic was an important time to practice generosity and mentorship towards my students who had less social and economic security to weather challenging times. As I taught my courses in an online synchronous modality, I found myself slightly reducing the workload and teaching expectations, and included explicit flexibility written into my course syllabi. I have always invested time into relationship building during classes and meetings, but I found it more necessary to include icebreakers and small group check-ins to increase motivation while engaging remotely. To address the changing needs that arose due to the pandemic, I started to emphasize time in my classes to ask students how they were doing. In the community I am building, it is important to me that not all class time be devoted to course content. Students can carve out space to speak openly about mental health, thus normalizing their struggles. This is an environment where I can offer resources, including class materials, local counseling options, and other freely available stress-reduction and well-being exercises.

I have stayed connected with some of the students from the initial period of distance learning and pandemic lockdown. For example,

I received a phone call in September 2021 from a student who had graduated. He had worked in his father's metalwork business before he started college, became a studio art major, and now manages the family business. We had connected early on about being first-generation college students with fathers who worked in the trades business. On the phone call he shared that everyone in his immediate family had gotten COVID and both of his parents had been hospitalized. His 58-year-old father experienced COVID complications due to living with one kidney and passed away. When he said his father valued me as a person and as his son's mentor, he added, "my father didn't just dish out compliments."

I was overcome with emotion for the loss of his father. He knew that my father had died in August 2020 from complications of a brain injury he sustained years prior. Talking through our grief, we proudly spoke about our fathers and how our memories of them will live inside of us forever. Fostering this meaningful relationship began many years ago in my studio course on color and was built over subsequent semesters. I hope to see him again in person one day, as he and my other students were not afforded the ritual of an in-person graduation ceremony. When I remember our last class, on the evening before lockdown, I think of the smell of wet cement that we were tinting blue and my anxious thoughts about needing to go home. No one knew at this time that this would be our last in-person class, and I don't want it to be the last time.

Thinking back on the time just before the pandemic lockdown began, I reflect on my travel to Alagoas, Brazil, in January 2020, where I engaged in ongoing internationally funded, collaborative research with a small group of professors from Brazil and the United States. We were there to begin our research with Brazilian indigenous tribes and *quilombolas* (Afro-diasporic communities) to study the connection art and creativity has with our happiness and well-being. This interdisciplinary collaboration led me to integrate professional practice into curriculum and develop a course, titled "The Art of Creativity: Cultivating Happiness and Meaning," which I co-taught with a Tibetan Buddhist lama. In this course students were introduced to processes and methods for cultivating creativity—from positive psychologist perspectives to Taoist and Buddhist meditative disciplines—and learned how to practice these complementary approaches simultaneously. If we only intellectually consider the theory of creativity and do not actively cultivate and practice the skills that promote human optimization, we risk "losing the chance to live a life worth living" (Mihaly Csikszentmihalyi). The *Art of Creativity* course encouraged students to inquire about themselves; teaching a course like this shifted the paradigm from a traditional art course to one that emphasized a student's emotional and phenomenological experience.

In the course, meditation methods were treated as creative learning strategies, cultivating knowledge through listening, noticing, self-reflection, and psychophysical feedback. The goal of haptic projects was to encourage risk-taking, curiosity, tolerance for ambiguity, and originality. We would never have imagined that by the middle of March 2020 we would be dedicating the second half of the semester almost entirely to encouraging a tolerance for ambiguity. We made sure that our course wasn't encouraging the pursuit of happiness, giving room to difficult emotions in this stressful situation. As we took time to acknowledge the tragedy of what was happening, we asked our class to try to maintain hope and find meaning in life despite the inescapable pain, suffering, and loss we were experiencing individually and collectively. To have the capacity to find meaning during this crisis was not easy. We tried to hold space for sadness, stress, and despair while allowing for glimmers of light, humor, and gratitude to emerge, helping sustain us all through the horror of what was happening.

In the semester we resumed in-person instruction, I co-taught a course with an anthropology professor that grew out of the pandemic experience, titled *There's No Place Like Home.* The COVID-19 pandemic, which made home variously a refuge or a prison, was/is a historic moment in which home also became a semipermanent space of work and school, raising questions for people around the world about who to make a home with and how to keep it safe. Home is a space of kin relations and primary attachments, an affective space of memory and emotion, and a repository of material objects that do affective work. At the same time, "home" as a literal and metaphoric space can be absented, fragmented, or traumatizing, through relocation, migration, or violence. Evictions and home insecurity are on the rise, as is global migration, which forces us to struggle with the economic and social forces that constrain people's abilities to retain attachments to people, places, and things and to find refuge in a rapidly changing world. Students in this class engaged in creative expression and auto-ethnography, in conjunction with cross-cultural and comparative analysis of scholarly and fictional films and works of art, to consider their own and others' affective ties and displacements that manifest through the resonant space of home.

The community created in my classroom is a reflection of interdependent thinking and inquiry-based studio art education. My mentoring involves a constellation of ways of assisting students during the obstacles of COVID-19, their academic studies, careers, and beyond. In addition to supporting accommodations for learning differences and COVID-19 challenges, I work on making the concentration a place where students experience the benefits of collaborative learning and an exposure to and an increase in understanding of diverse perspectives. My approach to education is to establish a place where

students teach each other, build resilience, and look for creative ways to make life better—to not accept the status quo, to not accept adversity as what they have been given, but to take adversity as an opportunity to grow. As an advocate for valuing social and emotional learning in higher education, I want to lead a community who actively develops artistic citizens capable of creating, leading, and contributing to the greater good of society. That we can try to understand one another and the variables we face in life and learn the strength and influence our voice individually and together can have in this world. This concept in pedagogy recognizes that each student brings the assets gained from their personal experiences—their family background, their cultural heritage, and their daily life and work within the community—to the classroom.

Chapter 4: International Perspectives

Introduction
JOSÉ GALARZA

In the spring of 2021, I moderated a panel session entitled "Teaching Studio Online: International Perspectives" as part of the Art School Pedagogy 2.0 Symposium. This session brought together five art and design faculty from outside of the United States, in the Global North and South, to share their own ethical and technical challenges to teaching in online environments in the midst of the great tragedy that has been the pandemic. The intention of the conversation was to create alliances between these art educators and encourage learning across borders.

As well, this panel session highlighted shared difficulties among educators from across the globe. Despite differences in local context, we all recognize commonalities in our responses to teaching art and design remotely.

The following compilation of reflections reunites this cohort to reflect on the lessons we have learned over the past 2 years, while simultaneously looking ahead and speculating on the future of the discipline. The advancement of newer and more accessible communication software has created common digital tools for teaching, but our social challenges are quite different. So are our approaches to solving the problem of delivering a high-quality art education. Drawing from international perspectives, we situate ourselves in relation to one another in the hope of creating new solutions. In reuniting for this publication, we have asked the contributors to respond to two questions: What are the most significant issues that have shaped pandemic teaching and learning for you and for your students? And how are your challenges specific to your particular academic or cultural environment? In this introduction, I highlight some common themes that emerged in their responses. In turn, these themes have prompted more questions that I put forth as an invitation to continue this conversation.

Structural Conditions of Art Education and Production

An obvious starting point for our conversation is to consider if the challenges of delivering art education are indeed the same, from a global perspective. This is particularly pertinent in a field that, prepandemic, had relied on face-to-face studio interaction and benefited from sharing a physical place for making, teaching, and thinking. Art education requires both intellectual and manual training. Creativity in a cohort is inspired by sitting shoulder to shoulder in a common space, sharing tools, equipment, and ideas. Learning in a traditional studio environment is relational and social, but remote learning can undermine these conditions.

How much does inequitable access to both technology and uninterrupted electricity become a dividing line between art education in the Global North and Global South, rural and urban settlements? How much do uneven infrastructure, poverty, and distribution of student populations across remote geographies belie the myth of the Internet flattening the world? The relative strengths of teaching environments in the industrialized North and the agrarian or pastoral South are radically different. Can we therefore even compare them? Has the pandemic made the gaps between these worlds, both in terms of culture and infrastructure, more apparent? As you read the following statement papers, you will find that the contributors focus on very different take-aways from the predicament of remote teaching and learning.

Professor Sangbin IM, at Sungshin Women's University in Seoul, teaches digital natives, young South Koreans who have been raised using communication technologies. Sangbin's students' worldviews and skillsets are shaped by South Korea's concerted investment in mobile and Internet infrastructure and through the influence of large electronics companies like Samsung and LG. However, he finds a gap between the technological savvy of his students and the emerging technology-driven modalities of learning that South Korean higher education institutions offer. To address this, Sangbin suggests that teachers and institutions of higher education need to catch up with the skills that students bring readymade to the classroom. The "catching up" of e-studio and e-class is not a benign call. It comes with transformative consequences for art, education, cultural institutions, and the public consumption of art.

In his writing, Sangbin acknowledges that educators need to develop ways to view and assess student artworks in virtual and hybrid spaces in addition to the physical classroom. But, more importantly, catching up will reconfigure the social context in which learning in art institutions in South Korea happens. It will bring into question whom one learns from, what one learns, and how artists relate to others and social space. It will rewrite the rules of mediation between the

symbolic consumption of art and the institutions of art, like magazines, museums, schools, and the marketplace. If Walter Benjamin celebrated the production of art in the age of mechanical reproduction, Sangbin invites us to envision both the power, and conversely the inability, of art to communicate in the age of digital diffusion.

The production and consumption of art through digital mediation is also of great interest to the rest of our contributors. Compared to the in-person art studio, the remote studio requires a financial investment, made by the student, in expensive gadgets. This new investment in hardware and software is required for remote learners to curate the mediation and perception of their work, expenses not required in a traditional context. While this additional cost creates an accessibility gap, communication software like Zoom reduces the disjuncture between extroverted and introverted students by offering tools for student engagement that align with new rules of online communication. For example, the chat feature in an online classroom has become an indispensable tool for shy students to articulate their positions without having to voice them. It has created solidarity and nuance around different positions, notions that are only available to the more extroverted students in traditional classrooms. For faculty, it has enabled them to gauge how their intellectual positions and technical ideas are received.

Conversely, the record and screen-capture features of Zoom and similar platforms, while useful for asynchronous teaching, also afford participants an editorial function; they can anonymously cut out clips, decontextualize them, upload them to the web, and indulge in cyberbullying. The potential threat of digital editing can lead students and professors to censor themselves, turning what might have been free and open conversation into a highly distorted and toxic public space.

Ways of Making Art

So, the collective question for all of us in art education is: How do we ensure that these new teaching and learning tools create an equitable and civil public sphere of communicative action? We cannot continue with syllabi and curricula as usual. We have to ensure that art education over digital platforms, predominantly created by a handful of powerful and navel-gazing White men, does not lead to predetermined artistic production, driven by coding and algorithms. Our course objectives must have enough foresight to maintain the creative agency of our students and not produce artists as cogs in a machine designed in Silicon Valley. We have to make sure that their work functions as a tool for the empowerment of the historically dominated, as opposed to a source of continued subjugation.

If contemporary education perpetuates the body–mind divide, it will in turn increase the divide between two types of artists: those

who begin with manual, traditional modes of making and those who begin digitally, from the vantage point of digital natives. In this way, the mind–body divide will perpetuate the colonial association of the Global North with the mind and intellect and the Global South with the body and labor; thought versus intuition; reason versus emotion.

Professor Rainer Wenrich at the Catholic University of Eichstätt-Ingolstadt in Bavaria, Germany sees an opportunity to find a balance between analog and digital. In his view, digital tools should not replace the body as the locus of creativity but extend it. These tools diversify our teaching methods and incorporate students who learn differently. Wenrich finds promise and potential in a hybridized studio space with both in-person and distance learning modalities. His department, taking advantage of a pre-existing resource in a digital maker space and presentation platform, leveraged those facilities during the pandemic to reimagine the possibilities for remote teaching and learning toward what he calls a "responsive [virtual] space," as a multimodal strategy.

The remote studio lacks the energy that comes from sharing a physical space with one's peers, where learning happens formally as well as informally. To compensate for this deficiency, Wenrich suggests more frequent check-ins with and among students. For example, during these check-ins, explaining to peers and instructors one's stage in the creative process reinforces connectivity between class members.

In the virtual, remote studio environment, creation and iteration unfold over multiple conversations. In face-to-face learning, such check-ins leave behind physical traces, such as sticky notes, redlined drawings, and written comments drawn on photos or models. These are the analog counterparts to the audio recordings and chat notes captured through online platforms such as Zoom. The difference here is that these digital tools create a much more complete record of studio learning communication. This more complete record of students' creative dialogue can be a potent instrument of reflection on the evolution of one's ideas, intuitions, and habits of mind. Wenrich notes that this digital record helps both student and teacher narrate their design tendencies and excavate their creative processes in ways not discernable in traditional analog learning modalities.

The Role of Art in a Digitally Connected World

Most of what I have presented previously pertains to the attitude of faculty from the relatively affluent, technologically well-equipped parts of the world. For technologically under-equipped societies, a different opportunity arises at this juncture in art education to avoid the pitfalls of those already immersed in digital learning spaces, to treat the Global North less as a role model and more as a cautionary warning.

In contrast to the students of Sangbin and Wenrich, Professor Dina Lutfi's graphic design students at Imam Abdulrahman Bin Faisal University in Dammam, Saudi Arabia, are first and foremost natives of the material world. The necessity of remote teaching and learning during the pandemic has highlighted the lack of Internet access for those living outside of the modern metropoles. This in turn seemingly puts into question the very value of art education in a country like Saudi Arabia. At a deeper level, this questioning is more about the gap between what is valued in art education and the burning needs of the society, which ought to be addressed by professional creatives. Modern/Westernized art education can be alienating for these studio art graduates, not only by the creative solutions to problems posed by their context but by the very articulation of those creative solutions.

The mediation of the digital interface has also intensified the disconnection of Lufti's students from their learning community. The invasiveness of web cameras, when introduced in private spaces, and the formalization of informal learning does not work for students in rural/pastoral Saudi Arabia as it has for Wenrich's students in Germany. Lufti's students don't need digital media to overcome social distance. Instead, they need to strengthen their existing social spaces against the devouring nature of digital technology. For example, video teleconferencing to outside lecturers gave her students new exposure to new ideas. And yet there is a sense that this exposure is not worth celebrating for Lufti's students, unless it reinforces the value of their own identities and articulates the role of graphic design through their own particular context.

The strengthening of social interconnectedness is also at the heart of Rabeya Jalil's contribution. She speaks of her colleagues' and her own experience at the National College of Arts in Lahore, Pakistan, through their stories. Jalil documents how they rebuilt a formal university art institution as a cluster of e-villages. Her students and colleagues repurposed domestic appliances and spaces and built their ateliers at home. They improvised, transformed waste into art, and made do with what they had. Assignments became much simpler, more stripped down. The space of the home expanded, rather than constricted, the students' creativity, expanding the confines of a formal studio. One of her colleagues calls this informalization of pedagogy a renewal of sorts, with the effect of slowing down, removing distraction, and bringing awareness to the present.

In conclusion, the call for ideas here explored the topic at hand in a variety of ways from a variety of positionalities. The comparative analysis of the five idea papers creates a robust conversation that is by no means conclusive in one direction or the other. What unites all of these papers is their invitation to readers to think through these sticky, complex topics in their own context.

Toward a Better Balance Between Onsite and Online Education

SANGBIN IM

The pandemic situation has led us to rethink the nature of the classroom. Teachers and students have finally realized that class does not have to take place in physical form but can be fluid, encompassing the digital realm. In this paper, I will argue that a creative combination of onsite and online art class benefits teachers and students in multiple ways.

In my doctoral dissertation, "The Generative Impact of Online Critiques on Individual Art Practice," I investigated and discussed the significance of online critique as follows:

- It encourages critical reflection and promotes participation.
- It nurtures various types of "real talk."
- It is accessible anytime, anywhere, by anyone.
- It is a new venue to continue life-long learning.
- It is a collaborative practice sharing information/knowledge.
- It may adopt new technological methodologies.

After the completion of my doctorate in art and art education at Teachers College, Columbia University, I became a professor at Sungshin University, the second largest art school in Korea. Before the pandemic, my online education included regular online homework, threaded discussion, irregular prerecorded video, and virtual mentoring via phone or SMS. However, it did not include real-time video conferencing. At that time, I thought these other modes of communication were enough, since I regularly met students face-to-face in the classroom. Given the situation, online education was only secondary to support the primary venue, onsite education.

This situation was literally turned upside down during the pandemic; onsite education became secondary, in support of the primary venue, online education. At the beginning of the pandemic, when onsite education literally vanished, online learning modalities were never enough. Even then, I struggled to experience students' physical artworks in art studios without any in-person contact. This is because many artworks need to be appreciated as images as well as

physical objects or events. If you only depend on viewing images on a computer screen, you lose a sense of materiality, a significant factor for many artworks. For example, two images may look the same on the screen, but the ways of seeing are quite different if one is 100 times larger than the other or if they have a different surface texture. This leads to accommodations and compromises; if onsite viewing is not possible, one needs to be more thoughtful in directing online viewing to achieve a sense of physicality.

In sum, onsite and online education have different characteristics, as much as the physical world and the metaverse do. These two venues are not interchangeable but render synergy with one another. Agile teachers and students make the most out of each modality, in context. The pandemic has accelerated this future shift. Therefore, it is always better to embrace the new era equipped with creative and critical minds. Onsite and online are mere tools; their common purpose is our common purpose, studio teaching and learning.

Even after the pandemic era, online education will not simply shrink. Rather, onsite and online education will seek to coexist and synergize. In this new hybrid environment, the quality of communication technology matters most. For example, poor video or sound quality diminishes the quality of learning. A variety of online miscommunication can also be problematic. South Korea is the world's most wired country, and most students today are digital natives. Therefore, when it comes to technology, it is often teachers who need continuous training. For example, real-time video conference programs have a lot of settings with constant updates, which may be confusing for educators not accustomed to navigating learning tools with constantly shifting interfaces.

In art school, studio critique plays a crucial role. Yet, in-person and online critique have different strengths. First, in-person critique is based on the "physical encounter," which makes rich, diverse, and vivid interaction possible. In this setting, verbal articulation as well as nonverbal and emotional entities may generate a unique experience. Second, online critique is based on telecommunication, leading teachers and students to join it at their convenience and discretion. In this setting, talks are mediated online, making real-life positions less visible, and thereby providing a freer and safer environment to speak up. Therefore, online critique may boost the level of participation and generate diverse types of real talk. And at the very least, it still extends a basic means of communication.

From my personal experience, online education has many pedagogical implications. First, online education has helped me focus more on art dialogue during the class. For example, when real-time video conferencing is the class, students make art before or after the class, and they discuss art during the class. By doing so, art practice and

art dialogue could make a systematic balance. Second, online education has led me to continue art schooling, becoming a life-long learner. With the magic of telecommunication, I am a teacher not just at school but at home, on the street, in the car, or virtually anywhere, at any time. As a result, I am busy constantly navigating here and there. Whether I like it or not, the distinction between work and home continues to disappear. Third, it has encouraged critical reflection by helping me to look at myself through a more objective lens. For example, by looking at myself on the monitor and talking at the same time, I am somehow led to reflect on what I say and who I am. On the other hand, by reading my text in threaded discussions, I am somehow led to reflect on what I have said and who I have been.

In sum, the online learning environment conditions different modes of education. As we all know, a particular medium delivers a particular message. I argue that onsite and online education could be happy life-long companions, making multidimensional education possible. And rather than obstruct this development in studio art education, we must instead become passionate key players in this new environment.

The Art Education Makerspace as a Responsive Teaching and Learning Arena

RAINER WENRICH

Pandemic teaching and learning multiplied our methods of instruction in art education. This comes with new challenges: Communication became a core issue, as the mediation of the manifold visual practice is considered in more detail. This applies the structuring of tasks and affects ongoing formative assessment.

Studio art instruction, via online distance learning systems such as Zoom, requires the selection of suitable tasks, presented with additional techniques, like a document camera or prepared short videoclips. Our learning environment needs to be reimagined under the conditions of the pandemic. Remote mediation conditions a virtual teaching and learning environment as part of a responsive space concept that let us adapt to the multifaceted concerns of our students and helps us to respond with clearly considered, small-step organized units with diverse interactive or participative options (e.g., by using applications such as Genially, Miro, Padlet, Poll Everywhere, Mentimeter).

The necessity to deal with different technical options and to vary with distance teaching methods is no less important than in a real space studio. In the real space, communication between teachers and learners is an omnichannel experience, in which different levels of language (e.g., spoken and body language, gestures, and facial expressions) play an important role. This applies to task setting and to feedback and critique phases while working in the studios. Compared to the distance teaching mode, in-person teaching succeeds in providing immediate, personalized feedback. While teaching remotely, we use much more general language in addressing the group. Face-to-face teaching or critique implements internal differentiation through the personal and individual approach, whereas in distance learning, we have to make sure that instruction or feedback takes place as an independent part of our teaching. Otherwise, it becomes difficult for our students to realize the differences in communication.

During the pandemic our Makerspace played a special role as it linked the real and virtual world and enhanced our teaching. The elaborate feature of our Makerspace distinguishes this space from other discipline-specific studios for painting, printmaking, or ceramics.

Within one room a smooth, creative transition from analog to digital techniques is possible. Flexible design options become particularly clear when we start a design project with an idea sketch, scan it, digitally process it, and eventually create a file for a 3D print. Besides, our Makerspace is equipped with a 360-degree video camera to include remote students or faculty while they are not on campus.

The pandemic condition forced us to organize our teaching as small steps and an alternation of instructive phases and the often longer time periods for free artistic work. The complexity of virtual communication as a digital-media speech-act was not to be underestimated, especially in formative teaching with necessary feedback loops. Via Zoom, the level of speaking and the discussion of artistic creation both meant the experience of medial translation. The physical and psychological strain on everyone involved in the remote teaching and learning process becomes an incisive experience. Distance teaching usually means that both teachers and learners spend many hours alone in front of the screen. Our voice is the main means of communication while various linguistic differentiations are omitted. Language takes on a new importance with a focus on articulation and the coherence of meaning. For the presentation and discussion of working results, this is crucial. The frequency of regular work meetings related to design processes in real time and space decreased under pandemic conditions. But important feedback was not completely absent; it was less intense due to the limitations of our remote communication. Some students felt downright neglected as a result and occasionally withdrew from classes. It took some time for these students to find their way back to university education, and to bring the overall academic discourse back to the scholarly level required of university education. For their part, the students had to cope with the fact that communication with other students and with us teachers was reduced. Overall, a high degree of pedagogical empathy was necessary. The latter aspect should not be overlooked in any case, especially not when there will be more hybrid teaching in the future. As distance learning throughout the pandemic has taught us, such pedagogical empathy must play an important role in future teacher training.

We had already set up a presentation platform, called carte blanche, on our website before the pandemic. Our virtual gallery was now used to present our students' work from individual seminars. Yet, despite these previous digital preparations, teaching and learning under the conditions of the pandemic represented a special phase of tension and uncertainty for all those involved. During these challenging times and as we all experienced a much greater awareness of societal concerns, we now more often discussed artistic positions with social, political, or philosophical implications. In their artistic conceptions, aspects of inclusion, gender justice, diversity, or climate change played a central

role. Aspects such as loneliness, and strategies for coping with personal but also social and political problems then had a visible impact on the artistic inventions of our students from sustainability, ephemerality to lost spaces or flight and migration. In addition to the problem of loneliness, there were often financial problems (due to the loss of student jobs during the pandemic). It was noticeable that student awareness and response to these social and political issues led not only to formal inventiveness but also to remarkable personal content. Students began to react more sensitively to the framework conditions around us and then implemented them creatively.

The shift to distance teaching and distance learning modes has changed the academic environment at our university, especially in the field of studio art, digital-media design, and the theoretical study of different forms, roles, and meanings of art and artists. We were all used to short distances between our studios, the availability of our open studios and workshops, and the access to the diversity of available artistic materials. All this was transformed into virtual meetings. Prior to the pandemic, our students took particular advantage of the openness of the learning environment and the availability of materials, working with analog, digital, and hybrid media, as this is a campus university characterized by high levels of student/faculty and student peer-to-peer interaction. During the pandemic, we were faced with the question of how to come close to substituting the specific conditions described previously in the context of remote teaching and learning and to continue offering our students the best possible study conditions. During the phases of mostly working off-campus, care was taken to ensure that our students had regular access to materials. A new culture of teaching and learning art from a distance emerged.

The special didactic-methodical conception of our Makerspace helped us to cope with these issues. With hybrid teaching offerings in our other studios, communication continued in the virtual space of remote teaching. This proved true with regard to the concept of the analog/digital Makerspace. An understanding of the teaching and learning environment in art education as a mixed-media space has been further developed, even in the pandemic. Our Makerspace evolved from a multifunctional space for analog/digital design to a studio that ideally facilitated teaching at a distance and participation in design projects from a distance. Central to this concept of space was the idea that analog and digital design, the use of different tools and materials, and technologies, was intertwined in the dialog of hybrid teaching and learning. The Makerspace design, as a real place where physical dialogue encounters took place and students worked individually and in teams, now enabled both phases to coexist: physical presence and remote communication. During the different stages of the pandemic our Makerspace functioned as a hub. While other students still stayed

off campus, some of them used the equipment to proceed with their design work and discussed it with their fellow students and faculty off campus.

The Makerspace unites the principles of a responsive learning arena for exploratory, deconstructive, or experimental design approaches. Exemplary design projects in the Makerspace during the pandemic and processed with the help of 3D printing were related to the design of utility objects, such as small containers for storage, as well as the conception of architecture, such as a pavilion for an upcoming state garden show in a nearby city. Fluid design possibilities and the ease of participation for students from a distance (e.g., individual and group discussion, creative work, and student presentations) proved to be particularly advantageous. In our Makerspace, we enabled analog and digital working steps in a fluid working routine and in one space already before the pandemic. We will integrate the findings from distance learning in our future teaching and, in doing so, will also enable students to participate in courses from a distance whenever this is needed or helpful. By this we intend to expand the range of our artistic language and develop it in a responsive space that does justice to the diverse manifestations of in-person, hybrid, and distance studio teaching and art making.

Challenges and Advantages of Post-Pandemic Art and Design College Education in Saudi Arabia

DINA LUTFI

Art education during a pandemic comes with its own set of challenges. I teach graphic design and multimedia at IAU University's College of Design, an all-women's college in the city of Dammam, Saudi Arabia. Like many other places around the world, we were impacted severely by the pandemic. Reflecting on art and design education during the years 2020 and 2021, among the most significant challenges for my students and I were finding effective ways to communicate through remote learning modalities and overcoming the separation felt from being virtually in different spaces. Most courses offered in my program are practical classes, but due to the shift to online learning, the experience of working together in a classroom abruptly disappeared. Students began to perceive the process of making as secondary to theoretical aspects of conceiving art and design outcomes. In other words, instead of actually engaging in creative practical activities, they felt discouraged to do so in the absence of a familiar studio setting. Consequently, they directed their energy toward the safety of focusing on proposing hypothetical outcomes as opposed to practically attempting to create them.

What exacerbated matters further was that students who lived outside of the city faced difficulties attending classes due to lack of Internet access. It became challenging to communicate with students when providing them with feedback or introducing new ideas within an online format. Students reported a loss of self-confidence when discussing their work, an inability to focus due to distractions, feelings of fatigue, and social isolation from peers. Additionally, some students did not consider the online learning format as important as in-person learning, and this perception took a toll on their interest levels.

Another dilemma that surfaced during pandemic-era teaching and learning relates to the novelty of art and design as creative educational fields in the local environment. These are disciplines that have only begun to gain ground educationally in recent years, and the communication challenges that have resulted from online teaching

have led students, their families, and society at large to question whether it is worthwhile spending time learning about artistic fields remotely, or if the quality of online learning will contribute sufficiently to securing students' professional futures.

In addition, many students are not convinced of the potential impact of artistic fields in Saudi Arabia, and online learning has magnified their doubts. Since we live in a conservative society, the majority of students are not comfortable with using the video feature on online educational platforms. Consequently, having their images or faces exposed for everyone to see is usually out of the question, so most cameras are switched off during online classes. Being unable to see students made the teaching experience bizarre. It became difficult to gauge nuances, such as facial expressions and body language. As a result, rich dialogues have been scarce during much of our online class time. The seamless back and forth discussions students usually have with one another during pin-up discussions, for example, have also been diminished. By contrast, being in class together in-person, seeing all of them, and being able to discuss their work would be more dynamic because of the visibility of their physical presence.

When COVID-19 restrictions began to ease off in 2021, some classes switched back to in-person learning. While a number of students regained a sense of community and confidence, there were also a large number of students who felt awkward being back in a traditional classroom setting. These behaviors were noticeable in younger students who had joined the program as the pandemic began and had not attended college classes before. Social distancing restrictions in classrooms also made it harder for students to work together and attend group activities in shared spaces, which added an additional layer of isolation and frustration.

The College of Design encourages a focus on local and regional cultures. Online learning, however, strengthened a sense of networking beyond the regional. It led to new vistas of communication; connecting to other students, artists, and designers was reinforced. Before the pandemic, the educational focus leaned toward the immediate locale, and students were normally interacting with a tight-knit circle of their peers. However, during online learning, the diverse connections students forged with different artists and designers, and the connections I made myself, helped all of us gain more exposure to multidisciplinary approaches to making creatively and unexpectedly.

All these findings have contributed to a reassessment of the program's approaches to education by making both in-person and remote learning the new norm. Before the pandemic, exhibitions held within the College were opportunities for students to communicate their thoughts on creative outcomes. When that was no longer an

option, many students started to actively participate in and create for online competitions and exhibitions; a lively level of engagement that pandemic obstacles brought into perspective. One student commented: "Before the pandemic happened, I was nervous about showing my work to my classmates, let alone to people I've never met before. But being isolated made me realize that sharing what I make with others doesn't feel as foreign as being separated from the world." The familiarity of sharing work in physical spaces was replaced by the new experience of sharing work in virtual spaces—which, despite being challenging, has also provided opportunities to disseminate art and design in ways that were unimaginable before in physical spaces due to the scarcity of appropriate venues. Simultaneously, the possibilities for multidisciplinary artists from around the world to collaborate and participate with students increased exponentially. As another student explained: "I always thought that when I connected with other creatives from around the world, it would be in-person. But just through virtual exposure to global artists' work, I learned that everything I make can be used towards social exchange and not just social beautification."

During the pandemic we learned that educators and students can indeed find ways to make the classroom engaging even if it is from a distance. Something as simple as forming channels for sharing ideas or brainstorming and creating a balance between structured and informal learning experiences can be achieved remotely. Online teaching can be an asset that continues to be available even as life goes back to some form of normalcy. The challenges of education during the pandemic have taught us to be more flexible and leave room for the unexpected. These challenges have also stimulated an innovative awareness of educational needs, tailored the development of communication skills, and encouraged cross-cultural engagement. And as our familiarity with technology has increased, we have awakened to the challenges of the unfamiliar, viewing these challenges as teaching and learning opportunities rather than obstacles.

The Shift—Off-Line

RABEYA JALIL

Though overbearing, the pandemic signaled opportunities that were unimaginable prior to its outbreak. We were fast-forwarded into a digital virtual realm that was remote and unfamiliar to many, but this unfamiliarity broadened and altered our ways of thinking and making. Domestic spaces were adapted; basements, restrooms, kitchens, attics, and garages were converted into offices, studios, and classrooms. The meanings and methods of education were also put to the test. Many teachers were able to adapt to rapidly changing academic needs, while some were nostalgic and held onto prepandemic ways of working in hopes to resume hands-on physical activity in classrooms. This sudden shift to the virtual was drenched in uncertainty, especially for senior thesis students who were accustomed to developing their creative processes primarily through hands-on tools and mediums.

This essay brings together viewpoints of art and design educators and students from three major cities (Lahore, Rawalpindi, and Karachi) in Pakistan who were engaged in higher education online studio courses during the lockdown. It enlists faculty and student perspective as parallel data, tallying conflicting and similar ideas that offer a set of common questions about assessment, equality, justice, objectivity, and community-building in art and design teaching and learning.

Should empathy, flexibility, and generosity influence our methods of evaluation? What is to be assessed and why? How can learning systems ensure equity and fair grading, if level playing fields are disrupted? How can new intuitive ways of correspondence and expression be developed to ensure individual and collective growth? This period threw us, as educators and learners, into a deep pit of questions, but it also made us think backward and eliminate the abstraction that often blurs the eventual goals of learning, being creative, making art, and being human. It pushed us to find meaning in what we do and value what remains at the core.

Students, almost across the board, shared that they were able to realize the value of peer-learning and said that they developed an acute sense of proximity and a taste for community. Even without teacher instruction, they were in tandem with each other's work and life, and many connected digitally at every stage of their semester. Some teachers realized the inevitability of a physical studio regimen and reinforced its value, while others tried to reinvent their methods of learning, teaching, and making to ensure online academic productivity. Some educators managed to facilitate, or simulate, a studio environment

for their students while others took the anomaly as an opportunity to dismantle older and traditional ways of working and develop newer methods of production.

Educator Perspectives

Owing to diverse student demographics, we were able to engineer modes of learning to address individual needs of online engagement. Many students, particularly female students who were enrolled in graduate degree programs, preferred the online format while working from home because the role of caretakers was heightened at this time and students had heavy responsibility outside class as well. Course content was also adapted to consider strategies of making that were mobile, ephemeral, and virtual, and accounted for collectibles and material from within the home or from any other context outside of a classroom. Class preparation time, preproduction content, as well as student contact hours, increased, which in some cases, remained undervalued and unaccounted for.

> *Madyha Leghari,* **visual artist, researcher, art educator, visiting faculty—School of Visual Arts and Design, Beaconhouse National University, and National College of Arts**

While the active on-ground studio space had its pros and privileges, the ritualistic methods of prepandemic teaching did not account for individual experiences and worldviews of a mixed, ethnically diverse group of students within a white walled studio. Therefore, online teaching allowed students to observe their contexts and lived experiences and see opportunities outside art room confines that could fully play out during the process of making. The projects allowed them to question the scope of material, both tangible and intangible. Being home and working with the ordinary, as a value, as opposed to searching for extraordinary ideas within their creative practice was crucial to the shift. Putting a limitation also enabled learners to pay attention to surroundings, and hunt for material in the vicinity. This led to greater introspection and divergence of trajectories.

> *Fatima Hussain,* **visual artist, researcher, art educator, assistant professor—Department of Fine Arts, National College of Arts**

Although virtual tools with confined screens enabled remote conversation, the scale and proportion of work output could not be manifested with clarity and precision. However, this challenged students to pay attention to minor details of presentation and display as they became more sensitive to viewership and audience experience.

Students tried to address this issue through the use of 3D visualization software where students could imagine and play with virtual scale.

Omair Faizullah Bangash, designer, design educator, researcher, associate professor, former head of department, Visual Communication Design, School of Visual Arts and Design, Beaconhouse National University

Online teaching overcame physical barriers and allowed for more guest speaker sessions, artist talks, lecturers, and international critiques by academics present elsewhere. It facilitated interaction and viewership on a broader scale that otherwise seemed unimaginable. Students, already adept at digital manipulation, were encouraged to make short videos, as reflective practices of their own work.

Rohma Khan, designer, design educator, researcher, associate professor, School of Visual Arts and Design, Beaconhouse National University

The printmaking studio also brought surprising alternatives, keeping in mind the burning question of how to teach seminal printmaking intaglio, relief, and planographic techniques without complex equipment. For one part of the exercise, the studio prepared material boxes with the bare essentials (paper, inks, tools, linoleum sheets, wood blocks, a silkscreen, and some rollers) and posted them out to students.

Laila Rehman, visual artist, art educator, associate professor— Department of Fine Arts, National College of Arts

Keeping students within the parameters of group learning was a crucial consideration, as the solitary mode of the pandemic was already alienating for many. Students also shared that they felt a digital burn-out and screen fatigue, as a result of which they consciously reverted to analog methods of ideating and creating. For instance, type design and typography students started sketching, sculpting, and painting with material available at hand. In doing so, they claimed to be more discerning of their environment. One colleague vehemently spoke about his ideas on the overarching ethos of formal or informal pedagogy—to be able to listen and accommodate, to give the other the benefit of doubt, to develop the capacity to understand each other's position, especially at a time of global crises.

Umair Abbasi, designer, design educator, researcher, visiting faculty—School of Visual Arts and Design, Beaconhouse National University

Student Perspectives

From a year of social distancing, I learned that community plays a crucial role in personal and professional growth. The pandemic, and subsequent lockdown, came as a course-altering shift in my studio practice. The restrictions, both in material and technique, were difficult to navigate. Making work in physical isolation was a challenging feat, and I would imagine teaching it, even more so. Critique and open dialogue became restricted to virtual spaces, but these channels opened up avenues for media exploration. The shift in accessibility was also a learning experience in addressing and exploring alternative, sustainable materials. However, despite the innovation and module adaptability, distance learning lacked a certain degree of discipline building and sensory learning which, I think, is an integral part of any academic experience.

Nisha Ghani, **BFA student during the pandemic**

University years are the most critical for intellectual and psychological development. The imposed lockdown and restricted social activities disrupted the third year of my academic session. There was poor communication, limited guidance between us and the teachers, and a hovering pressure of exams. Student–teacher bonds did not develop because of lack of physical studio learning environments. Even at home, a monotonous lifestyle and lack of personal space was demotivating and frustrating. It was tough to maintain health, manage finances, sustain satisfactory academic records, and contribute to domestic duties simultaneously. However, I did develop a sense of independence, caution, self-awareness, and empathy. Most importantly, I started valuing time and close relationships.

Hamza Bin Faisal, **BFA student during the pandemic**

Till August 2020, it was very difficult to switch to a virtual classroom and navigate how that works, but it became easier with time. However, after August, everyone expected us to get our problems and struggles sorted. Toward 2021, my mental health deteriorated as I was unable to process so many deaths of close family friends and relatives, especially of my grandmother. Amidst all this, college and work felt meaningless. I am an ambitious one, but my goals and ambitions seemed trivial and so unimportant that attending classes and submitting works on time made me angry. It reminded me of the once normal routine that we so desperately tried to hold onto, which now seemed irrelevant. I hardly had space to paint at home and had to juggle between care-giving and work.

Hafsa Nouman, **BFA student during the pandemic**

I had gone back to formal education for my graduate studies, almost a decade after finishing my undergraduate degree. Studying during the pandemic meant that I was managing coursework in addition to running a household and being a mother to a toddler and a school-going boy, who also had online school. There were numerous distractions during class time to resolve kids' affairs and outbursts. I also missed the interaction, vibe, and energy of my colleagues and instructors, which I had experienced earlier in physical classrooms; I also missed the support of hand and body gestures that play an important part in communication. As a mother, being physically present and being available became distinct from each other. However, I am grateful that I was able to continue my graduate degree remotely without having to travel.

Asna Khan, **graduate student during the pandemic**

There was uncertainty about life, work, money, and relationships on a day-to-day basis. Yet, oddly, there was a sense of looming monotony, as if the same day was being played over and over again, like a nightmare. During the first lock-down, universities shut down and we lost access to our studio spaces. I was left with a tiny spot in my room. I never truly appreciated the privilege of having a studio space and the possibilities it can offer to an artist. Oftentimes, there wasn't enough money to buy preferred art materials or cover transportation costs, apart from having to work in a distressed mental state and sometimes in a toxic home environment. Communication became harder as students and teachers struggled to discuss art works relying on images of artworks rather than the work itself, altering the viewing experience entirely. We learned and adapted, not by choice but through circumstances. Ironically, we collectively went through a similar kind of experience of isolation.

Ayesha Naeem, **BFA student during the pandemic**

The spread of the coronavirus had pushed the pause button on the world's fickle flashes and its randomness in the mundane. I was a thesis year student then, residing at a hostel in a province away from home. Traveling back and forth to another city for education meant I had to travel miles away from my college, that too with my art supplies and canvases. Our thesis instructors made it a lot easier for us and put up with us at our toughest times when the normality of life previrus seemed impossibly distant. I also wrote. I managed to write for a renowned newspaper, representing a whole province (Balochistan). I visited people in my own city, who were not aware of the precautions they had to take but were affected passively. It was an odd vulnerable year, yet it brought out the good in me in many ways. I learned resilience and control, and the number of tears I had shed reminded me of so many things I had taken for granted.

Durrie Baloch, **BFA student during the pandemic**

Interlude

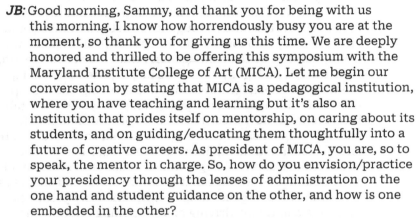

A Conversation Between Judith M. Burton and Samuel Hoi[1]

JB: Good morning, Sammy, and thank you for being with us this morning. I know how horrendously busy you are at the moment, so thank you for giving us this time. We are deeply honored and thrilled to be offering this symposium with the Maryland Institute College of Art (MICA). Let me begin our conversation by stating that MICA is a pedagogical institution, where you have teaching and learning but it's also an institution that prides itself on mentorship, on caring about its students, and on guiding/educating them thoughtfully into a future of creative careers. As president of MICA, you are, so to speak, the mentor in charge. So, how do you envision/practice your presidency through the lenses of administration on the one hand and student guidance on the other, and how is one embedded in the other?

SH: Thank you so much for asking this wonderful question. First of all, let me thank you for the invitation to join you this morning to engage in this dialogue; for those of you who don't know us well, whenever Judy and I gather to talk for 20 minutes, we end up still talking 3 hours later. So, this morning we'll do our utmost best to contain our conversation within 20 minutes! At MICA and I am sure at Teachers College and elsewhere, new forms of mentorship and pedagogy are emerging to respond to the issues shaping today's world, but we are still in an inventive stage. When I received your invitation for today, I was curious to see the prevalent concept and conventional wisdom about mentorship, so I looked up the term on the internet and found that it is basically different versions of the same idea: that is, a relationship between two people where the one who is more experienced and knowledgeable guides or advises the other who has less experience and knowledge. If you map that general idea onto an art school context, you can see four aspects of a traditional definition of mentorship that are being upended at MICA and

1 This online conversation took place in March 2021 during the *Art School Pedagogy 2.0* Symposium at Teachers College, Columbia University.

other places: One, it's a one-way transmission from a senior person who "has" to a junior who "needs." Two, it's a one-on-one relationship. Three, there is a linear path from study and theory to practice and profession. Four, in the context of the art school pedagogy that is deeply rooted in the historical atelier model of master-and-apprentice relationship, it implies a professional focus that emphasizes intellectual and skill development over emotional wellness and whole-person development. That kind of relationship does not involve loving care. It is a kind of tough love that oftentimes could either destroy someone in the process or push them forward, if they survive, as the next master. I think what's interesting is, as today's pedagogy confronts its purpose to help shape the world we need for tomorrow, it is evolving and disrupting these traditional notions of mentorship. Maybe we can talk a little bit about how these basic concepts are changing from one-way transmission to intergenerational collaboration, from one-on-one relationship into more of a team-based generation of knowledge and exchange, from a linear path into a much more complex—I would call it—upward spiral and sideways-expanding loop of generating new theories and practices involving a mutually driving and propelling relationship, and finally from the old-world and outmoded master-and-apprentice situation into a comprehensively nurturing model that is deeply aware of the students' emotional wellness and whole-person development. This kind of pedagogy as mentorship is informed by empathy, compassion, intercultural learning, and understanding that wellness supports rigor and excellence. It is exercised in a mutually empowering context. I love having this conversation with you because so much of your writing is about reimagining what mentorship and pedagogy might be. Anyway, I've spoken so much that I am going to pass the floor back to you. Do you think this all makes sense?

JB: It makes absolute sense, and you've raised a whole host of issues that if we took them one by one would take us for the rest of the day to explore. But let me narrow the focus a little bit because much of what the relationship between pedagogy and mentorship seems to devolve on is how we construct relationships with others, and clearly mentoring has always presupposed, you know, younger–older persons, somebody more experienced and somebody less experienced. However, at this moment in time, as a consequence of the pandemic and experiences of this past year, students and teachers are returning to MICA and other colleges across

the United States having had the shared experience of being locked in and of being alone, of not being able to touch each other. Interestingly, this aloneness has brought forth considerable writing about the critical importance of physical contact such as hugging; now, you and I are great huggers, so we know how important that is as a moment of contact, of communication. So, as we think about pedagogy as mentoring at this moment in time, perhaps we can envision hugging as a kind of encompassing metaphor for empathy, caring, and communication. I say this because as teachers and students return to classrooms and actual physical interactive experiences, they need to be able to form new sets of relationships that are very real. We can't return and do what we've always done; we need to rethink our sense of self in the context of others and of community, and practice new ways of collaboration both as individuals and groups. This raises a rather subtle and sensitive set of issues that need to be dealt with on the campus—it has to be dealt with within the network of a caring community; there needs to be a new kind of pedagogical and social balancing between individual selves and the wider community of teachers and learners.

SH: Absolutely, and I think that we need to think beyond the coming fall. After the return to campus, we will be fashioning a new normal going forward. At MICA, the faculty, students, and staff have been very resourceful, really coping with this, as a collective crisis manifests its impact every day and so I think we have been learning and growing through struggling. I don't think there is a clear way out yet, so we have to be very mindful when we come back in the fall—how do we actually construct that caring-mentoring community as you describe? I also don't want to just think about this simply as a kind of remedial and healing process because that's reactive; it would be more interesting for us to think about new paths that we have to develop together and, as we're building them, learn in a proactive way how to recover. I would also say what you brought up before is very relevant—that is, finding ways to really bring into teaching, education, and pedagogy a kind of mutual support that is based on compassion, empathy, and curiosity, and use them as ways to anchor faculty and students in teaching and learning spaces that will be increasingly affected by mental health. Without mental health, we don't have true excellence in art and educational practice, so I think everything needs to be linked together to support and foster a higher level of and more holistic creativity and collaborative risk-taking, a more evolved kind of exchange.

I think it will be interesting, especially on the faculty side, to see what kinds of new endeavors might emerge. I would like to think that, moving forward, the notion of who is the expert in the classroom will evolve; the concept of a faculty defined as someone who has versus someone who has not will be deconstructed because the overvaluing of age-based authority disempowers the students, who are pigeonholed as nonexperts. The pandemic has made everyone feel isolated, and I think that faculty members have the opportunity to reposition themselves now to create a more communal setting in their classrooms so that, while they are the ones with life and practical experience, they communicate a caring for students more like in a family or an openness more like in a team or community; they can explore in the teaching and learning context that sense of wellness and care on a human and personal level versus the traditional and formal differentials of expert faculty and novice students. We need to be mindful that, for many faculty, shifting/moving from an expert role to an elder role is fundamentally very scary; it means that authority and power have to be given up and renegotiated. I think we can no longer uphold the idea of faculty as single-perspective authorities; by shifting into an elder position, one can be a kinder and gentler mentor, generating within the classroom a kind of coalescing between faculty and students that will allow students to recognize what they can bring to the table and generating a more experimental and playful classroom environment where learning and knowledge can really flow in much more natural and organic ways. This is a very long way to answer your question!

JB: Again, you raise a whole host of issues that we need to be thinking about. In fact, you are asking for a new kind of balancing between faculty and students, self–other, expert and nonexpert, and a much more thoughtful embrace of each other because, basically and to some extent, the pandemic has put everybody on almost the same kind of footing, the same play deck. And so, it gives us a chance to rethink things, to do a rebalancing. I am wondering if it is helpful as we move out of the pandemic and lock-down to think how things might move forward in phases, so to speak, so we don't let it all get away from us. That we also think of new beginnings, new ways of finding ourselves in each other in caring and compassionate relationships so there's a new kind of confidence in self and growth, in the relationships you're talking about. But it's not only the community of the classroom; it is also of the college

and of the city and acknowledging the community with the world; this brings with it a sense of projecting forward, of growth, of moving into the future, and one of the things that I am wondering about is how to make sure that we ground things, we settle things, we route things into our internal beings as it were, and we try to create a stable basis for the future. We need to try to make something of a plan for moving forward into what it is now an uncertain future. Actually we've got both an uncertain present and an uncertain future; so how do you see the future as mentorship, in terms of the professional education of the artist-designer—the traditional mentor usually means to guide somebody through into a profession but actually, the sheer notion of a profession has just kind of exploded at the moment, so what are the challenges?

SH: Yes, I think there's great uncertainty, but I also think there is a kind of North Star to humanity and to education that provides a clarity and direction for us to navigate through these uncertainties. For me, the North Star to education is to maximize human potential for individual development and common good; no matter what age we are in, that is a constant for me, that's very hard to argue against. If we apply that ideal and principle to today's societal needs for humankind's sustainability, for humanity as a kind of collective, and for our navigation through the current reckonings with all their ugliness and hopefulness and complexity—therefore, our extremely confusing present—it means we have to emerge with a kinder, more humane, more complex, and more diverse society that allows everyone to exercise their value and live with dignity, based on their authentic selves, their expertise and individual identities. We have to move away from the kind of single-perspective authoritarian power positioning and structures we have now. With that North Star in sight and in mind, we can understand the directions through the murky waters around us presently, and we can see the value of the kind of mentorship and pedagogy that you and I are discussing and exploring. Why would we not want to evolve mentorship and pedagogy based on the needs of our peoples, our times, and our society? I think there is both confusion and clarity regarding what we need to do.

JB: Yes, for the longest time, pedagogy has devolved most often on the notion of skills, the idea of skills being interpreted as formal skills, skills we've inherited from the past. Without underestimating the importance of formal skills, it seems to me that these have to be radically rethought in light of the

new knowledge, practices, and ways of thinking that have evolved over the recent past. As caring mentors, we also have to rethink the nature of what skills are and the divergence of possible interpretations they now hold. We need to consider the application, and flexible application, of skills to a whole diversity of professional outcomes; but this also means we need to mentor faculty and think about the kinds of help we can offer them, both those already in the profession and those just coming into the profession. What should we be doing to help new teachers to do very new kinds of pedagogical and mentoring work?

SH: Yes, again, a wonderful question. I would say that in the design field, perhaps more than in fine art studios, we're realizing that formal skill-based practices are not enough and that we actually need designers who have human-centered perspectives, who understand design and its impact in a much more organic way and not just focused on a narrow definition of design excellence; this is transforming the field. I think other arts fields are learning from that evolution and especially in teaching. I think we are now more aware of our responsibility to nurture and educate as we empower and unleash talent; it's not so much that young people come to us as a blank slate, for us to imprint expertise upon them, but we need to help them recognize their own powers. Our faculty are actively inventing new ways of supporting and educating students, and we are seeing this in action every single day; it's very exciting. Oftentimes the most powerful teaching is from faculty to faculty, peer to peer, and we are exploring how to break down the siloed barriers of communication in terms of pedagogy. I think we are still struggling with that a bit, to be honest, in terms of conducting dialogues so that students can provide the feedback to the faculty, telling them what they actually need, and have the faculty comfortable enough to welcome that kind of conversation; it's a kind of educational democracy. When we look at pedagogy and mentorship, I think we all believe in free dialogue, but our system over several hundred years has actually set up very strong barriers, conceptual and practical barriers, that we don't even see anymore. The pandemic is a great opportunity for us to, as you say, level up; I think a lot of systems are being leveled down, too, and that's some of the pain we're going through right now, but out of this we can achieve constructive outcomes. We can gain clarity to say that these are the new rules, which empower faculty to explore pedagogical practices of today and students and faculty to level their dialogue spaces in

order to recognize new forms and exchange of experiences and expertise.

JB: Thank you, Sammy, that was wonderful. I think in my work with students I always recognize that young people entering college bring with them extraordinary experiences, and often richly developed expertise. But sometimes we as educators do not always recognize those experiences; we think that, if we can teach skills formally apart from those experiences, then these skills will get applied to real-world events, but I think the opposite is true. I absolutely think that we need to rethink skills in the context of the diverse and complex experiences young people bring with them so those experiences can become present as a kind of reflection on self-in-the-world and how the self relates to the rest of the world, and this brings us back to the idea of community. That is what you've been focusing on which I think, if anything, this pandemic has accelerated the importance of community in almost everything we do, especially as teachers and mentors, and makes us think of how we find self-in-community as professional artists.

SH: Also, we often address skills in the abstract, but skills cannot be separated these days from their embeddedness in cultural awareness and expertise, in diversity, equity, and inclusion. The students are bringing their backgrounds into the classroom, and there's not one single human being—whether you or I or any individual professor—who can encompass for our students everything of today's complex and diverse world. So I think, on that level and in wonderful ways, artists and art school pedagogy are creating new kinds of open space consisting of complexities and ambiguities that, Judy, you have often talked about that weave things together in new ways.

JB: Yes, Sammy, that raises the next question, which we don't have time for today, but for another conversation perhaps! That is, how we embed art more deeply into the sociocultural world in a way such that its roots are planted in the very fabric of who we are and what we do. Sammy, I promised Richard that I would obey our time because, as you stated earlier, we could go on talking forever and ever. So, Sammy, thank you for your wisdom and your thoughtful and wonderful responses; this has been a lovely start to our day, and I hope it's offered some ideas for folk to take forward and play with. All I can say is, more to come, and thank you! Sammy, do you have some parting words that you want to leave us with?

SH: As I said, this is a very inventive time. To all of you in the audience, I cannot see you, but you are the inventors. I would just say if you have been stimulated by what Judy and I say, please bring on your game and create that new future for us. Thank you.

JB: And as everybody knows, I always end my courses at TC by charging students to go out and make magic in the world. This time I would like to charge everyone to go out and make new kinds of magic to help heal this hurting world, and this new magic carries with it the charge to care for each other and help mentor this into being. Using the arts as important ways in which we can care about each other, give voice to all of us, so we can speak to those things through the arts that we can't speak of in any other language, and so I think if we can mentor people through to that, then we've done well, Sammy.

SH: Thank you for this great charge.

Among the many things that have been displaced or brought into question by the experience of the pandemic is the very idea of the "studio" in "*studio*-based art education." The forced remoteness of teaching and learning that took place during this period gave us a clear window into the detailed practices of materiality, embodiment, and physical gathering that shape the assumptive foundations of studio-based learning environments. Pieces of the studio were hived off and moved into domestic spaces, and pieces of domestic spaces became part of the studio construct. New and portable practices emerged, as working across different time zones and geographical locations became a persistent part of everyday life. The pandemic greatly accelerated global processes already in play for making visible on a massive scale the institutional boundary conditions and associated power relations of conventional art education. In my view, we are living in the early aftermath of this collective shock . . . a time that is, in equal measure, full of shared possibility and shared anxiety for the future.

—David Bogen

I think learning extends beyond the systems offered and is best when one finds what ignites their interests/passion and learns for themselves while building a supportive environment/community. When there's a teacher–student dynamic associated with an outcome of grades, it creates a hierarchy and pressure to perform for results based on educator and/or institution's standard. It teaches one to appease outward approval, whereas I believe learning should focus on fostering how one thinks for themselves and their inward growth, values, confidence, and providing tools in creating their experiences. How does one measure value or success, and how do educational settings create environments to uphold and/or undo these systems and ideas? I think one of the roles of the educator is to provide spaces for questions and dialogue. I believe one has to find questions and experiment, invent and build their ideas and find ways to express them.

—Gi (Ginny) Huo

If truit learning extends beyond the
systems offered and is best when one
finds what raises their interest/questions
and learns for themselves within a nurturing
... community.
When there is a teacher-student dynamic
associated with an outcome or grades,
it creates a hierarchy and pressure to
perform for results based on educators
and/or institutions ... teacher one
to appease or ... whereas I
believe learning ... on fostering
how one thinks ... s and
their inward ... confidence,
and providing ... their
experiences. How ... treasure
value or appease ... and how do educational
settings create environments to uphold
and/or undo these systems and ideas? I
think one of the roles of the educator is to
provide space for questions and dialogue.
I believe one has to turn questions and
experiment, unlearn and build their ideas
and find ways to express them.

Part II: Road Maps for the Future

Introduction

RICHARD JOCHUM
JASON WATSON

Part I of this volume gathers a broad variety of experiences teaching studio art during the first years of the COVID-19 health emergency. Taken together, they suggest four themes that address the dilemmas of teaching and learning during the pandemic and suggest a platform for reconsidering the foundational assumptions of art education as a discipline:

- *Relationships.* Teaching during the pandemic upended and hyper-personalized the traditional roles and relationship structures of studio pedagogy. Ongoing social distancing forced us to think differently about means of support and student needs. Mentorship surfaced as the primary model for teacher/student engagement in many writers' pedagogical practices.
- *Spaces.* The pandemic radically decentered institutional space. The necessity of distance learning required modifying homes to accommodate a wide variety of studio art fabrication and critique that had formerly lived in art classrooms and university studios. In this way, many writers' experiences blurred the boundaries between personal, domestic space and collective, institutional space, opening up important dialogues on equity and accessibility within expanding modes of studio art instruction.
- *Media and Materials.* Several writers address how disrupted access to studio art media and materials has laid the groundwork for a new organizational structure for studio art education that requires no particular materials or equipment but instead prioritizes engagement and social justice concerns.
- *Digital Transformation.* An overall sense of digital transformation pervades this writing, experienced first as a necessity to weather the enforced isolation of the early pandemic, then later explored as a viable alternative to the standard ways in which we produce, consume, critique, and share the products of an increasingly complex and decentralized visual culture.

Part II presents these emergent themes to experts in the field and asks how they might use them as a springboard for imagining the future of art education. When we first contacted these artists and writers, we did not task them with formulating distinct solutions for the myriad social and political challenges raised during, or exacerbated

by, the first years of the COVID-19 pandemic. Instead, we asked them to simply sit with these issues and think forward, exploring multiple avenues of inquiry. They responded with essays addressing central questions in art education through various and often overlapping lenses: origins (the history of pedagogy before the pandemic), lived experience (coping through and reevaluation of pedagogy during the pandemic), and projections (how we might move forward, developing pedagogies of change).

The serendipitous dialogue across the two parts of this book expands the conversation beyond individual experiences of pandemic era teaching and learning, shifting the focus from *reflection* on what was, to *projection* into what might be.

In his essay "Teaching Beyond the Art Studio," Ernesto Pujol delivers a critique of the art education system in higher education, specifically MFA programs and their promise of professionalization. Pujol reveals how community-based arts practices are often an odd fit for an academic system that prizes measurable, repeatable deliverables and marketability. Like Bill Gaskins, he notes a significant gap between what art programs promise and what they deliver.

Although Pujol does not mention "carceral aesthetics" directly, like Gaskins he stresses the need for MFA programs to abandon elitist systems of production in favor of a more humanistic, even spiritual approach that prioritizes deep social connection over rarified processes that lead to expensive cultural products.

Pujol, Gaskins, and several others in this collection discuss the hegemony of student and faculty populations in art schools, insisting on opening the franchise to embrace more Black and minority artists and students. These questions of gatekeeping around studio art in higher education echo the concerns of Neil Daigle Orians when he asks us to consider who is "given permission to be an arts student." All these writers look to larger societal structures of race, class, and ethnicity that shape these gatekeeping tendencies, citing capitalist principles of economic oppression as their foundation. In her essay "Material Matters, Material Lives (Words of the Not-Yet, Right-Now)," Kaitlin Pomerantz expands this critique of art school practices, shifting the focus to connections between economic instability, impending ecological devastation, and an overall need for sustainability in studio art teaching and learning. Several writers from Part I offer accounts of personal experience that support the need for precisely the reevaluation of the status quo that Pomerantz suggests, including Linnea Poole and Carlos Arturo González-Barrios.

The focus on relationship-building, a common theme in Part I, is taken up again by Seph Rodney, who gives depth and resonance to the state of contemporary mentorship. Rodney illustrates the emerging

hyper-personal tendency in contemporary mentoring by narrating the specific approaches he takes with graduate-level critique, tailored to the specific needs of individual students. And while Jun Gao urges us to see beyond the painting studio as we know it, considering virtual reality as a promise yet unmet, Tracie Costantino and Kimberly Sheridan provide concrete suggestions on how to expand the studio classroom into community spaces and study abroad programs, pushing beyond the constraints of traditional studio habits and cultures.

Mick Wilson took our invitation to imagine road maps for the future of art education most directly by offering a philosophical outlook to guide the discipline forward in the face of continuous, and continuously disruptive, change. Like many other writers in this collection, Wilson envisions a future for art education deeply rooted in social justice principles, grounded in a bold new understanding of the social imagination. And finally, Steven Henry Madoff's text expands on the digital transformation that permeates all our contributor's reflections and projections by suggesting an ongoing collaboration between artistic practice and artificial intelligence.

Chapter 5: Teaching Beyond the Art Studio

ERNESTO PUJOL

Contemporary art instruction should be simultaneously global and site-specific. Teaching art in New York City is not the same as teaching art in San Juan or Kiev. Because different visible and invisible forces frame and inform it in terms of empire versus decolonization, dictatorship versus human rights, religious fanaticism versus secularism. This *site-specific globalism* signals the increasing pedagogical importance of teaching social practice. I believe we must urgently consider placing social practice as the new core of all art training, undoing graduate art instruction as a studio-cloistered methodology that is physically, intellectually, and emotionally distant from autocratic threats to democracy and climate crisis.

Art studios are increasingly obsolete as the architecture of art training. No matter the postcolonial theory and ecological thought increasingly informing our MFA seminars, whiteness and isolationism are still exalted nonverbally through these still-intact material containers of art education. We should finally break from the encoded ethnocentrism and physical alienation of these white boxes and educate our art students everywhere but inside them. We need a diversity of new hybrid spaces in the field, experimentally and generously shared with farmers, ecologists, animal and human rights advocates, and all manner of healers, where all processes and outcomes, regardless of whether they are recognized as art or not, contribute to a culture of consciousness.

Social Practice as the Core of Art Training

Most American graduate art training is stuck in a 1990s pedagogical template that would be humorously pathetic if it were not dangerously nostalgic, considering the potentially violent future that awaits humanity. American graduate art training self-complacently plugs along, pretending it can teach social practice as yet another passing medium of the moment. Social practice is approached as a studio product that can be fabricated quickly and pinned to a gallery wall for hyper-theoretical, cynical group critiques; for bureaucratic, micromanaged, mid-term evaluations; or for competitive, pompous final evaluations within our shake 'n bake, 2-year MFA program factories. Too many

MFA degrees within this system are not truly awarded based on talent and skill but on credit score and student loan size (if you can pay for it, you get it), feeding tuition-driven programs whose income mostly benefits expanding, academic real estate campaigns, and ballooning academic bureaucracies, while adjunct instructors, who make up the majority of our teaching faculties, remain underpaid. It does not help this perverse situation that art schools tend to be the step-children of universities, even Ivy League ones.

Social practice projects require long-term, deeply sited presence, the unhurried, uninterrupted act of inhabiting to undo haunting histories of long-distance, unethical extraction from imperial centers. Yet American graduate art programs are still pretending to teach social practice while holding on to rigid art-studio assignations as a form of house arrest, with fast conveyor-belt art product requirements, inevitably approaching communities as surface, their members as material, their feelings and emotions as residue. These art mining programs remain clueless about the ethically complex relationships required between artists and formerly invaded, colonized, and exploited communities. Most art schools in America are still lily-white institutions, so MFA students often have to start by slowly undoing the bad reputation of their academic sponsors among communities. Yet art schools act as if these delicate, subtle interactions were something that graduate art students should be able to generate within weeks, subject to hurried, extractive academic calendars rather than the psychic calendars of patient trust-building and emotive generosity.

How can American graduate art programs begin to require generosity of field practice when the cult of artistic individualism is still triumphant; when competitiveness between art students is still unabashedly encouraged, not to mention competitiveness between a program's faculty, now rushing to add their acquaintance with community gatekeepers and stakeholders to their name-dropping during faculty meetings, adding forays into "community projects" in-between biennials, art fairs, museum, and commercial gallery shows? The addition of social practice projects into CVs is suddenly de rigueur among those who wish to be considered cutting-edge for the sake of cutting tenure.

Most American graduate art programs should be ashamed of themselves at this point in time. They are hyper-theoretically based, producing textbook art by institutionalized artists operating mistakenly under the illusion of poetic license, as the *cult of creative failure* continues unabated within their cloisters of art-speak. Young artists are allowed to fail communities as long as they are theoretically sincere. It's as if they were still working on studio-based paintings that can ultimately be dismissed if underworked or trashed if overworked; as if it were acceptable not to achieve a community's accurate, holistic

portrayal through deeply assessed needs, healing relationships, and successful gestures. In my experience, the successful rendering of accurate collective portraiture is *cathartic* and thus *healing* to those who participate and witness it. There is no room for failure in this *deep education*, in this profound pedagogy.

How do we redesign American graduate art programs so that they stop being so conservatively Marxist, so that they start addressing the human spirit? From the point of view of the humanities, the human spirit is not about religion, even as comparative religious studies should be a required course among sign and symbol encoders, among metaphor-makers. Neither is the human spirit about "spirituality." The human spirit is code for that which makes the human animal try to transcend weakness, fragility, infirmity, loss, and mortality of the body, the end of the so-called self. This has made humans strive to transcend illness and even death in countless creative ways, including a diversity of mythologies about human immortality. Humanity is a myth-making machine.

Unfortunately, our notion of artistic modernity is still based on a dated, anxious secularism that should stop being the sole curator of art training. I understand that religious fanaticism makes the art world feel like a space under siege, keeping it a furiously secular environment that angrily considers all things "spiritual" as suspect, anti-intellectual, and dare I say "primitive." Religious fanaticism can trigger terrorism, not to mention promoting the oppression of women and queers. I understand a fragile early modernism constructing itself as a religious-free zone. But by now we should have evolved pedagogically beyond that early modernist fearful stage because it has become a blinding prejudice that fosters a preaching-to-the-choir, self-complacent bubble, and thus a limited art training for our students, who need to face global realities with more than only a secular elite's dated modern tools.

I never trusted those twentieth-century art school studios where I studied and later taught, those seemingly generic physical environments whose walls and ceilings were thickly painted white, white upon white, year after year, creating a thick white, milky film that drowned out everything not white; that felt like the enlightened skin that contemporary art was ultimately supposed to have, because materiality conveys messages. Even as a student, long before I studied art theory, my body felt that my body felt that the pretension to create a nowhere-is-everywhere art studio space was deeply contaminated with White supremacy. Because there is no such thing as a generic space. All space is cultural. Whiteness is not a value. Whiteness is a color of many shades. All space is encoded with agendas, either seeking to empower or disempower its inhabitants. White cubes are culturally whitening of their young and vulnerable inhabitants.

I have experienced graduate art students from so-called developing countries who, upon receiving art studios in American graduate art programs, looked at me as if they had just been handed torture chambers. What were they supposed to do with them? More often than not, they were young artists who were natural social practitioners, suddenly made to feel inadequate and compromised, because they now had to fill art studios overnight with art inventories in order to satisfy art teachers and not endanger art scholarships. Some surrendered and created skin-deep installations of translated documentation to appease the system. Others fought back, were bruised and even deeply wounded, feeling completely unappreciated and unfairly criticized for not complying like the rest of the students in the program. They suffered, and I suffered watching them struggle, as my own critical voice was dismissed by entrenched administrators without a vision of the future.

In considering the future for American graduate art programs, we must dismantle *studio art nostalgia* because it evidences a crisis of the imagination, a bankruptcy of the imagination that has turned American art education into a dead-end street that keeps repeating itself, as is the case with all end-of-empire cultural cycles, when the formerly dominant culture is depleted of creativity and develops a nostalgia for its former culturally glorious days. Unless we exit the nostalgic art studio, so that there is field testing during a graduate program, even the trendiest art theory seminar will only serve to fan this playing with fire.

There is nothing more dangerous than untested theoretical discourse. Theoretical instruction must go hand in hand with a supervised, early field practice. Otherwise, it is nothing more than an act of liberal self-gratification that may perform unethically when later tested alone in the field. The two-year calendar of MFA programs may need to be expanded into three, with an accompanying revision to tuition costs, to balance the longer time requirement. Two-year graduate art programs are nothing but the result of streamlining art instruction within university settings in order to fit their general academic landscape so that all careers proceed within the same chronology. But only requiring two years of graduate art training has always been unrealistic, now exposed as even more inadequate by what the future is going to require of the next generations of artists, conceptual or not.

There was a time when art programs seeking to update themselves took on conceptualism as their core, thinking it was the art practice of the future, believing that even art students without any talent or skill could be made into successful conceptual artists because art was going to be about collectible ideas manufactured for artists by artisanal labor. But that notion of the artist as a capitalist producer

is increasingly bankrupt as it was based on an industrial model and notions of abundance no longer sustainable.

I believe in slowing art education. I encourage slowly transformative, educational experiences deep in the field, as a series of immersive workshops which, over generous and thus unhurried blocks of time, amount to a more meaning-full education that can sensitively support the making of a sustainable culture of consciousness. But in order to achieve this, all graduate art programs must end their structurally cubical insularism, competitive dynamics, and show-driven speedways to graduation. They must restructure themselves from the point of view of a global future based on natural depletion, widespread political extremism leading to wars over our remaining natural resources, human impoverishment, Machiavellian genocide, and *renaissance*. Yes, renaissance.

I recently spent 2 years working in the U.S. territory of Puerto Rico, which was declared economically bankrupt in 2007 and destroyed by a category 5 hurricane in 2017. Since then, hundreds of thousands of Puerto Ricans have left for the U.S. mainland, seeking jobs. Although the island officially exited bankruptcy in 2022, it remains plagued by corruption. Forces at play are neither allowing it to become a new state of the Union nor achieve freedom as a new republic. Forces at play are trying to turn it into a new tax haven. And yet, the island is experiencing a renaissance: the heroic birth of organic farms led by creative millennial farmers, unaided by their government; the daring flowering of community cultural centers, unassisted by politicians; the brave fruiting of social practice projects, independent of art schools.

Art schools need to come out of their campuses to inhabit economically depressed communities of all colors across Democratic and Republican America. Art schools need to establish partnerships with grassroot organizations, and the foundations that support them, to create offices, classrooms, craft, and project spaces in boarded-up houses and shops, diners, and gas stations; in empty lots, weedy parks, and malls. American graduate art programs need to embrace this "internal globalism" in their back yard, in the embarrassing continental provinces of their waning empire. Before sending their art students overseas, they should send them deep into the American South, the vast Midwest, and the far West.

Embodying Field-Teaching Strategies

Several years ago, I led a week-long summer workshop for over a dozen artists during which I invited them to come prepared to work outdoors as a group, but in complete silence. I convened the group early one morning in a New England field and asked them to literally deconstruct a nearby stone wall, in silence. Just to be clear, it was an ordinary wall,

the kind that criss-crosses the northern American landscape, supposedly made by farming families and farmhands, by men, women, children, seniors, and slaves as they cleared their fields for plowing. Naturally, most laid the stones along their properties' boundaries, performing the double duty of both clearing the fields for cultivation and demarcating their so-called land, taken from Native Americans.

I asked the artists to silently form a line parallel to the wall, facing it. Then, as they felt physically motivated to engage, to approach the wall slowly, select a stone, bend carefully, pick it up gently, study it visually, consider its shape, feel its weight, its smoothness or roughness, nurse it in their hands or arms, take a deep breath, turn around 180 degrees, and then carry it slowly, 30 steps over, to thoughtfully deposit it down, at first on the ground and, over time, on top of a growing pile. No matter if that person was strong enough to pick up two stones, or many stones, the instruction was to only pick up one stone at a time, whether a boulder or a pebble. The first part of their artistic task was to mindfully dismantle an old wall of no apparent importance, an ordinary wall, undesignated as a historic site of human significance, a dismissible roadside construction of anonymous authorship, and then to reassemble it, unhurried, reconstructing it as a parallel line, approximately 30 feet away. I explained nothing more than that.

I participated in the exercise, just like everyone else, as yet another silent worker in the field. We spent the next 4 hours doing this, over a dozen people working silently side by side, increasingly smelling and listening to each other, as the work inevitably made our bodies sweat and sigh audibly. There was absolutely no conversation. And there was no competitiveness. It was not a stone hauling competition. So, there was no stress. There was no price for whoever carried the heaviest or the most stones. There was no award for whoever rebuilt the wall the fastest, or the prettiest. Our notorious American cult of speed was wonderfully absent. Speed would have sabotaged our effort at deep presence.

Over the hours, as the sun rose in the sky, our labor became increasingly hard even though it was not meant to be a performative rite of endurance. Indeed, without calling for it, participants began to help each other spontaneously as they noticed, out of the corner of their focused eyes, that someone was struggling with the weight of a particularly heavy stone. There was an amazing display of spontaneous generosity coupled with admirable patience. And trust. There was no human audience other than the stone workers. They were both the participants and the audience. They worked and watched each other work with wonder. They moved the wall slowly, from one place to another. And then they stopped. I rang an old-fashioned school bell and everyone sat on the grass and ate lunch. In silence. We contemplated what we had done, together. And it was beautiful. And

Figure 5.1. Documentation of a Participatory Workshop by Ernesto Pujol.

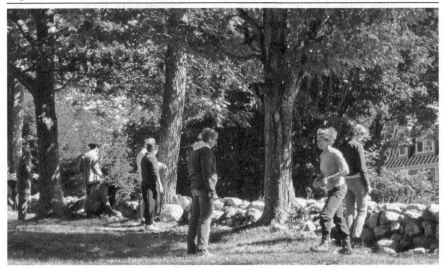

Ernesto Pujol

it was remarkable. And then everyone got up, a bit tired and sore, to stretch and walk around the new wall.

After a reasonable amount of rest time, I spoke and gave instruction for the second part of the making workshop. I invited everyone to please put the wall back, in silence, one large stone and one tiny pebble at a time. We spent the next four hours moving all the stones back to where we found them, rebuilding the old wall again. We repeated the same ritual but backward, as it were. And then, when we were eventually done, without hurry, always unhurried, we paused again, and contemplated it. We did not merely glance, gaze, or look at it. We contemplated it. The group experienced the act of truly, fully contemplating an object outside the realm of mere academic research, of detached intellectual consideration. Because by then, it was no longer just another old wall dotting the New England landscape, ordinary and meaningless to our contemporary lives. Not only had we undone and redone it, materially understanding it from within our bodies. But it was also now a symbol of our unity as a new community, quietly bonded and born that morning. And finally, it was a new memory, but one defined by fairly pure love.

The new old wall looked, deceptively, just as it had looked that morning, before we moved it. Carefully. But it was no longer the same wall. Not to our perception. Not to our fresh experience and new knowledge. Perhaps it looked slightly cleaner, because the stones had lost some of their debris when we moved them. The wall was there, once again, in its "original" place, simply there in its thisness, as it had

been for one hundred or more years. It had had authors, twice. But once again, it had no authors to passersby. Once again, there was no record of who had once created, and recently re-created it. It was as silent as we were silent. But in its silence, it had educated us, profoundly. I still remember that workshop with love.

I have wanted to teach that stone workshop again but have not been able to. Few institutions give their instructors the opportunity to teach without requiring their students to quickly produce a tangible product, trusting them to manifest learning experiences in which something is not only talked about but *experienced*, in an unhurried way, in an empathic way, resulting in contemplation, resulting in a wise lesson that does not have to wait for a future outside of art school; so that information can become experience and result in knowledge if not wisdom within the educational process. And during that meaningful, perhaps memorable experience, not to perform as a group of fiercely competitive if not toxic professionals, but to serve as a humble community bonded through generous and ultimately transformative making.

I have never understood the point of making art if we lose our humanity in the process. The art world used to love monstrous talents. But the extinction of such monsters is the one extinction I have welcomed during the past few years. And nothing unmasks and dismantles a monster like the reality check of society. I do not expect all graduate art programs to take on stone-moving workshops as a sort of foolproof template for the future, but I do invite them to consider where they are, the history of the people and place that surround them. I invite them to become site-specific programs, understanding that, in doing so, they will begin to discover the curriculum they need to implement there. The *curriculum of place*. Of that place. The curriculum of deep presence. For it is already there, all around them, like the Buddhist notion of enlightenment, already present in the public body, if only one disrobes of institutional habit and walks naked out of the studio.

The more site-specific graduate art programs become, addressing their hamlets, villages, towns, cities, and regions, the more global they shall be. Because true globalism is nothing but a network of diverse human intimacies that, while recognizing their unique specificities, also recognize remarkable similarities within our common human condition. Like a Zen Buddhist koan, we are as similar as we are diverse.

Envisioning Our Austere Future

After teaching for a quarter century across the United States, I remain genuinely grateful for every invitation I receive to this day, for still being remembered. Yet I find it almost impossible to accept any more

invites from standardized MFA programs, particularly if they consist of climbing and walking through floors upon floors of white-cube studios; if those programs are still unconsciously trapped in the 1990s, late modernist template. When younger, I used to think that I made a difference, and perhaps I did for individual students, particularly for queers, those of color, and from abroad. Nowadays, I feel that the system often used me to appear cutting-edge, because little to nothing changed. I was inadvertently enabling the status quo by being part of a roster of visitors or adjuncts who gave oxygen to a dying body and allowed it to live a little longer. Between 1997 and 2017, I helped to open the doors for the hiring of more instructors of color, queers, and artists from abroad. But on hindsight, I have realized that achieving diversity of faculty is not enough because, as those new hires sought tenure, they were pressured to conform, irrespective of their color, persuasion, or provenance, just like the students.

Envisioning the future, in addition to the need for diversifying the profile of art school instructors, administrators need to back their instructors to lead their students beyond art studio curriculums into factories, corporate lobbies and offices, clinics, hospitals, laboratories, pharmaceuticals, hotels, motels, nursing homes, rehab clinics, welfare centers, public schools, schools for the deaf, the visually impaired, orphanages, shopping malls, strip malls, restaurants, diners, gas stations, storefronts, parking lots, canals, beaches, docks, airports, forests, farms, barns, parks, and gardens. We must all use our ecological, social, political, industrial, and post-industrial pedagogical imagination.

But let me be clear, because in the past art schools have taken over spaces in places like that, only to turn them into cold clusters of crappy white studios and galleries through institutional habit. The point of inhabiting those places now is to approach them in nonextractive ways, not searching for materials and space but seeking collaborative cross-fertilization; ethically approaching them as respected sites where there is no anxiety to make art, but veritable concern about responding to our collective, future crisis in creative, multidisciplinary ways. Seeking the kind of places that can engage budding artists in the creation of community water filtration systems, alternative sources of renewable energy, beautiful organic kitchen gardens and soup kitchens for the homeless, recycled clothing and household goods initiatives to upcycle and exchange, challenging conversations about ethical economies of service, participatory systems of shared authority, and countless others, potentially informed by art; utilitarian projects that can help communities consume less and consume better while reconnecting to Nature and becoming resilient and sustainable. This is the twenty-first century education that our graduate art students need, transformative

of their making beyond the studio and thus unforgettable, where selflessly making art with others and for others, or generously informing non–art-making projects with artistic notions, is about the performance of love.

Thinking back on art history, I often think that the notion of making "art for art's sake" was not the pinnacle of civilization but its decrepitude, a fallacy that marked the beginning of the cultural decadence of the American 20th century. In terms of mindfulness, art was never the destination, the point of making. Art was always but a cultural channel, a complex conduit for achieving individual and collective consciousness. Yet while seeking consciousness in America, we experience a pedagogical problem in the classroom, in terms of being culturally framed by the ongoing American mythology of abundance, now going green but no less mythically plentiful. So, when I speak of teaching art making as an act of generosity, it is not from the American notion of material plenty, of a bottomless cornucopia which we somehow own at everyone else's expense, but of generosity of the human spirit.

Teaching social practice in America, whether imprisoned inside a white-cube studio or finally set free in the field, is still educationally challenging because the American belief in entitlement to abundance contaminates its liberal notion of social justice. American social practice suffers from this because of the implicit, misguided Marxist belief among young artists that pursuing and achieving social justice still means, strictly speaking, the redistribution of material wealth. But what if there is no material wealth anymore, or soon to be little to none? What if there is no "greatest nation on Earth" anymore; what if we are witnessing the end of that nationalistic triumphalism because America has squandered whatever wealth it appropriated and produced during the last two hundred years? Because America is now living a debtor's fantasy, pursuing bespoke lifestyles on the back of the otherized here and abroad; fighting wars paid by its debt holders to protect their investment, which banks precisely on its bespoke status. And American graduate art education is complicit, structurally riding that very same time bomb of a credit industry, while self-complacently passing untested, liberal ideas, keeping their students chained inside the Platonic cave of the cubicle.

Teaching art in America during the first decades of the 21st century should be a humble and humbling exercise because it is the practice of facing the bitter, dragged-out end of a modern empire that colonized everything and everyone to material and psychological depletion. It is a practice engaging the visible and the invisible, among material and psychic ruins, where we face what little is left and try to heal and share it ethically. American graduate art programs should be

training their students for *austere practices*, training young artists for a diversity of futures, but all of them austere.

The artist studio internships of the future need to be everywhere but in yet-another museum, no matter its diverse programming, not in yet-another gallery, no matter its edgy liberalism. Because, if after more than a decade of paying lip service to cross-disciplinary, interdisciplinary, intradisciplinary, multidisciplinary, and transdisciplinary art education, if all that graduate art programs still come up with is "a work of art" hanging "perfectly" on an impeccable white wall, inside a sterile white gallery, inside an all-white top-administrators' art school, then these programs deserve to shrink and eventually go extinct. Because a cross-disciplinary, interdisciplinary, intradisciplinary, multidisciplinary, and transdisciplinary art education cannot continue to look, smell, taste, sound, and feel like the old studio-based art education we should have left behind years ago.

Upon rereading this text, I realize that I can be repetitive. But when one studies pedagogical theory, one learns that educating consists in the generous and patient repetition of a message, presented in different ways, until one such utterance is finally recorded in the listener. Of course, unheeded teachers can become impatient and thus over-repetitive over time, even as this does not help the presentation of their messages. I would like to think that I practice a *methodology of vulnerability*, through which I think out loud with my reader. This is a barefoot practice. While we need to speak strongly in seeking to provide a stronger education, we also need a widespread psychic disarmament in vulnerably approaching this pedagogical moment.

I have become a sort of pedagogical deep-sea diver who only surfaces when someone invites me to speak or write something for what hopes to be a prophetic event or publication. I remain optimistic enough to keep risking being thought of as the village fool, taking book project directors at their word, and thus submitting frank texts, even as I fear an eventual editing that will demand that I explain, justify, translate, and cut. Because some of us will always deliver more than they bargained for, often in the form of "throwing down the gauntlet," as a colleague once said to me. Yet simply put, when I am invited to share my vision of things, I take people at their word and do it. Seriously. As asked. And all the more so now, because I am currently under the impression that pandemics and wars, that the current state of world affairs, is making some art instructors and art students restless, impatient with the status quo, which keeps talking about change but remains unchanged. So, this text is for them. Because the future belongs to our young faculty and students.

Nevertheless, I am not a cook; I am not going to pretend to write a recipe to get out of this pedagogical kitchen pit. As I wrote earlier

in this text, art schools have more administrative staff than ever: deans, assistant deans, chairs, co-chairs, assistant chairs, directors, co-directors, assistant directors, coordinators, co-coordinators, assistant coordinators, and secretaries. All are better paid than their mostly adjunct faculties, who are kept on hand-to-mouth salaries and insecure yearly contracts. So, art schools seeking renewal need to start by cleaning house, by reducing their top-heavy administrations and dense bureaucracies, followed by a reconsideration of their longest serving faculty reevaluated in terms of their social, political, cultural, and ecological active roles in healing and rebuilding the local, regional, and global; followed by reviewing their roster of visiting artists, avoiding superfluous celebrities-of-the-moment, instead seeking cultural prophets of the inhospitable future that may await.

It is psychically exhausting (and professionally thankless) to sustain the voice that cries wolf, particularly when I welcome the wolf because I do not want to be part of an MFA machinery that keeps producing sheep that think they are foxes, bleating along student loan-debt paths to rude awakenings. As a multicultural wars veteran and as a social practice elder, I believe that there needs to be an art-pedagogical revolution across American graduate art programs once and for all. May you start it. Today.

Chapter 6: Intercultural Education and Expanded Notions of the Studio

TRACIE COSTANTINO

One of my most rewarding teaching experiences was at the University of Georgia's (UGA) study abroad program in Cortona, Italy. Through a partnership developed by my colleague, I prepared and supervised a cohort of preservice elementary and middle school art teachers to develop and teach a thematic, arts-integrated curricular unit in the local elementary and middle schools. The Cortonese students and teachers spoke little to no English, and likewise were my students' skills in Italian; hence they needed to develop ways to communicate, including various nonverbal strategies, while providing a substantive and meaningful arts education experience. While teaching English vocabulary and art-making skills and concepts were central objectives (English language development was particularly important at the middle school where we focused on art criticism), the intercultural understanding that developed between the Italian students and my preservice teachers was a significant mutual learning outcome, one that many of my students would cite as critical preparation for the diverse classrooms they would teach in as certified teachers in the United States (Henry & Costantino, 2015).

Several years later, I had the honor of accompanying artist and faculty member Shirley Tse (teaching at California Institute of the Arts [CalArts]) and MFA students from her class Artist as Traveler, to the Venice Biennale where Shirley was representing Hong Kong (the first woman to do so). Like several of the UGA students traveling to Cortona, a number of these students had never been outside of the United States. As a transnational artist, Shirley developed this course because she understood the significance of encountering new people and cultures in the development of an artist. Indeed, there is a long tradition of travel as integral to an artist's education and livelihood, as artists have journeyed long distances for commissions for hundreds of years.

We spent extended time in the Biennale including visiting the pavilions throughout the city, and the students were assigned independent artistic research on designated research days. I organized a trip to the Accademia because I thought it was important for the art

students to be exposed to the art histories that have shaped the city they were visiting, a city that has been a nexus of cultural exchange and international trade for centuries. I admit that I was worried the students may be somewhat disengaged and find the art too far removed from their contemporary experience; instead, I was rather unprepared for the fascination many of the students exhibited as I tried to summon my art historical knowledge from graduate school in response to their many questions about the works on view.

I focused on helping them read the images by sharing specific iconographic references and explained that the same skills they would use in visually analyzing a work of contemporary art could be applied here, emphasizing that the cultural context is critically important to the meaning of the work. Jeanette Winterson, writing in *Art Objects*, describes a similar experience while traveling in Amsterdam and encountering a painting, "that had more power to stop me than I had power to walk on. The quality of the draughtsmanship, the brush strokes in thin oils, had a Renaissance beauty, but the fearful and compelling thing about the picture was its modernity" (Winterson, 1996, p. 3). The students brought this experience of the Accademia into their approach to Venice as a site of research, and many of them interrogated contemporary Venice and its environmental challenges, ultimately titling the exhibition that would culminate the class *Acqua Alta*.

That was a few months before the world shut down from the COVID-19 global pandemic. International travel became an ongoing challenge due to virus variants and safety protocols varying by country and region. In addition, significant environmental events, due to climate change, impacted travel. What does this mean for the education of the artist when encountering different people and their culture and art has been a formative aspect of that education?

Intercultural Education and Global Learning

Study abroad or global learning is considered a high impact practice as defined by the American Association of Colleges & Universities (AAC&U), an organization committed to the democratizing potential of education around the world. Their definition of global learning emphasizes the importance of engaging with difference, "These studies—which may address U.S. diversity, world cultures, or both—often explore 'difficult differences' such as racial, ethnic, and gender inequality, or continuing struggles around the globe for human rights, freedom, and power" (https://www.aacu.org/trending-topics/high-impact). Global learning is a form of experiential learning that happens through engaging with an unfamiliar community and environment, whether locally or abroad. This kind of learning can be hugely influential on an art student's

developing understanding of the world and their artistic practice. For example, the students visiting Venice gained a deeper, experiential understanding of the environmental crisis facing the city, and they made this realization a central theme of their final exhibition, bringing this learning home to the CalArts community.

Intercultural education, as exemplified in the UGA study abroad teaching experience described previously, is characterized by "intercultural dialogue, meaning dialogue that is 'open and respectful' and that takes place between individuals or groups 'with different ethnic, cultural, religious and linguistic backgrounds and heritage on the basis of mutual understanding and respect' (Council of Europe, 2008, p. 10)" (as cited in Rapanta & Trovão, 2021, p. 9). Jansa and Anderson (2021), calling for a more socially responsive internationalization in higher education, explain the difference between international education and global learning:

> "international" differs from "global" insofar as the former focuses on knowledge and passive understanding of geopolitical developments and interconnected economic, technological, and sociocultural systems, while the latter aims to capture wider aspects of the human experience. As such, we employ "global learning" to emphasize intercultural and linguistic proficiency, understanding and appreciation of multiple perspectives, and developing empathy for the "other," all of which help learners develop the skills, attitudes, and behaviors necessary to integrate into and thrive in a multicultural environment. (p. 13)

Short-term study abroad, defined as a program or academic experience that is less than a semester, quarter, or 8 weeks (Donnelly-Smith, 2009), such as the Venice Biennale experience, is particularly impactful when led by a faculty member or integrated into a course. It can be more accessible financially to students, especially when underwritten by philanthropic support or institutional grants, a necessary strategy for increasing access to global learning until a more equitable infrastructure is developed. It can also be accommodated more easily in what are often strict curricular sequences in the arts, which can make it difficult for a student to take a whole semester abroad and still graduate on time.

Our attachment to rigor in the arts may sometimes interfere with the kinds of experiential learning that are critical for artistic development. Faculty-led trips are also opportunities for students to develop professional networks as they meet and work with their faculty member's collaborators and may benefit from additional mentoring from their faculty member while working together outside of the classroom. For example, CAMPING, the international dance festival that

brings students, faculty, and choreographers from different countries together for workshops and performances over a couple of weeks in the summer, is a valuable professional opportunity for dance students in what is a highly competitive field.

Intercultural education and global learning are pivotal aspects of a responsive arts pedagogy because of their potential to significantly influence artistic development that is richly complex and deeply immersed in difference, and it is critical for the survival of democracy. Engaging difference, fostering empathy and mutual respect, disrupting students' worldviews toward openness and plurality, and having that influence their work are fundamental to the arts as a transformative social force. While international education often has been considered attainable only to those with means (consider the 17th–19th century tradition of the Grand Tour as an essential component in an upper-class young man's education), constraints on international travel has forced a change in thinking about international education and global learning as primarily focused on student and scholar mobility. There is a recognition of the need for conceptual frameworks in internationalization that disrupt the concept of geographic and political dimensions being centered on the nation-state to incorporate, for example, indigenous frameworks (Jansa & Anderson, 2021). While the COVID-19 global pandemic put a pause on this kind of education, it also opened possibilities for a different kind of intercultural engagement.

Expanded Notions of the Studio

Studio art practice during the COVID-19 shutdown opened increased opportunities to invite artists from around the world into classrooms, both because it was more affordable and because artists were more available. Utilizing video conferencing tools, visiting artist lectures could now be accessible not only to a single class but to a broader institutional audience as well as alumni and prospective students, providing an introduction to the institution regardless of a student's location. The critical importance of intercultural education for an artist's development was ideally made available to more students through these virtual means (a form of virtual internationalization, see Rogers, 2020), as there are many students for whom travel outside their region is a challenge. This is an aspect of pandemic-induced responsiveness and resourcefulness that should be maintained to increase access to an international network of artists for everyone, not just those with the resources or immigration status to travel abroad. This is an example of internationalization at home, "the process of integrating an international, intercultural, or global dimension into the purpose, functions or delivery of post-secondary education" (Rogers, 2020, p. 4).

At a multidisciplinary arts institute like CalArts, the notion of the studio is expansive, including the dance studio, recording studio, design studio, and so forth. Studio culture and studio learning, that is the peer-to-peer learning and close faculty-to-student mentoring that occurs through formal and informal critique, is applicable regardless of arts form. However, the shutdown proved particularly challenging for the performing arts, where in-person ensembles and collaboration are essential. But restrictions are a fuel for creativity, and arts faculty at colleges around the world applied that inventiveness to their commitment to provide their students an engaging arts education regardless of the shutdown.

For example, for the annual winter dance concert at CalArts, prominent international choreographers typically visit the institute for several weeks to stage repertoire for the undergraduate students, who audition for specific pieces. This is an important event in the program's professional preparation curriculum and students train intensively for the opportunity, which is held at the institute's downtown Los Angeles performance space and attended by numerous dance professionals in the Los Angeles ecosystem. During the COVID-19 pandemic shutdown, however, the winter dance concert needed to be presented virtually, and CalArts's experimental approach to arts pedagogy was on full display as the visiting faculty incorporated the aesthetic framing of Zoom into the choreography, synchronizing and disrupting gestures across the individual Zoom boxes. With the dancers spread across the globe, dancing from their homes, this embrace of Zoom as performance space and stage design created a cohesive and compelling aesthetic experience that also provided a brief reprieve from pandemic isolation for students.

Another example of an expanded notion of the studio as virtual, this time in music, was a music production course that explored the creative potential of Zoom to record through specific software a global ensemble's compositions, with students and visiting musicians playing together from their individual home studios located in several different locales ranging from South America, Africa, Europe, and the United States. Through this experience, students not only learned how to build a home recording studio but also had the unprecedented opportunity to play with musicians from across the globe, an example of online global learning that understandably has become more prevalent (the 2021 *Open Doors Report on International Educational Exchange* indicates that over 10,000 U.S. students received academic credit for online global learning experiences in 2019–2020; Martel & Baer, 2022, p. 20).

While this chapter presents just a few examples from my experiences of the different forms global learning and intercultural education may take in the arts, whether short-term online or virtual internationalization at home, or a traditional study abroad, more

empirical research on the nature of intercultural learning within an arts education context is needed (using an expanded notion of the studio). Important extant theoretical and empirical studies occurring across arts forms (e.g., Burnard et al., 2016; Henry & Costantino, 2015; Pachova & Carbó, 2019) meaningfully inform this call for additional research, which is critical for securing the funding and developing the institutional infrastructures to make the benefits of global and intercultural learning accessible to more students. This investment is essential to achieving a more equitable and accessible arts education that leverages the transformative power of the arts for our global and interconnected society.

References

Burnard, P., Mackinlay, E., & Powell, K. A. (2016). *The Routledge international handbook of intercultural arts research*. Routledge.

Donnelly-Smith, L. (2009). Global learning through short-term study abroad. *Peer Review*. Association of American Colleges & Universities.

Henry, C., & Costantino, T. (2015). The role of cross-cultural experience in art teacher preparation. *International Journal of Education & the Arts*, *16*(3).

Jansa, T., & Anderson, D. L. (2021). *Socially responsive leadership for post-pandemic international higher education: Theoretical considerations and practical implications*. Institute of International Education.

Martel, M., & Baer, J. (June, 2022). *Spring 2022 snapshot on international educational exchange*. Institute of International Education. https://www.iie.org/Research-and-Insights/Publications/Spring22-Snapshot-International-Educational-Exchange

Pachova, N., & Carbó, G. (2019). Arts education in contexts of high diversity or intercultural education through the arts: Measuring overlaps and exploring the gaps. In L. Ferro, E. Wagner, L. Veloso, T. IJdens, & J. T. Lopes (Eds.), *Arts and cultural education in a world of diversity. ENO Yearbook 1* (pp. 55–70). Springer Nature Switzerland AG.

Rapanta, C., & Trovão, S. (2021). Intercultural education for the twenty-first century: A comparative review of research. In F. Maine, & M. Vrikki (Eds.), *Dialogue for intercultural understanding*. Springer.

Rogers, A. (2020, November). *Internationalizing the campus at home: Campus globalization in the context of COVID-19*. Institute of International Education. https://www.iie.org/Research-and-Insights/Publications/Internationalizing-the-Campus-at-Home

Winterson, J. (1996). *Art objects: Essays on ecstasy and effrontery*. Alfred A. Knopf.

As we move beyond the pandemic, I've found that many students have grown comfortable with being at home. At first thought, and on first sight, I found this troubling, as my education was very studio heavy. And I still find a studio heavy education the best way for studio art programs to operate. However, what I discovered is that this opens up the door to discuss a studio practice that extends far beyond the institutional walls. Which is our goal, right? I have students willing to allow their studio practice to infiltrate their 'home space' without distinction. I find this to be an avenue to discuss what it means to have a professional practice, once the support of the program ends. What I hope is, without coddling, we nurture our students' ability to transition between studio and home, as it may lead to a stronger studio practice as they exit our institutions.

—Martinez E-B

Planning curriculums is made more difficult than it would be with or without a pandemic by virtue of the variety of discourses which a curriculum must contain now as opposed to as recently as twenty years ago. There is art for example of the "materialist aesthetics" sort, where the work involves historical fact and truth; and at another extreme art which is made of perceptions of invisibilities—for instance, movements, gravity and its corollary, weightlessness, speed—and has an in some respects only quite indirect relationship to any truth that could be proved in the way an historical fact may be. If the first sort includes art about surveillance and drawing attention to the overlooked, the second is epitomized by painting and a kind of looking which is largely involuntary because of being unpredictable. Both need to be in the contemporary curriculum while having little or nothing in common.

—Jeremy Gilbert-Rolfe

Planning solutions in the modern era is
difficult than it would be with or without
a pandemic by virtue of the variety of
discourses which in turn makes most
contain new uncovered to as recently
as twenty years ago. There is at for
example of the "naturalist" aesthetic
self, where the work analyzes historical
fact and truth, and of another extreme
an which is made up of emotional
invisibilities ... movements,
gravity and ... restlessness,
speed -- and ... aspects
only quite in ... ship to any
truth that could ... the way
an historical fact ... the first
self includes but about agreements
drawing attention to the overlooked
the second is epistemic ... by painting
and a kind of feeling exhibits is
largely inventory because of being
impredictable work used to be in the
contemporary ... facts while having
little or nothing in common.

Chapter 7: Learning How to Be a Teacher

SEPH RODNEY

In autumn 2020, I was asked to be a "6X Critic" in the Painting and Printmaking Department at the Yale School of Art, working with the graduate students in the MFA program—my first appointment as a visiting critic.

I have taught several different kinds of courses over the years, most often feeling like I was swimming through molasses. Everything was difficult: figuring out what I wanted to teach or what the institution wanted me to teach, getting hired, allocating time so I could manage a full-time job while teaching part time, writing a syllabus, preparing lesson plans—all of it. And the time spent in the classroom typically exhausted me. For a long while now I've not really known why I've insisted on taking teaching jobs. Perhaps it has something to do with having a mother who was a teacher throughout much of her life and subconsciously wanting to adhere to her as a template. Maybe. Either way, teaching has long felt both like an obligation and a deep struggle. Then in 2018, when I was teaching a course on research methodologies at Parsons School of Design, I had a breakthrough. I need to talk about what happened at Parsons first because it lays the groundwork for the epiphany I had at Yale two years later.

It was the last day of teaching my research methodologies course. All the students had finished their presentations and we had about 40 minutes left in class, so I asked them what they would like to hear from me, what would be useful to them. They asked me to tell them my story, how I got to the place where I have a PhD in museum studies and (at the time) a job as an editor at a prominent arts publication. I love storytelling, and I don't think at that point I had had many opportunities to tell this story. I let them know all of what I had done to find my way to my professional life: the abject failures, the questions, the strategies, the hopes, the help I received along the way. As I was speaking, I rhetorically organized the story to jibe with something I had previously heard from the actor Billy Porter via a YouTube video: He talked about his life rules consisting of the charge to (this is a half-remembered approximation): "Believe in yourself; trust yourself; treat yourself." Initially I thought what I was saying was fairly obvious and perhaps even cliché, but as I explained sleeping on a friend's couch for years while working on the doctorate, having my thesis rejected twice, being out of work for 9 months, I could see in the faces of my students

blossoming awe and perhaps inspiration. I think I gave them the opportunity to believe that the world might make a space for them and their ambitions because it had done so for me. That's when I realized that the key thing to being a good teacher is not getting students to understand what constitutes principled research, but rather inspiring them to want to carry out their research in a principled manner.

When I arrived at Yale as a visiting critic, I understood that this wasn't a typical teaching role. I wouldn't be expected to transmit a body of knowledge over the course of a semester, nor would I necessarily be expected to inspire my students to attain the professional qualifications or status I had. This was a relief. But what I discovered was that I needed to be different kinds of people, or perhaps it's better to say that I had to formulate different kinds of relationships to the students.

In certain instances, I acted as more of a mentor. I had a memorable discussion with one particular student who was convinced that she needed to make work that explicitly and unmistakably addressed issues of gentrification that affected her ethnic group. I tactfully explained that she is an artist and as such is very much allowed to make work that excites her faculties other than her sense of justice or her political ethics. I could tell that she enjoyed the possibility of playing with color, form, opacity, and line. I said that these interests are pursuits that a multitude of artists have had for millennia, and that White artists have long had the wherewithal to make art that is not valued on the basis of its faithful rendition of a certain set of politics. I don't know that she was able to hear me. Still, I'm convinced that this needed to be said to her and might benefit her in the future. This reminds of an anecdote that was relayed to me many years ago by an elementary school teacher. (It strikes me that repeating this publicly now would likely trigger institutional censure or worse.) She said that teaching for her was like placing small bombs inside her students, completely unaware of when they might go off one day.

With another student, a man who had already lived quite a full life, we had rich, probing conversations that abstractly, obliquely approached what he was attempting to do in the studio. We talked about the idea of progression, what it might look like, how to gauge it over time. We talked about different ways to represent lived experience through gestural painting, how much information to give the viewer, how much to hold back and keep to the self. In this situation I was a kind of hybrid interlocutor: somewhere between being a therapist and an interviewer. To be clear, I don't think he needed psychotherapy, but rather might have benefited from the circumstance of having a safe space in which he could talk about his doubts, apprehensions, aspirations, and inclinations without fear of damning judgment.

In another instance, I found myself being quite judgmental, giving assessments of work that the student felt were finished and essentially

fully resolved. I questioned the techniques that he used and argued that certain approaches were more successful than others. He disagreed and stood his ground. I'm not sure how we found our way to this intellectual tango, but doing so reminds me of a moment from many years before when I was teaching an arts survey course and taught a bit of performance art by doing physical improvisation in class. Partners tended to slip into certain roles: oppositional, dominant/submissive, co-conspirators, and so on. In most instances the social and verbal cues that begin to establish the dynamic between two interlocutors are subtle and only fully appreciable in hindsight. With the benefit of this, after leaving that conversation I thought that once I understood what was happening I should have been forthright in identifying that appraiser/appraisee dynamic and should have asked the student whether they thought this dynamic was helpful to them. I believe it was, but he would have been better served by discussing other options for our conversation.

With one quite gifted student I felt I slipped into the role of being a kind of analytical cheerleader, pointing out how her work was the result of certain very intelligent and nonobvious choices made with her materials. In discussions with her, it felt important to urge her to keep going, to follow her intuitions, to keep experimenting. I believe that it's crucial to let artists know when they are making work that is compelling while explaining in what ways the work is so. It may be that the artist has never been verbally affirmed as gifted and talented, and hearing this may make a great deal of difference in the confidence with which they approach their making. But more than this, a discussion of how the work, in operating on me, offers signposts, intellectual wayfinding, so that the artist might know what forest glen or grassy savannah they've wandered into.

Because the relational options were as open as they were at Yale, I could be different people, depending on what the particular student needed. My roles mutated because I allowed myself to respond to what students were implicitly or explicitly asking of me.

I realize now that this epiphany doesn't have much to do with the pandemic. It has more to do with occupying an historical divot when the entire world was shaken and in some small ways broken. In this moment, I was severed from the set of assumptions I had about teaching going in. Going forward, I understand that it's more crucial to inspire rather than just impart knowledge. And more important still is to pose questions, listen intently, and take the time to find out what a student needs. Only then can I offer them the thing that might propel them to the next stage of their thinking and making. Knowing this not only reshaped my relationships to students; it has changed my relationship to the profession.

Chapter 8: How to Be a Time Traveler

Possible Futures

KIMBERLY SHERIDAN

Pausing is critical to the artistic creative process. As students work, studio art educators often circle the room, mindfully selecting moments to interrupt and pause the student's artistic process. A student might even be working along, humming, immersed in the material magic of mark-making, and we choose to break their flow. We ask them to step back, to look, to think about what they are doing, why, and how else they might do it.

Why must studio art instructors be so disruptive? Because the work and the creative process demand it—demand to be thought about in multiple ways, questioned, reconsidered, deepened. Each artist and artwork have potentialities—many directions they can go that are gradually revealed as they evolve. In order to make meaningful work, students need to time travel: to pause and look back at what they have done, and think about where they might be going and why.

Studio Art Teaching in the Pandemic

The pause from the COVID-19 pandemic was not so well-intentioned (well, not intentioned at all!). But it equally gave pause to the practices of studio art education. Studio classes shifted from in-person, hands-on, material, tool-, and relational-rich studio environments to virtual, hy-flex, hybrid modes where students were often alone in their rooms with whatever little they happened to have on hand. This was a reactive pause. No professor said: "I am posing a creative problem where you are each stuck in your dorm or childhood bedroom feeling uncertain and fearful about the world around you; now make art." Educators and students had to quickly respond to conditions they did not create.

Nonetheless, when studio teachers were forced to pause, they used it to take stock of the world around them and how the world connects to creative practices of art and teaching. Following Maxine Greene's conception, they imagined art education as if it were otherwise (Greene, 2000).

As the world trundles on, our educational transformations evolve. We may be back teaching in person, maybe in the same classrooms, but as the proverb suggests, you can't step in the same river twice. We

do not automatically return to our prior practices. Our pedagogical creative process demands that we pause and reflect on our recent experimentations and see how they inform how we reimagine future pedagogy.

Our artistic and pedagogical crafts have histories with embedded wisdom. When we teach, we balance the knowledge embedded in these histories with the experiences, needs, desires and imaginings of our current students, and the features and demands of present and future societies. This is a complex, unsettling task. To do it well, we also need to time travel: we need to gather up meaningful past resources in studio art education, envision meaningful potential futures for art in the world, and use both of those processes to inform how we conceptualize and make decisions about our teaching in the present.

In this essay, I do not provide my answers as to what studio art education's futures might be. Instead, I take stock of what I see as the resources studio educators have to work with, the rich core of studio art education, and suggest a stance of expanding its impact as we envision art education's future. I articulate questions to guide this time traveling. Some of these are questions that have motivated my research for decades; others have become more salient as I try to make sense of the present world and envision art education in its futures:

1. What important, common ways of thinking are learned through studio art and design?
2. How does studio teaching support students' individual and collective artistic agency?
3. How can we draw on these ways of thinking and this individual and collective agency to amplify the opportunities for artists to do meaningful work in the world?

Centering Art Education on Building Studio Habits of Minds

I begin with the question: What kinds of minds do we think studio art education builds? By minds, I don't mean disembodied brains, rather embodied, socioculturally situated minds that link our brains and our bodies and are built through interactions with others in cultural-historical moments through use of cultural tools and technologies (Vygostky, 1978).

Two broad concepts inform my rationale for what is core to building artistic minds: thinking dispositions and cultural repertoires of practice. Dispositions comprise of skills activated by inclination to put them to use and the alertness to know when and how to use them (Perkins et al., 1993). Skills without inclination and alertness are inert. They may be performed on command but have little life outside school. Repertoires of practice are habitual ways of acting learned through

participation in different communities (Gutiérrez & Rogoff, 2003). You learn many repertoires of practice in a studio art community, some practical (e.g., how to find and care for tools and materials), and some that reflect deeply held values (e.g., tone of critiques).

Both dispositions and repertoires are often tacit and absorbed through participation—just by being in the community you internalize the ways artists think and how things are done in the studio. But as we envision art education for the future, we need to think more explicitly about our existing tacit pedagogical knowledge and experiences.

Artistic Thinking and Studio Habits of Mind

About 20 years ago, my colleagues and I began researching the kinds of thinking developed in studio arts. We began our analysis at intensive arts-focused high schools, where students were planning to be artists and had more than 10 hours of art instruction a week from teachers who were also practicing artists. We looked at what teachers intended to teach through their assignments, their interactions with students in the studio, and through critiques. We focused closely on the informal, individualized interactions (over 4,500!) between teachers and students (Hetland et al., 2007).

We found that, regardless of media, the explicit focus of a given assignment, or pedagogical style of the teacher, teachers consistently worked on developing eight broad studio habits of mind in layered and integrative ways. These were:

Attend: Studio educators help students to become more aware of the world around them—to notice details, patterns, tensions, nuances, subtexts. They encourage them to view life as source material and attentive living as part of being an artist (Gude, 2007). We initially termed this habit Observe, but now prefer Attend to avoid a narrow focus on sight (Sheridan et al., 2022a).

Develop Craft: Learning to take care in the ways one uses tools and materials and to develop awareness of artistic conventions of media and genre builds a sense of craft. Craft is rarely taught in isolation; teachers layer technical advice with connections to other habits of mind.

Engage and Persist: Students find meaningful problems and ways to sustain themselves through challenges and frustrations and develop their own creative processes.

Envision: Students learn to see beyond what is currently visible and develop the disposition to imagine things as they could be rather than as they are.

Express: Students develop the disposition to look externally and internally for ideas, emotions, and concepts that motivate their

work, often engaging in research and journaling to help these develop.

Reflect: Examining one's work and work processes are central practices of a studio community, often through various forms of formal and informal critique, both mid-process and after work is complete.

Stretch and Explore: Students learn to push beyond their initial capacities and conceptions and try out multiple approaches, often in a playful way to discover ideas and ways of working beyond the first thought.

Understand Art Worlds: Students learn to contextualize their work in rich and varied contemporary practices and art histories.

These habits of mind have since been studied in a wide range of settings, including higher education (Sheridan et al., 2022a). From this work, we pose them as a reasonable framework for the basic components of artistic thinking that can apply at any level of experience. These habits of mind, however, are not isolated components to be individually taught; rather they are integrative aspects of an artistic practice.

Centering Art Education on Building Artistic Agency

While I pose studio habits of mind as elements of artistic thinking, the overarching goal of studio teaching is for students to gain ownership over their creative process. They become artists with a sense of agency: "the capacity to engage in creative and reflective processes, in which [artists] formulate creative problems, recognize, and refine their own expressive intentions and learn to control tools, methods and materials to create and interpret artworks" (Sheridan et al., 2022b, p. 14).

Agency may be thought of simply in terms of an individual's capacity for action or framed in a larger conception of self-determination. Self-determination refers to our ability to direct our own futures—whether as individuals or as a community. When we support students' self-determination, we support their ability to identify and work toward their own envisioned futures rather than our preset specifications. To have agency, students need autonomy—freedom to choose how to act. Students also need competence to make informed, skilled actions toward their intentions or goals. Self-determination also depends on relatedness—our real and perceived connections to others in the community (Ryan & Deci, 2000).

Autonomy-Supportive Pedagogy: Studies of studio art classes show they regularly engage in highly autonomy-supportive practices (Reeve, 2016; Sawyer, 2017; 2018; Sheridan et al., 2022b). Studio teachers regularly give open-ended prompts—suggestions rather than

commands—and provide rationales for their directions. Thus, students have enough information and flexibility to make meaningful decisions. This autonomy support is often deeply relational: teachers seek to listen to and understand the students' perspective. Studio teachers use strategies to help students vitalize their own inner motivations for their work, rather than relying primarily on extrinsic motivators like grades or praise. Based on a study of visual art professors, Sawyer characterized their relationship as guides who support students' engagement in nonlinear, iterative creative processes. Professors observe where students are going and provide relevant resources "opportunistically" to individuals as they might be relevant, and when students seek out direct advice, they often encourage them on ways they might return to the creative process to find answers rather than providing them (Sawyer, 2018).

Even subtle aspects of studio teachers' language tend to support agency. Teachers often use conditional language when giving advice, such as "If this were my work," imagining themselves as fellow artists in conversation with their students rather than an external evaluator. They regularly use mitigators like "might" or "maybe" to highlight that their advice is a suggestion to consider rather than a directive to obey (Konopasky & Sheridan, 2016; Sheridan et al., 2022b).

Artistic Agency as Time Travel: If we just view agency as the simple capacity to act, then making art would simply be the act of making marks. But to uncover the meaning of these marks, and how and why they are made, we need to think with a temporal lens. Emirbayer and Mische (1998) argue agency is always temporally embedded and pose a temporal model of agency that helps us understand this framing. When teaching students to be artists, we essentially teach them to time travel. That is, while it may look like they are taking actions, making marks in the moment, we are actually asking them to fluidly integrate past, present, and future.

As we work on an artwork in any present moment, we are continually recharacterizing the artistic problem we are working on, making decisions about our actions, and executing those actions—making marks. But to do so we need to draw on our habitual past where we selectively attend to the relevant resources and recognize types from our repeated past experiences that inform our current actions and decisions. Artists learn to mine their lives and earlier work for techniques, ideas, approaches, and concepts that they can "import" into their present work—creating through lines in their body of work from past to present (Sawyer, 2018).

Artists also importantly work in the future through processes that Emirbayer and Mische term symbolic recombination and narrative construction. Whenever we imagine future actions, we combine

existing symbols and ideas in new ways and construct new stories for what we should do and why. We don't just repeat our past approaches; we transform them. Much like the studio habit of mind of envisioning, in symbolic recombination, artists take their current work and mentally recombine multiple possible directions it could take. Narrative construction is closely related to express in that artists create possible meanings and stories for the recombined possibilities they imagine for directions not yet taken in the work at hand. When we make art, we continuously practice envisioning and making meaning from many possible futures.

Building Communities That Amplify Opportunities

Using the lenses of supporting artistic thinking and students' agency naturally moves us toward thinking of studio arts curriculum in ways beyond just discipline, genre, or media. These become critical resources for thinking and working with, but not necessarily the organizing focus. Art education becomes more responsive to context. Whether students are working together in a tool- and material-rich studio, scattered in isolated, ill-equipped rooms, or trying to engage a community in a socially-engaged art practice, educators need to find ways to help them think like artists and develop a sense of agency as artists.

One strength of studio communities—whether physical or virtual—is that everyone is engaged in artistic thinking. Students in a studio class do not time travel alone; they journey together—each on their own trajectories, but in loose coordination with each other. In supportive studios—whether physical or virtual—students become guides, resources, and collaborators for each other, and these relationships often extend far beyond the course they are in and the time they are in school.

Studio educators help shape the repertoires of practice that help form the community and help make choices that strengthen the sense of community. They encourage respectful use of shared space, tools, and materials. They ensure students know each other's artistic trajectories, develop norms for constructive critique, and support collaboration. Educators monitor the relationships and communal practices that are forming and encourage students to reflect on how well those are working. Studio art attracts students in part because studio art educators excel at creating strong relationships and supportive communities. One challenge, however, is that strong, supportive communities can often become insular.

Fighting Insularity Through Collective Agency: To build a strong community that also fights against insularity is to meet this head on: to continually ask how we can amplify the impact of our work, how

we can extend our impact on other individuals and communities and invite others to learn and care about our work. Agency is always contextualized, and artistic agency is best thought of in relationship to a community and an audience or broader world the artwork impacts. Thus, the time traveling frame that supports the development of individual artistic agency is also a useful lens for collective agency and can inform practices targeted on amplifying the opportunities for impact of students' work.

Conceptualizing Present *Artistic Problems Within a Community:* As members of a studio community share their ideas-in-progress, others often respond with what they think about the work. But to amplify the opportunities for each artist to do more impactful work in the world, we can encourage thinking about impact as an explicit repertoire of practice, an integral part of our collective critiques and discussions. Thus, we encourage community members to not just discuss the work, but also their insights into how one might reconceptualize an artistic idea or work to have greater impact, to potentially do more work in the world.

Community-Asset Mapping to Activate Past *Resources:* To do so, members of a studio community may use strategies such as community asset mapping to surface individual and collective habitual past resources that may amplify the impact of the work discussed (Sheridan & Konopasky, 2016). Through asset-mapping, the studio generates ideas of available potential resources relevant to the problem or opportunity.

Thus, as students share their projects, others are encouraged to suggest people, organizations, or venues they each have past connections to who might be interested in this work or be a source of support in some way. They can provide examples of tools and practices (e.g., social media approaches, upcoming exhibitions) they have used— or have heard about others using—to expand awareness of the work to wider audiences and sources of resources, partners, venues, and other opportunities. Any individual advice or example may or may not prove particularly useful. But engaging in the repertoire of practice of activating past and existing resources to amplify opportunities for artists builds the disposition to envision more possibilities and the collective agency to expand the impact of their work.

Collective Envisioning of Future *Possibilities:* Similarly, repertoires of practice can encourage symbolic recombination and narrative construction that center on how the work could be transformed or situated to have further impact. Though free-rein imagination of possibilities can easily turn grandiose or impractical, a repertoire of practice that encourages envisioning for impact can also lead to

unconsidered more realistic opportunities. The aim is to build a stance to transform work and ideas to have bigger impact than you were initially thinking. Studio teachers help support collective agency by monitoring the journey. They might encourage the community to return to the present when the future envisioning goes too far ahead—for instance asking to specify next steps and what resources at hand should be activated to make these next steps possible.

Expansive Conceptions of Impact: As we engage in repertoires of practice to expand the impact of our work, we also expand our conceptions of impact itself.

Expanding impact may not mean a larger audience for their work, rather a more intensive relationship with a particularly engaged audience. The audience might not be larger, but the engagement may be stronger, and strategies for artistic impact within a particular subculture likely differ from strategies to engage a broader public. Expanding conceptions of impact can also be turned inward. How can the work I am currently making have more impact on my own life and my creative process? The expanded impact of a work need not always be public.

A recent visit to an exhibit of Doris Salcedo's work encouraged my own reframing of impact. Her collection, *Disremembered X* (2020/2021), was informed by interviews with women who had lost their children to gun violence. The needle-filled, filigreed shrouds Salcedo painstakingly created were visceral and moving and spoke to the particulars of the mothers' experiences, how this ongoing nearly invisible burden of their loss was a constant source of pricks, some which would intensely stab you with the slightest of motions.

Since seeing this work, when I hear news of deaths by violence, I instinctively react by feeling myself wearing her shrouds as I think about the victim's loved ones. Her work has clearly impacted me as an audience, not only in what I feel and think but also by impacting the political energy I may put into the issue of addressing gun violence. The work has made it harder for me to become desensitized. But I also think about the impact of that work on the mothers who worked with Salcedo; she interviewed and listened to their stories until she felt she could generate a representation that could try and reflect an authentic aspect of what she heard from them. What is the impact of seeing an artist with painstaking tact, care, and craft respond to their stories?

Focusing on Artistic Thinking

As educators, we may also think about how we can increase the impact of art education—such as by increasing access to the intrinsic rewards of an engaged creative artistic practice for students not majoring in

art, not intending to become artists, and for the broader community. There are opportunities for ourselves and students to make meaningful art-making experiences more visible and available to others.

In a sense, my work in this essay has been its own form of asset-mapping—noting from my research my appreciation for the rich potential studio art education has for developing important habits of mind, increasing students' individual and collective agency, and building strong communities. I encourage studio educators to vitalize these rich resources of studio art education to envision many possible futures that help us better conceptualize and make decisions about how and why we teach studio art now. We need to continually expand the impact art and studio art education can have in the world.

When we focus on artistic thinking and agency rather than the particularities of a media or the histories of a genre practice, we may more easily adapt and reimagine our studio practices. This focus can be a guide through large disruptions like the pandemic, and through the more continual stream of disruptions from new tools, technologies, practices, and problems. If we support artistic thinking and student agency, we can find ways to have a meaningful studio class with (or without) any kind of tool, material, or space. Studio habits of mind and the repertoires of practice that build them are a toolkit that help us hold the center through disruption.

Though the language of habits of mind and agency are central to the arts, they are not unique to artistic practice. As such, they help make meaningful transdisciplinary connections to other important work in the world. There are many possible futures in flux that the arts can help form: jointly envisioning with scientists the potential impacts of climate change, engaging with social scientists to express evidence of injustice, stretching and exploring with community organizers to find ways to activate the public around important concerns. The world needs time travelers and artists and studio art educators have been practicing.

References

Emirbayer, M., & Mische, A. (1998). What is agency? *American Journal of Sociology, 103*(4), 962–1023.

Greene, M. (2000). *Releasing the imagination: Essays on education, the arts, and social change.* John Wiley & Sons.

Gude, O. (2007). Principles of possibility: Considerations for a 21st-century art & culture curriculum. *Art Education, 60*(1), 6–17.

Gutiérrez, K. D., & Rogoff, B. (2003). Cultural ways of learning: Individual traits or repertoires of practice. *Educational Researcher, 32*(5), 19–25.

Hetland, L., Winner, E., Veenema, S., & Sheridan, K. (2007). *Studio thinking: The real benefits of visual arts education.* Teachers College Press.

Konopasky, A. W., & Sheridan, K. M. (2016). Towards a diagnostic toolkit for the language of agency. *Mind, Culture, and Activity, 23*(2), 108–123. https://doi.org/10.1080/10749039.2015.1128952

Perkins, D. N., Jay, E., & Tishman, S. (1993). Beyond abilities: A dispositional theory of thinking. *Merrill-Palmer Quarterly, 39*(1), 1–21.

Reeve, J. (2016). Autonomy-supportive teaching: What it is, how to do it. In W. C. Liu, J. C. K. Wang, & R. M. Ryan (Eds.), *Building autonomous learners* (pp. 129–152). Springer Singapore. https://doi.org/10.1007/978-981-287-630-0_7

Ryan, R. M., & Deci, E. L. (2000). Self-determination theory and the facilitation of intrinsic motivation, social development, and well-being. *American Psychologist, 55*(1), 68–78. https://doi.org/10.1037/0003-066X.55.1.68

Salcedo, D. (2020/2021). *Disremembered X* [textile exhibition]. Glenstone.

Sawyer, R. K. (2017). Teaching creativity in art and design studio classes: A systematic literature review. *Educational Research Review, 22*, 99–113. https://doi.org/10.1016/j.edurev.2017.07.002

Sawyer, R. K. (2018). Teaching and learning how to create in schools of art and design. *Journal of the Learning Sciences, 27*(1), 137–181. https://doi.org/10.1080/10508406.2017.1381963

Sheridan, K. M., & Konopasky, A. W. (2016). Designing for resourcefulness in a community-based makerspace. In K. Peppler, E. R. Halverson, & Y. B. Kafai (Eds.), *Makeology: Makerspaces as learning environments* (Vol. 1, pp. 30–46). Routledge.

Sheridan, K. M., Veenema, S., Winner, E., & Hetland, L. (2022a). *Studio Thinking 3: The real benefits of visual arts education*. Teachers College Press.

Sheridan, K. M., Zhang, X., & Konopasky, A. W. (2022b). Strategic shifts: How studio teachers use direction and support to build learner agency in the figured world of visual art. *Journal of the Learning Sciences, 31*(1), 14–42. https://doi.org/10.1080/10508406.2021.1999817

Vygostky, L. (1978). *Mind in society: The development of higher psychological processes*. Harvard University Press.

Refamiliarizing students with the uncertainties of the studio classroom and to embrace varieties of interpretation is crucial. The intimacies and attachments that students developed while working in isolation has created a resistance to feedback, interpretation, and critique. Students are expressing deep emotional distress when their work is "mis"understood, and broadly assessed. In the seclusion of the pandemic, meaning and identity calcified. As teachers we need to insist that misinterpretation is a dynamic and learning opportunity and not judgement.

—Michelle Grabner

Years after the first signs of a global pandemic, studio art education remains faced with seeing the needs of its students, whether it is their mental, physical, or social well-being. I cannot go without mentioning the need to uphold the claims institutions and programs made to stand in solidarity with communities inflicted by ongoing racial and ethnic violence. Studio art education can lend students both the physical and conceptual space to make artwork informed by those living and learning in the world. To support the realization of these students as artists, studio art education needs instructors aware of the ever-changing art landscape *and* the ongoing social, cultural, and economic shifts happening around the world. We are in a time that cannot afford to ignore the subtle needs of its students and faculty. Studio art education must stand with and learn from the lives historically pushed into the margins.

—CARINA MAYE

Chapter 9: Material Matters, Material Lives (Words of the Not-Yet, Right-Now)

KAITLIN POMERANTZ

> What are the words you do not yet have? What do you need to say? What are the tyrannies you swallow day by day and attempt to make your own, until you will sicken and die of them, still in silence?
>
> —Audre Lorde, "The Transformation of Silence into Language and Action," *Sister Outsider*

This essay summons words around urgent reorientations in art teaching and learning in higher education and beyond, as we emerge from (dwell in?) the first years of what Arundhati Roy referred to as the "pandemic portal" (Roy, 2020). It finds form in a time of global grief, mass awakening to raging systemic inequity and racial violence, continued war and empire, corporate greed and extraction, rising sea levels and temperatures, and other terrestrial havocs. Speaking from the wounds of these times, staring back into the lineages of the violences that caused them, it offers possibilities toward equity, sustainability, and liberation in spaces of learning and creating. It does so by orienting attention toward the necessity for greater care in how we think about arts materials, as well as the actual material conditions of art teachers and learners.

The words speak to and from my experience as a multivalent practitioner in the arts and education—as an interdisciplinary artist dealing with issues of ecology and place, an independent educator in higher ed and in youth and community contexts, a student of pedagogical scholarship myself, a land/water-steward, and an engaged neighbor— working from the position of an able-bodied, White, cis-gendered, queer identity with diasporic roots, writing from the privileges and limitations thereof. They are the words of a person entangled, through an alternating current of necessity and choice, in the potentials and precarities of the frontline of education and cultural production. I thank other (en)tangled thinkers (many directly cited in this essay), with identities not easily circumscribed by academia's categorizing imperative, whose wisdom broke through the cracks of my own academic learning, undergirding all that I share here.

Words of the Not-Yet

Audre Lorde called for the *words of the not-yet, right-now* at a panel in 1977, in the face of a cancer scare, peering into her own mortality. We—artists, educators, students, multitudinous practitioners—can engage with these questions as a visioning framework, peering into our own micro and macrocosmic collective mortalities: the exacerbated perils threatening our democracies, lands, human and interspecies relationships, air, planet, lives. May the concert of our answers join in a collective soil that might alight upon, and remediate, our current wreckage.

As you read through this essay, my attempt to do my version of this work—I would raise up a final query, from Lorde herself, and ask: "are you doing yours?" (Lorde, 1984). What are the tyrannies holding you in silence? What are your words of the not-yet, right-now?

Here's to the embodied energy of our future plantsong.

Material Matters

> It matters what matters we use to think other matters with; it matters what stories we tell to tell other stories with; it matters what knots knot knots, what thoughts think thoughts, what descriptions describe descriptions, what ties tie ties. It matters what stories make worlds, what worlds make stories.
>
> —Donna J. Haraway, *Staying with the Trouble:*
> *Making Kin in the Chthulucene*

This essay is the ideas, incantations, and experiences alluded to in the introduction. But also, more importantly, this essay is matter itself. And that—matter—is what is, and will be, the essay's subject, and the heart of my vision for moving forward in educating artists. Matter is substance, and in this context, the stuff of art making and learning before it has even become material for creative use. Matter could be clay, fibers for paper, wood from trees, metals, oils, light, electricity, the body. Matter is inherently connected to the earth, to place, to the environmental conditions of its own genesis, as well as to the labor involved in its procurement. The word *matter* also operates to mean "holding meaning." What I endeavor to convey here is a vision for arts learning that is directly engaged with matter itself and material conditions. So let us begin with this very essay.

If this essay is coming to you as printed matter, it is commercial ink on a stack of bound papers. The ink is made of vegetable or petroleum oil mixed with lamp black, which the EPA defines as, "an extremely fine black fluffy particle . . . produced by the reaction of a hydrocarbon fuel such as oil or gas with a limited supply of combustion air" (Serth & Hughes, 1977). So, the words of this essay are made of compressed oil,

hailing from any number of subterranean extraction points, rearranged on the molecular level, to meet you right here.

These oil-words catch a ride atop a substrate of dried pulverized pulp of trees, likely pines, hemlocks, and spruces, from managed timberlands or cultivated tree farms. So, this paper that you are holding in your hand may have come from trees that were planted by humans or through the incredible and various methods of seed dispersal and were likely between 10 and 20 years old. The trees undoubtedly traveled far distances—if grown on U.S. soil, it is likely they went to other continents to become paper (as EPA restrictions surrounding papermaking have tightened in the United States, paper manufacturing has gone "elsewhere"). The trees used to make this paper are numerous. As you flip through this book, you are flipping through forests.

If this essay is coming to you virtually, it is equally embodied, just in other ways. This essay is light, pulsating through cables spanning oceans, gleaming forth from a screen of plastic, glass, electrodes, lithium-ion batteries of nickel, copper, and lead, mined from salt beds or ore deposits in the earth's crust, from any number of deposits throughout the world. The essay is saved as some kind of file, perhaps a pdf ("portable document format"). The pdf was born in 1990, via a six-page physical paper written by Dr. John Warnock, the creator of Adobe (which, interestingly, takes its name from Adobe Creek in Los Altos, California, which was an actual adobe clay bed—the name of the company intending to reflect the creative nature of its program by invoking the material of adobe). So, the ideas for the pdf first came together on paper, and fomented a vision for a generally accessible, digitally transmissible document.

Does thinking about this essay as matter, matter? And how? What does it mean, or do, to see it as paper, petroleum, cables, light? As trees, crude oil, plastic? We have naturalized the acceptance of different materials and mediums in our lives and creative work without questioning their origin stories. What would it mean, in the teaching and making of art especially, to take these matters literally and seriously?

At present, foundational art classes in U.S. higher education contexts are typically divided by medium (drawing, painting, sculpture, etc.) or "the mediums" grouped together as "Foundations." In these courses, the discussions of the materials of themselves—beyond how to prepare them for artistic use—are scant. Pedagogical trends in arts education in U.S. higher education emphasize unrestrained material experimentation and vigorous productivity, in contrast to creative traditions where material usage comes only after learning. Most syllabi feature that common addendum of the "materials list," and a student's first engagement with arts learning might actually take place at the store. This introductory framework offers materials neatly packaged, but stripped of originating qualities and stories, and also

links art making immediately to commerce, consumption, and even disposability (have you ever seen an art school dumpster at the end of a semester?). A prevailing art school ethos today could be phrased as: *Material, at all costs, for art's sake.*

Deeper discussion of the material of art is often relegated to artworks that happen to approach these topics head on, leading for those works to be categorized—and othered—with identifiers like "eco-art," "land art," and the like (even the "readymade" others the impulse to use already-existing materials). These categorizations exempt "standard" art-making practices from having to do any kind of careful self-examination vis-á-vis materials and the labors and lands that wrought them. But before and outside of global commerce and extractive capitalism (and an industry of arts pedagogy framed around colonialist concepts), art materials were earth materials, and they were local. Their procurement was part of the artistic process. Cultural production was inextricably bound to place. Many practices and knowledges still center sensitivity to place, process, and matter. They are commonly not the focus of standard academic arts learning, due to a tangle of systemic exclusions and hierarchizations.

We know that nothing is "from scratch," and nothing goes "away." And we know that these systems of extraction, consumption, and production are inextricably bound in the logics of those who, as Alexis Pauline Gumbs describes, "somehow think that it is wise to boil the world" (Gumbs, 2021). It is possible and necessary to imagine artistic studies starting elsewhere—as they have and still do in creative traditions that have survived and skirted colonial logics. Not at the art supply store, but with the plant, the pigment, the charred branch, the water source—and with discussions around the seriousness and responsibility of turning these matters into material for artistic use. Studies could also begin with the transoceanic Internet cable. Or at the dump, municipal waste center, salvage yard, or recycling plant. Or—if at the store—with consideration of supply chains, labor, footprint, or in the very least, a list of ingredients comprising the "art materials." The point is not to encourage anachronism or curb experimentation, but simply to decouple art making from an unexamined relationship to consumption, disposability, and waste, and to encourage an engagement with material as more than just a means to an end. To do this would be to acknowledge the devastations and devastators of the Anthropocene, to—as Kathryn Yussoff writes—"name the masters of broken earths" (Yusoff, 2018) and connect to creative approaches operating outside of extractive logics.

And if practices of art pedagogy were to shift out frameworks that focus solely on ease and convenience and refocus on logics of locality, care, and responsibility, it could only follow suit that artistic practices themselves might necessarily also rearrange. The "art career"

could move away from toxic individualism and art-star-ism (the barely attainable pursuit of which causes so many artists so much disillusionment and grief) and toward modalities of greater collectivity. "Medium specificity" could take on meaning beyond aesthetics, rooted instead in awareness of the teeming material ecosystems and relationship with place.

After years of thinking on these matters, I am piloting a course devoted to them, appropriately called *Matters: Connecting Arts + Design to Materials, and Materials to Labor + Land* at the University of Pennsylvania, made possible by a Sachs Arts curricular development grant for adjunct lecturers. The course "connects art and design learners to considerations, sites, and cycles around production and disposal of the defining materials of their creative fields, laying groundwork for creative practice rooted in social and ecological awareness, repair and care." It is a hybrid research seminar, field exploration, and studio investigation aimed toward forming a material ethics to guide future creative work. So far, we have visited a materials library, a construction and demolition waste management facility, a colonial papermill at the seat of an important Indigenous watershed, and more; students have responded heartfully in their presence and written and material reflections, noting how different this learning is from other arts and design courses that they have taken. I share these details to offer a more practical shape to the pedagogy I am urging here. I also know that ultimately, the concerns of this course should be part of all arts education today, and not topically sequestered. Lest we choose to continue to live with floods and fires, fracking and monocultures, wars waged on stolen lands, and to unquestioningly teach students to "represent these times" using tubes of plastic paint, purchased with student loans.

While artists are not, categorically, the primary agents of ecological devastation, it still holds immense meaning and influence for arts learning to shift to encompass values rooted in justice, regeneration, and care. "Sustainability" on the level of materials will not exist without corporate accountability and major systems overhaul, and the fight for those transformations hinges on ideological reconfiguration, which the arts can embody. Ursula Le Guin wrote, in her final year of life, that: "To use the world well, to be able to stop wasting it and our time in it, we need to relearn our being in it" (Le Guin, 2016). Art students are in a prime position for such re- and un-learning and are fortunate to live in a time of abundant teachers and access to their teachings beyond limited canons. Arts pedagogy must align in solidarity and center the leadership of those making connections between sustainable ecological and creative futures: Indigenous leaders and Land Back initiatives offering pathways to wider publics for right relationship with more-than-human life, cultural producers and activists of the Global

South exposing the disproportionate harms of colonialism and global capitalist extraction, and Black and Brown leaders with diasporic roots claiming new relationships to land, its caretaking, and reparations for enacted harms. Teaching about current conditions of material and its procurement, supply chain, waste, land and its peoples, labor, and alternatives within the context of creative practice is a way to foster those alignments; and furthermore, to call in the more major structural upheavals necessary to any meaningful transformation of academic spaces and the logics within, going forward.

Material Lives

> Precarity once seemed the fate of the less fortunate. Now it seems that all our lives are precarious, even when, for a moment, our pockets are lined . . . now many of us . . . confront the condition of trouble without end.

> —Anna Lowenhaupt Tsing, *Arts of Living on a Damaged Planet*

This essay, finally, is labor. It is the hours spent between teaching and freelance work and art practice, life necessities and relations, revisiting the thoughts of mentors, wrangling words as the world unfolds with intensity, to create something worth sharing. A vision for a more conscientious engagement with materials in the arts and arts pedagogy, which depends on a set of shifted relations to place, land, and planet, must necessarily extend to the material conditions— living and labor—of arts practitioners, teachers, and learners. Most educators and students know, in the words of bell hooks, that "The academy is not paradise" (hooks, 1994)—but there is myopia (perhaps necessary to avoiding utter disgust, or perhaps a fear-based silence), that propels an ongoing tacit relationship to these major issues. These conditions are the "tyrannies swallowed day by day" by the majority of faculty and students (Lorde, 1984), the seeming "trouble without end" referred to by Tsing (Tsing et al., 2017).

These conditions can be summarized as follows: the *majority* of art educators in higher education are working in exploitative and precarious positions, leading an equally under-supported student base saddled with loans and untenable living conditions that drive *nearly half of students to drop out* before degree completion. This is not hyperbolic, but a confirmed crisis. A look at current data attests to the urgency. According to the most recent statistics, 75% percent of teachers in higher education are contingent laborers making below subsistence wages, often without benefits, job security, academic freedom, or channels of advancement (AFT, n.d.a). This is *7 out of 10 faculty* members not making a living wage or having access to the full range of teaching tools and supports, having to work beyond full course loads and multiple jobs. *One in three adjunct professors lives below the*

federal poverty line (AFT, n.d.b). These realities are not a reflection of the abilities, skill sets, training, or intelligence of these teachers, but rather an institutional strategy to maintain cheap labor. The original function of the "adjunct," a part-time teaching role for professionals with other careers for their main sources of income, stood in contrast to tenure, a system that emerged in the 1940s to protect the academic liberties of career professors. Once school administrations saw that they could get highly qualified teachers for piecemeal pay, they ran with it—and the percentages totally flipped—with 69% of higher ed teachers holding full-time positions in 1969, to 75% of higher ed teachers as contingent laborers now (Colby, 2023).

And so, this so-called "precariat" of highly qualified, under-supported teachers is leading students who are up against surging tuition costs (a 173% increase in the last 40 years, while earning has increased by just 19%) (Colby, 2023). Currently, 40% of college students drop out before the completion of their degrees, in massive debt, without the "earning potential" to get out of the debt, and therefore likely to default on their loans. Again, only 6 out of 10 students who enroll in university will earn a degree (Colby, 2023).

These percentages become more disturbing when gender and race are taken into account. Of the 40% of undergraduates who do not finish their degree, the majority are Black, Latinx, and Indigenous students. And for faculty, 80% of tenured and tenure-track positions are White (and 53 percent of them are male) and of the contingent (adjunct, non-tenure track), 73 percent are White (34 percent male), and 27 percent are Latinx, Asian, African American, and Indigenous American (15 percent male, 13 percent female) (Colby, 2023). As of studies conducted in 2020, only 3 out of 10 tenured faculty are women. Pay for women in academia continues to be significantly lower as well (80% of what men earn) (AAUP, 2020).

These percentages indicate that for students, pressures leading to noncompletion fall along racial lines, and for faculty, positions in higher education viable to sustainable careers are still held nearly exclusively by White men. Although there is a rise in underrepresented identities in the faculty base in higher education, most of this increase is in contingent positions. There is also correlation between schools with students at risk of noncompletion and higher concentrations of contingent faculty (again, faculty with less support to be supportive to students). The American Association of University Professors sums up the overarching concern and interconnectedness: "Faculty working conditions are student learning conditions" (AAUP, 2006). And faculty systems of oppression are student systems of oppression.

The pandemic has brought some of these realities to a more widespread light, as awareness around work conditions has increased, furthered by incredible waves of collectivizing, strikes, and demands

in higher ed across the United States, as well as a halted presidential plan to forgive student debt that has captivated public attention. But there is still a veil of quiet politesse, fear, ignorance, and cultivated silence that pervades academia and preserves an abusive status quo. In addition to the more major waves of collective action, there are micro-advocacies that can and must happen within departments, classrooms, and schools and homes to illuminate and denormalize these entrenched and ubiquitous systems of harm. These center largely on transforming silence into language (and action).

For transforming silence into language, a first step could look like educating colleagues and students on the foregoing realities and statistics. More and more adjunct professors that I know are including "labor transparency" clauses in their syllabi explaining what it means to be an adjunct and how students might be impacted by adjunct labor. Here is an example from my own:

> I am one of the 70% of professors in higher education known as an "adjunct" instructor. Adjuncts are hired on a semester-to-semester basis, paid below "full-time" professors, and do not have protections and privileges. Adjuncts are as qualified as their appointed peers, yet are operating within a system of structural exploitation now endemic to the American University system. The majority of adjuncts are women, NB, and people of color. Students are ultimately the most affected by these labor conditions. The more we know, the more we are able to advocate for more equitable systems. Happy to discuss further.

Individuals within the system with any privilege to do so could be frank during faculty meetings about conditions and pay, engage in the sharing of earnings (wage transparency) and start internal documents at their own institutions. Faculty can also look up the 990 tax forms of their schools to find out who are the highest paid employees of the school; I regularly encourage students to do this, as seeing the figures for what deans and administrators are earning can really throw into perspective the perplexing mysteries around where tuition dollars go. Open discussion that emphasizes the ubiquity of this systemic problem can be a bridge into more localized institutional and departmental self-examination.

Learning about historic and present tactics for equity in higher ed is also necessary in addition to learning what ails it. Adjuncts can consider how to protect their intellectual property by looking up their institution's specific rules on copyright and syllabus ownership. Recent collectivizing wins at schools such as The New School, NYU, Temple University, Rutgers, and the UC System can offer models for study and emulation, including the fractional appointment model (pay that is

proportionately equal), salary caps and floors, examples of student and faculty solidarity, and more.

All of this work is better, and more safely done, in collectivity; however, I do think that some of the foregoing can be initiated by individual members of academic communities, regardless of whether there is a union or not (when done judiciously, of course). It may behoove outspoken educators in vulnerable positions to familiarize themselves with retaliation laws, and to partner with pro bono lawyers from national organizations like the Volunteer Lawyers for the Arts. *To be in, not of, the university* (to draw on Moten and Harney's characterization of the "subversive intellectual") demands that one resource oneself with knowledge toward protection and care and advocacy (Harney & Moten, 2013). This is the only way forward and through. And is certainly not part of the job description.

For art students, teaching artists, and educators, these forms of inquiry, ingenuity, communication, and circumnavigation are integral to the life of an artist today. They are necessary tools for figuring out how to live, make work, support one another, learn, and combat systems of oppression. Teaching students critical consciousness is not possible without turning the same lens on the structures surrounding that very teaching.

Words of Right-Now

To bear witness is not a passive act, it is an act of consciousness that leads to consequence.

—Terry Tempest Willliams

This essay offers analogy between two major ailments in arts pedagogy in higher education, pertaining to the physical matter, and the material conditions, of our teaching, learning, and making. By laying them out in parallel, they can be faced more fully, considered in all of their interconnection, and acted upon. This is what Lorde offered with the transformation of silence into language and action—that in giving expression even to pieces of experience and ideas, we gift fragments for others to build with, for action to grow, for reimagining the systems that have brought us to these points of breakage. Because the not-yet is always, and especially in this moment, right-now.

Many of us come to art specifically to be involved in imagining, visioning, dreaming, and creating the hitherto unthinkable and unrealized. We come because we do not see ourselves elsewhere and want to dream capacious dreams and bring them to reality. And we come to education to do this in community, to become *tentacular* (in the words of Haraway) and grow into forms of ourselves and our collectivities that we could never have known could be. We come to art

and to education for its possibility, its anticipated becoming, hoping for what Paulo Friere described: "revolutionary futurity . . . [which is] prophetic, (and as such, hopeful)" (Freire, 1972).

There is, as such, *hope* in knowing that transformation is possible and abundant because we have seen it in our communities, work, and selves; in knowing that trees can be words, and labor, and action, that can lead us, together, to trees again.

References

American Association of University Professors. (2006, July 14). *Background facts on contingent faculty positions*. AAUP. https://www.aaup.org/issues/contingency/background-facts

American Association of University Professors. (2020, December 9). *Data snapshot: Full time women faculty and faculty of color*. AAUP. https://www.aaup.org/news/data-snapshot-full-time-women-faculty-and-faculty-color#.ZBcbaOzML9F

American Federation of Teachers. (n.d.a). *2022 Contingent faculty survey*. AFT.org. https://www.aft.org/highered/2022-contingent-faculty-survey

American Federation of Teachers. (n.d.b). *Digest of education statistics, 2021*. National Center for Education Statistics (NCES). https://nces.ed.gov/programs/digest/d21/tables/dt21_330.10.asp

Colby, G. (2023). *Data Snapshot: Tenure and Contingency in US Higher Education*. American Association of University Professors (AAUP). https://www.aaup.org/sites/default/files/AAUP%20Data%20Snapshot.pdf

Freire, P. (1972). *Pedagogy of the oppressed*. The Continuum International Publishing Group.

Gumbs, A. (2021). *Undrowned*. AK Press.

Harney, S., & Moten, F. (2013). *The undercommons: Fugitive planning & black study*. Minor Compositions.

hooks, b. (1994). *Teaching to transgress: Education as the practice of freedom*. Routledge.

Le Guin, U. (2015). *Late in the day*. PM Press.

Lorde, A. (1984). *Sister outsider: Essays and speeches*. Crossing Press.

Roy, A. (2020). The pandemic is a portal. *Financial Times*.

Serth, R. W., & T. W. Hughes. (1977). *Source Assessment: Carbon Black Manufacture, EPA-600/2-77-107k*, U.S. Environmental Protection Agency: Cincinnati, OH.

Tsing, A. L., Bubandt, N., Gan, E., & Swanson, H. A. (Eds.). (2017). *Arts of living on a damaged planet*. University of Minnesota Press.

Yusoff, K. (2018). *A billion black anthropocenes or none*. University of Minnesota Press.

Chapter 10: Still to Come

STEVEN HENRY MADOFF

A New Technological Eruption

In the introduction to my book *Art School (Propositions for the 21st Century)*, I wrote: "Somewhere between philosophy, research, manual training, technological training, and marketing, an evolved profile of contemporary artistic practice has pressed the art school as a pedagogical concept itself to address what an artist is now and what the critical criteria and physical requirements are for educating one" (Madoff, 2009, pp. ix–x).

Art schools have remained substantially the same more than a dozen years since that book was published. True, what the pandemic and Black Lives Matter accelerated was the recognition of entrenched inequities that have long permeated curriculums and syllabi in every field, and this has brought much deeper and more active scrutiny to not only what is being taught but who is teaching. The reevaluation of systemic prejudices in the formation of studio art education mirrors every other field within education, as well as in the art world itself. We're now in the midst, as is clearly evident in the exhibitions being curated and the artists shown, of a powerful reversal of prior exhibition and collecting practices, with artists of color and Indigenous artists being recognized, art histories being revised, and art institutions addressing who they show and what they collect and restitute. At the same time, the head-on efforts to diversify teaching, faculty, and students is incrementally creating a pedagogical environment that leads to greater inclusivity in every area of artistic support—from grants to exhibitions to critical and historical writing to collecting for posterity.

Yet there is another consideration, if we are thinking about a post-pandemic art school in more equitable times, and it impels me to say that there is one technological shift that has now emerged that we need to adjust to and assimilate. In fact, this is already underway. This won't overthrow the fundamentally Bauhausian model that still inhabits most contemporary art schools—the model of material training imbricated with a belief in novel creation, alongside the art school's inevitable entanglement with capitalist art markets ever more tentacular in their grasp. But this new advance in technology, still undergoing rapid development, signals eruptive change—change that

demands new accommodations to a broader definition of the artist and, still more uncertain and quaking, a rethinking of who each of us is, of the human self.

The conditions of remote technological enablement that came with the pandemic and how we lived, worked, and, in the case of the art school, taught, brought a deeper acceptance of technology's pervasive empowerment of temporal and spatial artificiality—of at once compressed and extended space and instantaneity not found in nature that have now become habitual aspects of perception and behavior, corresponding to our haptic movement through the physical world. Of course, more generally, technology's facilitation of other forms of artificiality are ongoing in the pervasiveness of disinformation and surveillance. But now a new, pervasive technological force has burst into contemporary life and cultural consciousness: generative artificial intelligence programs that offer their tools, known as text-to-image generators and chatbots, to anyone who wants to create still and moving images, texts of every kind, music, and code—tools of immense and increasing sophistication that muddy the terrains of author, copyright, and, in a more powerful philosophical register, something almost universally lurking, slipped into the subconscious of art schools. And here I mean the long-lived and entirely anthropocentric Enlightenment concept of the individual "I" and the Romantic notion of the unique creator, linked to the idea of supreme acts of creativity fueled by gusts of ethereal inspiration and Herculean labor.

Created by engineers at deeply funded companies, such image-generators as Dall-e 2, Stable Diffusion, and Midjourney, alongside rapid iterations of ChatGPT and competing chatbots, have been unleashed and adopted at an astonishing rate by millions of people across the globe. An unending and ongoing number of mainstream articles, opinion pieces, academic studies, blogs, and podcasts have reported and commented on these tools, both in wonderment and moral distress, noting the advance toward indistinguishability from human productions, weighing the questions raised for decades in speculative fictions of machine supremacy, and promoting in turn the endurance of the human imagination.

These tools don't conceive of the people who use them as artists so much as end-users. After all, anyone can use them, and what they offer with the barest human input is the algorithmic manipulation of a seeming infinity of assets scraped from the Internet. A relatively early article on the subject stated that Stable Diffusion alone has a dataset of billions of images (Warzel, 2022). It and every other image-generator and chatbot's datasets may well continue to grow exponentially. What are these assets? They're the intellectual property of humans who have made them over centuries: digitized paintings, drawings, photographs, illustrations, lithographs, prints, and graphics of every kind, along

with animations and film and video captures, sounds, music, all of literature, scientific facts, coding languages, archives of every kind. And now, as one commentator noted, these AIs are "washing machines of intellectual property" (Plunkett, 2022).

They deliver oceans of images lifted from their authors, and for which copyright is proving an impossible restriction to enforce, though various strategies to create standards of ownership are being developed. There is yet to be any definitive jurisprudence and legal enforcement that doesn't leave all of humanity's visual production vulnerable to ethical compromise, and the issue, though it isn't the core subject of my thinking here, troubles not only older ideas of property as they continue to be levied today but also what the littoral erosion of those ideas means on the shores of contemporary and future societies, since these technological incursions are, I think, signals of irreversible motion. Some prominent repositories, such as Getty Images, have banned these AI-produced images from their sites for the time being. Along with these ethical and legal concerns is the pressing question of whether the kinds of shifts toward far greater sensitivity to equity and social justice that are finding their ways into the precincts of education and cultural institutions will help define the future of these AIs and what they generate.

Their image-production process works like this: using large language models and machine learning, engineers code the AI, feeding it training sets of images and text, which the AI learns to synthesize and manipulate with greater sophistication via increasing numbers of parameters that are detailed descriptions for taxonomic parsing, pattern recognition, and the assembly of new images from multitudinous strands of previous ones. End-users type in prompts that can be basic and broad or highly intricate in their directions: strings of descriptors of what they imagine they want to see, the process being called text-to-image and text-to-video. What happens inside the AI isn't fully understood even by its programmers. The black box of the AI is, as has already been said by many commentators, something akin to what humans have long called magic—unknown acts within an imperium of invisible production—though it's still computational data crunching. The images that emerge within seconds of the end-user's text prompts are not so much copies but diffusions generated from vast numbers of prior images; activated taxonomies whose remixes can be substantially unlike any individual stored image it draws from—something new, vampiric, those source images like zombies, neither living nor dead, brought back into the world.

Precedents

Immediately, I think about the ontological resonance of images and authorship in a range of theorizations, from Walter Benjamin's "The

Work of Art in the Age of Its Technological Reproducibility" to Roland Barthes' "The Death of the Author," Gilles Deleuze's "Postscript on the Societies of Control," and Hito Steyerl's "In Defense of the Poor Image," along with her more recent ruminations in various talks on chatbots and image-generators. Of course, there are deeper wells to draw from—Edmund Husserl's lifeworlds, Martin Heidegger's readiness-to-hand and standing reserve, Michel Foucault's considerations of resemblance and similitude, Gilbert Simondon's thinking about individuation, and Yuk Hui's meditations on cosmotechnics. There are markers within literature and art and art teaching that rise into view. After Gustave Flaubert's satirical characters Bouvard and Pécuchet, who are giddy human versions of witless copying machines, after Marcel Duchamp's readymades—who said of his shift from painting, "You see, I was already disgusted with my hands. I just wanted things to get to the surface on the canvas by themselves, from my subconscious if possible" (de Duve, 1991, p. 173)—after Sturtevant, Andy Warhol, Sherrie Levine, after the pedagogical routines of the Ancien Régime's academies in which copying and imitation were the students' primary tasks and the Bauhaus's *Grundkurs* in which the transformation of materials was at the core of the entire education, how can we ignore these precedents in the face of AIs within reach of every art student, every art teacher, every end-user? These precedents are the philosophical, conceptual, artifactual, and pedagogical strata beneath the new productions and ethical quandaries of AI as its processing moves toward the cognitive capacities, including sentience, of artificial general intelligence.

Let me place this new technology in the continuum of earlier thinking about machinic image production and its relation to human intelligence and imagination—in fact, into the frame of our sense of humanness that directly shapes how we think of ourselves as artists and teachers of artists. If Walter Benjamin famously sought to address "The Work of Art in the Age of Its Technological Reproducibility" by proposing that "the here and now of the original underlies the concept of its authenticity," needless to say, this isn't the sole case of experiencing artworks anymore. Transposition and transmissibility intrigued Benjamin, not only for photographs and filmic scenes but for musical recordings as well—the choral concert in the church now audited in a person's living room. For Benjamin, the shifting, weightless nature of mechanical reproduction meant that the "authority" of the object was lost, which he then called the "aura" of the work: "What withers in the age of the technological reproducibility of the work of art is the latter's aura" (Benjamin, 2008, pp. 21–22), as has been cited endlessly. Now, the questions of aura and authenticity are seen from the vantage point of the world's inheritance of what Benjamin foresaw, exponentially accelerated.

Of course, the physical experience of a painting on a wall in proximity to our bodies, the here and now, remains a specific sensory and cognitive relation. The concern about the photograph or film as a deracinated object, distant from its originating subject, if fundamentally true, has nonetheless, and for a long time, been washed over by the sheer plenitude of image production in every format that makes its artifacts feel simply like everything else in the furnishing of the visible world. Whole generations have grown up with another experience of images, both still and moving (as well as music), in which the intermediary surface of screens feels no less specific as a generator of authentic—that's to say, felt—experience, spatially different yet an equal habit of contemporary bodies. A variety of screenspaces, from desktop machines and laptops to mobile phones, gaming devices, and the slow advance of AR and VR headsets, have made transmissibility and situatedness hyperactively fluid, abstract, instant, and, again, habitual.

Even prior to the advent of AI image-generators, the idea of the photograph, as we all know, had shifted from enabling the sole intention of the exact reproduction of things to the making of altered reproductions via complex digital manipulations now made so simple in contemporary applications that anyone in a matter of a single second, a single tap on a key or screen, can hack the world's vast image repertoire with subtle variations or profound revisions. Further, the miscoding of digital objects, what Legacy Russell has written about as "Glitch" culture, is an instrument of cultural and political intervention and alteration. In these ways, Benjamin's worry over the aura of the original and what it meant as a reading of capitalist exploitation in the particular case of the reproduction of artworks seems far less dire compared with the impact of these new means of image production and how they're received, understood and misunderstood, and exploited. Further in the philosophical register I noted at the start of this essay, no longer is the concern only about authenticity and physical presence but also, more fundamentally, about the ontological supremacy of being human and what lies beneath the very assumption of that origination and authenticity now and in the future.

The Recombinatory Image and the More-Than-Human

With AI image-generation, the modularity of data reconceives reproduction and copying down to the molecular level, its underlying data, as I've said, so diffused that this new technological form isn't about the reproducible but about the recombinatory. As well, rather than a matter of depreciation or decay, as Benjamin claims for the mechanically reproduced image, the digitally conceived and produced image was never spatially other than it was (and is).

If it were to be critiqued as "distant" from some internal originary potency within the Benjaminian worldview (with inevitable shadings of a theological primacy), digitally screenscaped images offer themselves intrinsically as what could be called presence-as-distance. Implicit in the numerical abstraction of bytes and pixels that construct these images and are on the other side of the screen is an image always one layer away, though again, for those growing up in an *umwelt* of screens, the haptic relation *feels* physically present, right in front, hung on a wall, placed on a table, held in one's hands, and often manipulable. From a pedagogical perspective, of course, the pixeled image, whether made for screen or physical support, has for decades and with increasing sophistication been taught through tools such as Adobe's Photoshop and Illustrator. In other words, the use of digital means is far from new and is essentially an extension of older manual practices employed by artists. For decades these tools have been accepted as more arrows in the artist's quiver, taught to students to gain proficiency, while this practical teaching never really questions the centrality of the author of the work or the concept of author and its underlying ascendancy of personhood.

Now, with the more imminent fear that AIs will surpass human sentience, the recombinatory images being produced, and those to come, present an expanded causal chain for their operation. They signal a new collaborative collectivity, and with it a reframing of the human self, the agential actor who is, again in this case, the artist and the teacher of artists at work in art schools. There is, of course, the danger in these generative AI systems of social bias being spewn from their datasets, though filters are rapidly being developed to correct this. Yet none of this means that the premise of the solvency of the human imagination at the core of any art school is at risk—only that we need to place the art school as the laboratory of imagination within the context of our transformative historical moment in which the recognition of human Otherness and, beyond it, of other intelligences has swung fully into view. So James Bridle points out in *Ways of Being: Animals, Plants, Machines: The Search for Planetary Intelligence*, in which he tries to understand AI within the widest circumference of sentience. He writes: "If all intelligence is ecological—that is, entangled, relational, and of the world—then artificial intelligence provides a very real way for us to come to terms with all the other intelligences which populate and manifest through the planet" (Bridle, 2022, p. 52).

Trees and fungi, octopi, baboons, and climatological systems all express networks of intelligence in the more-than-human world. Bridle goes on to remark that the invention of cybernetics nearly 75 years ago already pointed toward "a way of thinking about more-than-human

minds that closely corresponds with our rejection of hierarchical, anthropocentric, 'intelligent' thinking and our embrace of agential, relational being" (Bridle, 2022, p. 152). Earlier writers, as I've already noted, can be said to have laid the ground for Bridle's thinking, though from a specifically human-centric vantage, interrogating authorship and affect within the anxious sphere of what it is (or was) to be an "I," increasingly sensitized to a more complex, congested, and interrelational world. Barthes's essay on the death of the author follows Benjamin's concern about the death of the aura. Both are essentially thinking about the distancing of the self from itself, about changes accruing that revise an understanding of the self, of the I that makes, a remoteness creeping in that can be thought of as a ramifying linkage, and in fact that the maker is a sort of noncentric, already-networked apparatus compiling and remixing. Barthes, proposing the true nature of writing and writers, states: "We know now that a text is not a line of words releasing a single 'theological' meaning (the 'message' of the Author-God) but a multi-dimensional space in which a variety of writings, none of them original, blend and clash. [. . .] Did he wish to *express himself*, he ought at least to know that the inner 'thing' he thinks to 'translate' is itself only a ready-formed dictionary" (Barthes, 1978, p. 146).

From the time he writes this in 1967 to Steyerl's technosocial assimilation in 2009 of what mass image manipulation and distribution augur, the ready-formed dictionary that is the Internet had inverted the decay of the aura as a negative. Her "In Defense of the Poor Image" is farther along the way to generative AI's recombinatory image. "The economy of poor images," she observes,

> with its immediate possibility of worldwide distribution and its ethics of remix and appropriation, enables the participation of a much larger group of producers than ever before. [. . .] Apart from resolution and exchange value, one might imagine another form of value defined by velocity, intensity, and spread. Poor images are poor because they are heavily compressed and travel quickly. They lose matter and gain speed. But they also express a condition of dematerialization, shared not only with the legacy of conceptual art but above all with contemporary modes of semiotic production. Capital's semiotic turn, as described by Felix Guattari, plays in favor of the creation and dissemination of compressed and flexible data packages that can be integrated into ever-newer combinations and sequences." (Steyerl, 2009)

In her more recent thinking, Steyerl speaks of the vast detrimental consumption of natural resources, of energy resources and therefore

also of human labor, required to scrape digital assets and for these new creative forms of AI computation to produce such that what is digitally rendered and dematerialized is nevertheless materially dependent and ruinously extractive.

In terms of semiotic production, we need to think as well about the self entwined with these hyperactive forms of image and text creation, for the I/author/creative producer/generator is also hybridized, extracted, redistributed. The inner thing is now inextricably joined to the outer/relational/distributive agency of the the AI as a non-I. This processual revision from the loss of the auratic center of the producer to the linkages of a global, ready-formed, and ever-increasing aggregation of the artifactual dictionary of human expression points at first to what Deleuze called the "dividual," the revision of the Enlightenment's projection of individuality by which each I, each subjective self, is reconceived computationally as a divisible entity of statistical use for capitalist consumption and control (Deleuze, 1992, pp. 3–7). Even if we aren't yet at the point of a fully dystopian extreme, what we're now seeing with the advent of generative AI production, which diffuses humanity's past toward what could be called "humachinic" recombination, is the sign of the self, of the I disappearing into the algorithm—at least at the edge of what human-ness has meant. The flattening out and spread of the poor image that Steyerl noted can also be seen as a flattening out of the I that is no longer solely an I, no longer solely autonomous—the image-maker also recombined and spread.

Not the Other, but Otherlessness

Of course, digital images are no longer poor. The resolution of digital images is already extraordinarily high, while those produced by image-generators can be essentially indistinguishable from the most photorealistic pictures. Steyerl closes her essay in an activist register of emancipatory nonconformism, which is to say, of human-centric involvement. Yet what generative AI is obviously and practically about is an operative chain in which text input driven by human imagination is joined beyond itself with another kind of producer. Not simply manipulation, not human revision through an extension of manual thinking, but a globally ramified, somewhat mysterious collaboration of something not originary in the traditional humanist sense—something without an Adamic necessity for Omega, of Barthes's "Author-God." We are entering a different foundational condition in which the "dividual," tied still to the Enlightenment concept of the individual, is no longer apposite, just as the promotion of artificial intelligence as an Other is inaccurate. While the idea of the Other remains anthropocentric, the internal machinations of AI as a processing entity itself operate outside that *umwelt* of the I, of the aura, of subjectivity, of difference from, of

sentient use for a distinction between simulation and reality, of author, property, copyright, of hierarchy, of bio-optics. In this sense, AI is not an Other, but other than Other. Not an I in relation to our I, but a technological entity that is best considered in terms of an ontological Otherlessness, just as the recombinatory images of generative AI represent an apotheosis of that Barthesian pluri-author that produces outside the terms of a prioritized original.

I think of W. H. Auden's opening lines in the poem "Lullaby," "Lay your sleeping head, my love, human on my faithless arm" (Auden, 1991, p. 157), and see an asymptotic version of a dreaming world without dreams in which generative AI is always operative—whose head is its computational engine and has no need of an anthropological condition of faith or desire, only algorithms and bits extracting and dissolving the human scene without the burden or penalty of affect, without fatigue or sleep. For now, both the human imagination and the black box of AI image-generators and chatbots are oracle machines, and their co-productions are images and texts falling from our minds into the world as much as they are the efflorescence of computation. These AIs indicate another horizon line, a more integrated, collective collaboration than we have previously known, albeit with the dangers of prejudicial pollution still to be addressed more effectively. What this prospect presents, as I've noted, is this hybridized worlding of worlds—not as philosophy or semantics or biological restriction, but as multiform modalities of production. Humans will make works without digital tools and with them, and machines will ultimately make works autonomously in that condition I've just described as Otherlessness.

What this means at this moment for the art school teacher who is handed an image-generated work as a student's own is that the teacher must revisit, revise, and supplement their Western assumptions of the artist as an altogether unique and self-contained progenitor striving for sui generis creation. That notion is ultimately underwritten by the old idea of individual selfhood—a concept developed hundreds of years ago as the proclamation of a universally noble self that we now understand as a triumphalist (White) colonizer of the order of all being, sociality, and power. Along with greater sensitivities to equity, inclusion, and social justice at the time of the pandemic that I began this essay with, in which Otherness is restoratively valued and projected forward institutionally, this assimilation of an entirely different, recombinatory, more-than-human world that is now present needs to be accounted for. Not like an Illustrator fill tool that has to be taught, but accommodating another accounting of what it is, in a broader and active verbal sense, to fill a transforming world and be filled by it.

If there is to be an advance in art school education, along with all that's already taught today, there will have to be an accommodation,

as well, even to the idea that creators working with these new image- and text- (and sound- and code-) generators want, in a Duchampian sense, to get their creations to the surface as quickly as possible without their hands to paint or take pictures. Instead, they *take* pictures from fathomless datasets and use words as prompts instead to give primacy to the weightless velocity of the imagination. And with this dilation of pedagogical thinking, new courses ought to enter the curriculum that look deeply into what association and kinship, collaboration and confederation, collectivity, and hybridity mean in this reconfiguration of I and author, of the I itself. Courses on copyright and intellectual property as ethical dilemma and legal prerogative should join them if art students are to understand what technological reproducibility, and beyond reproducibility, mean for the work they'll do with these new tools. The old notion of civics, rewritten to assimilate ideas of multiple intelligences and interlocked forms of sociality and being, should join these other courses. And with these courses, there need to be workshops in which students are taught how to form the most creative and exacting prompts possible to accomplish what they imagine. (A new profession of prompt engineers is already here.) In all of this, it's crucial to understand that humans are not just training machines; machines are training us as well. This is all of a piece in deepening who we are, in our Otherness and with the Otherless, as we teach and learn what it is to make and be in this more-than-human-world, and inevitably in the incrementally and radically altered world to come.

References

Auden, W. H. (1991). Lullaby. In E. Mendelson (Ed.), *W. H. Auden: Collected poems*. Vintage International.

Barthes, R. (1978). The death of the author. In S. Heath (Ed. & Trans.), *Image-Music-Text*. Hill and Wang.

Benjamin, W. (2008). The work of art in the age of its technological reproducibility. In B. Doherty, E. Jephcott, T. Y. Levin, R. Livingstone, & H. Eiland (Eds.), *The work of art in the age of its technological reproducibility, and other writings on media*. Harvard University Press.

Bridle, J. (2022). *Ways of being: Animals, plants, machines: The search for planetary intelligence*. Farrar, Straus and Giroux.

de Duve, T. (1991). *Pictorial nominalism: On Marcel Duchamp's passage from painting to the readymade*. University of Minnesota Press.

Deleuze, G. (1992). Postscript on the societies of control. *October, 59* (Winter), pp. 3–7.

Madoff, S. H. (2009). *Art school (propositions for the 21st century)*. MIT Press.

Myers, T. H. (2023, April 8). Can we no longer believe anything we see? *The New York Times*. https://www.nytimes.com/2023/04/08/business/media /ai-generated-images.html

Plunkett, L. (2022, August 25). AI creating "art" is an ethical and copyright nightmare. *Kotaku*. https://kotaku.com/ai-ar-dall-e-midjournety-stable -diffusion-copyright-1849388060

Steyerl, H. (2009, November). In defense of the poor image. *e-flux journal*. https://www.e-flux.com/journal/10/61362/in-defense-of-the-poor-image/

Warzel, C. (2022, September 7). What's really behind those AI art images? *The Atlantic*. https://newsletters.theatlantic.com/galaxy-brain /6317de90bcbd490021b246bf/ai-art-dalle-midjourney-stable-diffusion/

In the early days of the pandemic, we were forced
to quickly rethink the studio art curriculum
for a remote and online context. Students and
faculty were each grappling with the uncertainty,
anxiety and alienation of sheltering in place,
while attempting to continue artmaking and art
education as if we could simply pick up where we
had left off. I realized early on that the classroom
and syllabus had provided a spatial and temporal
structure that instigated interactions amongst
students outside the stated objectives of the
class. While we faculty were focused on how to
teach students mold-making or performance
through Zoom, we struggled to enable the kinds
of collaboration and cross pollination that used
to organically build within a student group
meeting in person. Indeed, when I reflect back
on my own experiences as a student, those
interstitial interactions stand out more than the
official content exchanged in class. I bring this
realization to my classes post pandemic. I see
my role primarily as creating sites of possibility
for students to have unplanned experiences
of connection and learning with each other. I
ask myself: how can I create the conditions for
trust, intimacy, and camaraderie to develop
amongst a group of students, so that they may
share, disagree, collaborate and teach each other
thoughtfully and respectfully?

—Sreshta Rit Premnath

I used to teach art like we were in Sunday School. Have faith, and if you are blessed, you may be elevated. I used to think it was possible to know "good" from "bad" art. Like most folks, I confused taste with judgment. I have lost my faith in such pronouncements. A thousand years of playing chicken with "the man behind the curtain," and now "they" are calling "our" bluff. COVID-19 amplified this. Currently there is an opportunity to rethink things, to see more clearly. The catch is that we still need money for a place to sleep and three squares. I try to support my students. I try to armor them against slings and arrows. I urge them to stand in front of work, to see it for what it is. I try to give them some skills and knowledge that will help them pursue their own paths.

—Lane Cooper

I used to teach at ... like we were in
Sunday School. Have faith, and if you
are blessed, you may be elevated.

I used to think it was possible to
know "good" from "bad," but like
most folks, I construed taste with
judgment. I have put my faith in such
pronouncements. A thousand years
of playing chi ... "the man
behind the ... now "they"
are called ... COVID-19
supplied ... there is an
opportunity ... things, to see
more clearly ... te that we still
need money for a place to sleep and
three squares. I try to support my
students ... but their agony
slings and arrows. I urge them to
stand in front of work, to see it for
what it is. I try to give them some
skills and knowledge that will help
them pursue their own paths.

Chapter 11: Imagining Elsewise

MICK WILSON

> Sociotechnical imaginaries are generally future-oriented visions of connected social and technological orders, with more or less determinism built into them. . . . They are infrastructures of imagining and planning futures.
>
> —Sismondo, 2020, p. 505

> The ascendancy within the contemporary art system of e-flux announcements, social media posting, art-blogging, website mediation of exhibition, and jpeg-enabled art sales has been in place for some time. Further complicating these developments, there are the various technological dimensions of the re-ordering of some contemporary art markets as integral to . . . a new financial asset class with the much-vaunted claims for algorithmic value mapping, blockchains and NFTs. . . . In what seems like a global institutional convergence—similar in ways to the pervasive distribution of the white cube though much more accelerated—there has been a widespread adoption of the exhibition-online as the immediate solution to the demands of physical distancing, lock-down and travel restriction in the context of the global pandemic.
>
> —Slager & Wilson, 2022, p. 2

> I think it really quite dramatically improves my confidence that a city on Mars is possible. . . . That's what all this is about.
>
> —Davenport, 2015

This text responds to an invitation to imaginatively project some ideas that might play a role in unfolding the possible futures for studio art teaching in higher education in the post-pandemic moment. It seeks to map out something of the challenge faced by any attempt to formulate future visions within the current conjuncture. It does so by appealing to the idea of the social imaginary and considering the rhetorical conditions of any future vision that seeks to win the assent of a wider collective. It is not a vade mecum. It is rather an attempt to access a horizon beyond the dominant dispensations as to what is practicable and pragmatic within art education. (This approach might be contrasted with that of James Elkins in his 2014 *Art Critiques: A Guide.*) It proposes to access the scenario of a world imagined elsewise, not in a bid for escape nor in a rehearsal of institutional critique nor through

a performance of radical dissidence. In place of these stratagems, it proposes a simple but perhaps counterintuitive affirmation that—to rework the familiar slogan—*another possible is world*.

The Future Is Not What It Used to Be

In the mid-1990s, David Noble published a fascinating essay—"Selling the Schools a Bill of Goods: The Marketing of Computer-Based Education"—on the push from the 1960s onward to technologize the classroom with particular reference to the U.S. American context (Noble, 1996). Editing a book recently that addresses the massive proliferation of online modes of exhibition in response to the COVID-19 pandemic, I was prompted to reread Noble's text (Slager & Wilson, 2022). The push to technologize the classroom as described by Noble is suggestive of an analogous impulse to technologize spaces of exhibition and mediation within the museum. Both pushes for the application of computing resources in novel settings emerged before the advent of the Internet and mobile wireless devices. Both are greatly informed by a species of futures thinking predicated on technological determinism and the inevitability of technological progress.

It is noteworthy that this discourse on technological progress has been thriving during a period that saw the rise of a very different discourse, one on the postmodern with its various announcements of the loss of confidence in metanarratives of progress; the end of history; the collapse of modernist futurity; and with these the end of the avant-garde, the derailing of the teleological narrative of self-purifying medium specificity, and the unredeemed promise of high culture's bulwark of aesthetic value to fend off the fraudulent incursions of the low, the mass produced, and the popular. Arguably, technological determinism, attributing historical agency to the autonomous evolution of technology, has been an enduring progress narrative that has framed much of the way in which futures thinking in general, and future thinking on higher education in particular, has unfolded for many decades.

There is a special USA-inflection of this, because of the ways in which the narrative of technological progress has been historically deeply entwined with the narrative of nation. Frederick Jackson Turner made the famous proposition—at the end of the 19th century when the frontier was already deemed to be "broken up" as reported in a note on the 1890 census (Porter, 1891, p. 4)—that "the peculiarity of American institutions is, the fact that they have been compelled to adapt themselves to . . . the changes involved in crossing a continent, in winning a wilderness" (Turner, 1893). Turner asserted that "this progress out of the primitive economic and political conditions of the frontier into the complexity of city life" was the engine of American exceptionalism. The frontier was presented as the structuring logic of

American futurity. In the course of the 20th century this overarching narrative of frontier futurity was reworked so as to posit the horizon of technological innovation as the new frontier, as Michael L. Smith proposed: "in the absence of a geographical frontier, mainstream American culture placed new emphasis on an alternate iconographic terrain: the technological frontier" (Smith, 1994, p. 43).

These narratives of the technological frontier operate a paradox. On the one hand, there is an autonomous and self-producing drive internal to the development of technology, as a kind of second nature, a "brute technology" (Kerr, 2001, p. 37) to be exploited, domesticated, made over as a new civilization. On the other hand, the development of technology is seen to demand, to be contingent upon, the focused and planned effort of human agents ("human capital") to drive innovation and build the future. Famously, in the aftermath of Sputnik, JFK invoked the "New Frontier" explicitly framed in terms of science, technology, and the space program as the galvanizing mythos of the nation's future: "We stand today on the edge of a New Frontier—the frontier of the 1960s. . . . Beyond that frontier are uncharted areas of science and space. . . . I'm asking each of you to be pioneers towards that New Frontier" (Kennedy, 1960).

The extension of this frontier futurity into the arena of the technological has been a key rhetorical framework for all manner of policy and planning, notably deploying the "national" so as to disavow the fault lines of race, gender, and ethnicity. Clark Kerr in his influential (1966) *The Uses of the University* provides an emblematic case of this rhetorical framing when he writes:

> Each nation, as it has become influential, has tended to develop the leading intellectual institutions of its world—Greece, the Italian cities, France, Spain, England, Germany, and now the United States. The great universities have developed in the great periods of the great political entities of history. Today, more than ever, education is inextricably involved in the quality of a nation. It has been estimated that over the last thirty years nearly half of our national growth can be explained by the greater education of our people and by better technology, which is also largely a product of the educational system. (Kerr, 2001, p. 65)

This futurity of the technological frontier is multivalent and has provided different resources for visioning and imagining multiple futures, ranging from the giddy pronouncements of techno-utopianism to various forms of radical dystopianism. Seeking for more recent iterations of this techno-frontier futurism, one might consider the "billionaire space race" where various mega-rich figures compete to initiate grand schemes of self-sustaining off-world habitations,

with their projected colonies on the moon and mega-cities on Mars. While clear continuities may be seen in this techno-frontier futurism, there is also a radical discontinuity apparent in the transfer of agency from the national imaginary of citizen "pioneers" to the egotism of billionaire entrepreneurs. Given these radical displacements of the national collective subject, it seems reasonable to say that a radically different economy of futurity emerges whereby a nation-building project (albeit an imagined community of rugged individualists) is displaced to make way for an ever more radical imaginary of individualism that envisions sociality itself—living with each other— as an entrepreneurial production *ab initio*. It is important that this also coincides with a symbolic struggle over the construction of both nation and state themselves, marked by competing attempts at the radical reconstruction of the origin narrative of the nation and the attempted wholesale delegitimization of core public institutional frameworks.

There are many other dimensions to the changing terms of the techno-futurist discourse, especially when we turn to the global imaginaries of technology and culture. This intensification of life on screen and the expansion of digital networks to become the fundamental circuits of everyday existence happens at the same time that large digital media corporations and data harvesters are pushing to digitize public cultural institution holdings and collections. For example, "Google Arts & Culture" announces itself "as a non-profit initiative" that works with "cultural institutions and artists around the world" and asserts that "together our mission is to preserve and bring the world's art and culture online so it's accessible to anyone, anywhere" (Google Arts & Culture, n.d.). This universalist discourse of technological redemption is in contrast with a nationalist discourse of exceptionalism; however, both draw upon a foundational and enduring technological progress narrative, a variety of modernist futurity that persists beyond the horizon of the postmodern.

These opening observations on how a rhetorical framing of American exceptionalism extending from the territorial to the technological frontier has provided one framework for institutional future visioning, are made by way of foregrounding the rhetorical—that is to say the suasive—resources that any projections of the future must draw upon in making a bid for acceptance and in seeking to recondition the wider social imaginary. I do not intend to make the sociotechnical imaginary the central or exclusive focus of the discussion here. Rather my purpose is twofold: (1) to use this as a means to open onto a wider field of rhetorical framings in the imagining of futures in general, and of the futures of higher arts education in particular; and (2) to foreground something of the changed conditions within which the future imaginaries of institutions are elaborated.

Meanwhile Back in the Studio

The techno-futurist discourse outlined previously has made inroads within the higher arts education field. The recurrent refrain of interdisciplinarity as virtue belongs to this discourse: "In today's world the lines between the arts, technology, engineering and the sciences are increasingly blurred. The leaders of tomorrow must possess a solid foundation in the traditional arts as well as expertise in new technologies and innovative ways of thinking" (Purdue University, n.d.). As Singerman noted in his classic study of the institutional professionalization of the artist in the United States, there was already in the 1970s a recognition of institutional art education as a site where newer technologies were being transferred into the operational spaces of art making (Singerman, 1999, p. 158). Arguably in manifesting a somewhat reactive dynamic, studio arts education has also been a site where a broadly humanist and—what may be partly specified as—a *counter-discourse* has emerged and endured in spite of the overriding drive to professionalize the field. This counter-discourse centers on individual creativity and the holism of the artist-subject as the fully actualized autonomous human that is the outcome of the educational formation. Singerman's book maps out the way that fine art education was seen, at the opening of the 20th century, as a site that offered "a clue as to the whole of humane learning" (Singerman, 1999, p. 21) and how this exemplary humanism was over the decades displaced by an ethos of professionalization. In Singerman's account, "artistic subjectivity" in becoming "the university's problem and its project" was "written over and over in the likeness of the university professional." Nonetheless, there persists within higher arts education a particular version of liberal individualism, comprising a residual humanistic layer that continues to resonate in an instrumentalist discourse on creativity and the cultivation of individual creative talents.

The relay between an instrumentalist framework of human capital formation and the residual humanism of higher arts education is evident in the field of research that seeks to specify effective pedagogies for fostering creativity. As an illustrative case, consider a paper on "The Influence of Institutional Experiences on the Development of Creative Thinking in Arts Alumni" (Miller & Dumford, 2015) that opens by first remarking how creativity is "increasingly cited as an important skill for the 21st-century economy" and concludes by foregrounding the intersubjective dimension of student–faculty interaction leading "to enhancement of creative skills." In the discussions of the post-pandemic transfer of studio arts education into the circuits of digital networks, the themes that are foregrounded in this research are partly echoed, most notably with a focus on the changing nature and tenor

of student–faculty interaction, suggesting both a disruption and a "hyper-personalisation" of these. There is also a focus on the spatial reordering of the institutional setting from the fixed locus of the room on campus—"classrooms, labs, and studios"—to the distributed networked sites of home, office, and all manner of everyday elsewheres. There is also a focus on how the attenuated materialities of screen encounters displace "direct contact" into the cascading mediations of virtual contact. These themes are not only resonant with the themes already foregrounded in the pre-pandemic discourse on pedagogies for creativity, they also echo the themes at play in the pre-pandemic discussion of the societal impacts of mobile telephony, social media, and life-on-screen. This thematic continuity may be seen to mark the pandemic as a moment of intensification of processes that were already well underway before any fateful cross-species viral transference in a market in Wuhan emerged as a global health crisis, bringing death to many millions.

Another focus, in the reflections by studio arts educators on their changed conditions of encounter with students, is on the changing terms of the actual practices of art making. There is an emergent tendency identified as "a new type of carceral aesthetics" that requires no particular materials or equipment but instead "prioritizes community engagement and social justice issues."[1] This seems to be also partly continuous with a pre-pandemic "social turn" already apparent in the 1990s and 2000s. However, it may be that we are also seeing something that indicates the action of another set of ideas, values, and social percepts that are not reducible to the familiar tropes of the social relations of the liberal subject and the residual humanism of creative individualism. The turn to the social has been marked by a resurgent collectivism that is polycentric and not delimited within the hegemonic prescriptions of the art systems of the Euro-Atlantic or the global North. Ruangrupa's extraordinary reconstruction of *Documenta* in 2022 may be taken as indicative of this. This is not the social turn around that Claire Bishop's 2006 *Artforum* essay pivots (Bishop, 2006). This is a turn to social imaginaries that operate through other genealogies and from other scenes beyond any Euro-Atlantic centrism. This may be seen for example in Chimurenga's relationship to Festac '77 (Chimurenga, 2019). It may also be seen in Ruangrupa's contexts of emergence within the geopolitically specific traditions of cultural activism and collectivism that are not reducible to the terms of the relational aesthetics or social turns immanent to the histories of the Euro-Atlantic's fine arts and aesthetic paradigms (Antoinette & Maravillas, 2020).

1 This is a reference to the terms used in the editorial brief for the current volume.

In what follows I wish to consider some of the ways in which a futures visioning might opportune different rhetorical framings and different imaginaries: different that is, from both the technofuturism that I opened with and the residual humanisms of creative individualism that I have summarily rehearsed here under the rubric of "back in the studio." The rhetorical frames that I turn to here are those of survivance and climate crisis. I specifically turn to these because of the ways in which they open out possible constructions of the social that are not reducible to the intersubjective, the economic, or any putative social contract among self-possessing individuals.

After the End of the World

> American Indian people have recently experienced the end of the world. . . . They are postapocalypse people who, as such, have tremendous experience to offer all other people who must, in their own time, experience their own cultural death as part of the natural cycle. The ways in which American Indian people have suffered, survived, and managed to go on, communicated through storytelling, have tremendous potential to affect the future of all mankind. The process by which this information might be organized is temporal unification of the past and future with the present.
>
> —Larson, 2000, p. 18

The attribution to these "American Indian people" of an experience of the end of the world might seem at first to be the flip-side of Turner's frontier thesis, a corollary narrative of world-ending and genocidal violence with what must at first appear as a strangely cruel proposal to further extract value for the universal ongoing "all mankind" by drawing insight from the sufferings and survivals of a particular "postapocalypse people." However, as Sidney Larson, Geralda Vizenor, and others have shown, it's quite a different story. The temporal reordering that enacts *after-the-end-of-the-world* as an integral past-present-and-future takes us out of the chronological framing of the narrative of nation and into a temporal imaginary that structures the collective experience of survivance. Survivance is a historical consciousness and continuity within radical discontinuity that is not limited to the narrative of "temporally ordered sequences of events that are causally linked," nor to operating an exclusively one-way flow of determination: Survivance is not about an event of origin that unfolds monologically and inevitably toward a pregiven telos or a manifest destiny. Survivance is not a counter-history but an elsewise grammar of living–dying time. Survivance, while speaking to an imaginary of blood and soil, has a potential to place us beyond the ethnonational, beyond identity categories of the U.S. Census and beyond the claims of the living blood quantum. Survivance seems to propose a time-thinking that is not tracing and claiming biological

ancestry among the colonized, the enslaved, the indigenous, and the oppressed. Survivance is a mode of historical consciousness that is not operated primarily as a claim for individual genetic heredity. In survivance the ancestor is not the transmitter of genes or biopolitical markers. The ancestor is that stranger kin that continues to resist those very same biopolitical inscriptions that categorize, separate, and distribute who is to live and who is to die.

Survivance may be contrasted with other modes of imagining the continuities and discontinuities of life–death. In his correspondence with James Madison, Thomas Jefferson offers one of the most succinct and rhetorically sharpened exclusions of the dead from community with the living: "I set out on this ground, which I suppose to be self evident, 'that the earth belongs in usufruct to the living': that the dead have neither powers nor rights over it. [. . .] The earth belongs always to the living generation" (Jefferson, 1958; orig. 1789). Jefferson elaborates his thinking on this point, noting that the "principle that the earth belongs to the living, and not to the dead, is of very extensive application and consequences, in every country." The Jeffersonian exclusion of the dead from community and common property with the living is a classic example of a modern ordering of life–death, time, and the social that segregates the living and the dead and frames the dead as forfeit of their claims upon futurity, along with any claims upon property. There has been much recent scholarship on the question of how mortality has a central role in the constitution of temporal and social imaginaries that is not limited to this colonial modern exclusion as proposed by Jefferson. Within this scholarship there is a reimagining of—as Hans Ruin's book (2018) terms it—*Being With the Dead* that seeks to access a different social ontology and a different temporality of living with the dead. This moves along a related though different path to that of survivance. These imaginaries of survivance and of being with the dead draw us into different ways of constructing the social and different modes of futurity. What happens when we try to project futures from within these very different ways of constituting life–death, temporal flow, and social relation?

However, before rushing to make a claim for futurities built upon these elsewise social imaginaries, some reservations demand consideration: What happens when one tries to think elsewise futures within a societal dynamic marked by an intensely violent contestation of collective historical consciousness? What possibility is there for thinking elsewise, within a moment of sharpened conflict, sectarian violence, and the highly orchestrated politics of fear? I write at a moment when that which for some is the obligation to speak the truth of the foundational violence of genocide, enslavement, and systemic exploitation is for others a divisive, faux-moralizing, and treasonous betrayal of the very foundations of personal liberty, equity, justice, community, and order.

I write at a moment when a new distribution of drought, famine, flood, fire, plague, storm, and war manifest the changed climatic conditions of the carbon economy, but where no collective planetary political intelligence appears capable of forming and scaling itself to counter the systemic regime of these catastrophes. This is also a moment marked by a pervasive sense of corrosion in an (always already compromised) public discourse where mendacity and fantasy, deceit and delusion run riot. (One might pause to consider which polity is being described here: Brazil? China? Germany? Hungary? India? Russia? South Africa? Turkey? Ukraine? United Kingdom? United States?) Given the regime of terrorizing fantasies and the seeming incapacity to collectively cognize the ecological and environmental collapse that already unfolds, is it not a little reckless and foolish to appeal to imagining elsewise? Given all this horror, what chutzpah, what world-oblivious naiveté would dare to utter the clichés of imagining another world? Indeed, within what distribution of water, food, shelter, violence, and catastrophe is it even possible to utter these clichés of imagining the world elsewise?

What Imaginary?

> *Imaginary* is becoming common in the place of *culture* and *cultural beliefs*, *meanings*, and *models* in anthropology and cultural studies. I believe it is not a coincidence that talk of imaginaries became common just as *culture* was falling out of favor: to a certain extent *the imaginary* is just *culture* or *cultural knowledge* in new clothes. We need a way to talk about shared mental life: if culture is too redolent of Otherness, fixity, and homogeneity, then another term will have to be found. Ironically, however, *the imaginary*, in the hands of some authors, has taken on many of the same connotations of homogeneity as *culture* did.
>
> —Strauss, 2006, p. 322

In order to pay heed to the challenges of naiveté and cliché in respect of the appeal to imagining elsewise, there is a need to reframe the claim made upon the imaginary. Imagining elsewise is not invoked as some *deus ex machina* that averts tragedy, fends off the enemy, and secures safe passage into futurity. It is not a matter of individual creativity and invention. Rather, the imaginary is proposed as providing a key condition of possibility for the various conflicts and contestations cited previously. My use of the construct is not as an alternate for "culture" or "worldview" but for a specific dimension of these, for what may be termed their onto-epistemological register. Used in this way, the term refers to the creative, imaginative acts that undergird any social-political order or any social project and that delimit the sense of possibility operative for a social collectivity. The imaginary pertains to the collective projection of: What exists? What matters? What is

possible? What is a realistic expectation? What collective subject or what "we" might be possible? What can "we" hope for? What are the parameters of "our" world? What is outside "our" world of possibility?

While the construct may be related to similar terms—ideology, worldview, belief system—it has a different tendency and does not simply reduce to these. This way of using the term is informed, on the one hand, by recent work on the social imaginary in several disciplines where the term has acquired a renewed currency in the last decade, and on the other hand, by the critique of the pronounced Eurocentrism at work in Cornelius Castoriadis's early formulation of the term.

> Castoriadis, Ricoeur, and Taylor have articulated the most important theoretical frameworks for understanding social imaginaries, although the field as a whole remains heterogeneous . . . (the) notion of social imaginaries draws on the modern understanding of the imagination as authentically *creative* (as opposed to imitative) . . . social imaginaries involve a significant, qualitative shift in the understanding of societies as collectively and politically-(auto)instituted formations that are irreducible to inter-subjectivity or systemic logics. (Adams et al., 2015, p. 15)

The significance of the turn to the imaginary as an analytical and as a speculative strategy lies precisely in this dual nature of the construct: (1) that it does not collapse the pair of "the imaginary and the real" into the binary of "the false and the true"; and (2) that it seems to offer a way to access questions of meaning, symbolism, belief, value, and identity as forces effecting the construction of lived worlds without presuming to stand outside the object of study in the privileged position of ideology critique nor of presuming to unmask other people's illusions about themselves and their lifeworld while safely ensconced in one's own uninterrogated illusions of insight. Of special interest is the rhetorical dimension of the imaginary, by which I mean the persuasive force, the compelling sense or the strength of conviction that a social imaginary allows to be generated for different visions, projects, and programs. A social imaginary is not in the first instance something that is produced and shared by persuasion; it is the matrix of conditions that enable the experience of something as persuasive, as compelling, as believable. A rhetorical approach to the imaginary entails looking at figures, images, and tropes, and the suasive affect whereby these "just feel right," or feel "believable" within some social constituency. This might be exemplified for example by the way in which the ideas of freedom and of the individual function in the world of neoliberal capital: *How can "one" not believe in the importance of individual freedom?*

I have been drawn to the theme of social imaginary in a number of contexts. One of these contexts has been within research with

colleagues on the social being of the dead and on the possible forms of political community with the dead in the wake of colonial modernity. Another of these contexts is that of studies in respect of a range of collaborative arts practice that operate as experiments in the collective imagining of alternative ways of living, of cobelonging, and of circulating power (e.g., Philadelphia Assembled, Trainings for the Not Yet, Company Drinks, PARK LEK, New World Summit.)[2] I would provisionally differentiate these experiments from more familiar and established patterns of socially engaged work within the academy by reference to the way these practices unfold within the fabric of an institutionally heterogeneous everyday, albeit positioned in complex ways by the intersections of multiple institutional regimes (community, education, health, arts and culture, local economy, local democracy etc.); their shifting terms of authorship and agency; and the different social and political imaginaries that they (operationally) elaborate. It is precisely the way such complex embedded relationality—while being both enacted and thematized in a collectively lived art practice—is not fully foreclosed that in my estimation warrants the claim made for these practices as applied experiments on the imaginary.

However, there are still substantial problems and challenges with the ways in which this term is being mobilized. The social imaginary, to be a serviceable construct in a program of educational formation, requires greater specification with respect to:

1. The relationships of connection, overlap, and difference with other social analytics such as hegemony, ideology, discourse, and doxa
2. Locating the specific registers of the imaginary—as distinct say from acts of imagining or different modes of imaginative production—in analyses that move between different orders of concrete and specific instances of imaginative production such as an utterance, an image, a project, a policy, or a transgenerational project
3. The cross comparison of existing exemplary case studies to identify affordances and limitations of the construct as used in actual concrete enquiries
4. A resolution to the theoretical eclecticism and persistent Kantian undertones active within the discussions of social and political imaginaries

2 The webpages of each of these projects are respectively http://phlassembled .net/; https://trainingforthenotyet.net/; https://companydrinks.info/; http:// www.parklek.com/; and http://www.jonasstaal.nl/projects/new-world -summit-utrecht/.

5. A clarification of the imaginary as something that cannot simply be instrumentalized but yet can somehow be worked upon

Another caveat that must be brought into focus here is the ways in which speculative and imaginative operations have become so centrally valorized within the virtualized circulation of capital as dataflux. Operations in the space of the imaginary cannot be divorced from practices of living-doing or, as Bassam EL Baroni terms it, "leveraging" when he so cogently argues:

> There exists a link between the seemingly unopposed power of the fictitious in present-day capital and recent practices of fictioning and futuring within the expanded field of art . . . the arena of speculations and counter-speculations emerges as the space where various social injustices and inequalities can be challenged by constructing and interjecting worlds that . . . enact society otherwise, all through the creative processes, artistic competencies and interdisciplinarian ethos many of us are already accustomed to as practitioners in the 21st century. If this sounds too good to be true, that is because it most likely is so. . . . Whilst artistic practices that embrace future oriented approaches to worldmaking are actively speculating, what is often overlooked is that for speculations "to come true" there is a necessary condition that needs to be satisfied. Simply stated, this is the other half of speculation, it is called leveraging. (El Baroni, 2021, pp. 98–99)

And You're Back in That Room on Campus

My proposal then for unfolding possible futures for studio art teaching in higher education in the post-pandemic moment is that there is a recalibration of art education away from the cultivation of the free creative individual as its epitome, and toward adopting an applied experimentation within the space of the social imaginary without thereby foreclosing the subject-to-come. This is not to simplistically abandon the individual and embrace the collective. It is rather to seek to (re)construct an imaginary that is not owned by the possessive individual (of the liberal imaginary) nor operated inventively by the creative individual (of the neoliberal imaginary). It is also to seek something other than the thin sociality of the intersubjective contract among learners and mentors. This is, as with many things, easier said than done. However, we can look to artistic practices that are already seeking along these paths. We might find that we are already in good company.

References

Adams, S., Bllokker, P., Doyle, N. J., Krummel, J., & Smith, J. C. A. (2015, May). Social imaginaries in debate. *Social Imaginaries, 1*(1).

Antoinette, M., & Maravillas, F. (2020). Positioning contemporary art worlds and art publics in Southeast Asia. *World Art, 10*(2–3), 161–189.

Bishop, C. (2006, February). The social turn: Collaboration and its discontents. *Artforum, 44*, 179–185.

Chimurenga & Afterall Books. (2019). *FESTAC '77: The 2nd world Black and African festival of arts and culture*. Afterall Books Exhibition Histories.

Davenport, C. (2015, December 22). After SpaceX sticks its landing, Elon Musk talks about a city on Mars. *The Washington Post*. https://www .washingtonpost.com/news/the-switch/wp/2015/12/22/a-day-after -spacex-sticks-its-landing-elon-musk-talks-about-a-city-on-mars/

El Baroni, B., (2021). Whither the exhibition in the age of finance? Notes towards a curatorial practice of leveraging. In C. Gheorghe, & M. Wilson (Eds.), *Exhibitionary acts of political imagination* (pp. 96–103). Vector/ Parse.

Elkins, J. (2014). *Art critiques: A guide*. New Academia Publishing.

Google Arts & Culture. (n.d.). Bringing the world's art and culture online for everyone. https://about.artsandculture.google.com/

Jefferson, T. (1958). Letter to Madison dated 6 September 1789. In J. P. Boyd (Ed.), *The papers of Thomas Jefferson, Vol. 15: March 1789 to November 1789* (pp. 392–398). Princeton University Press.

Kennedy, J. F. (1960, July 15). Democratic National Convention Nomination Acceptance Address, Memorial Coliseum, Los Angeles. https://www .americanrhetoric.com/speeches/jfk1960dnc.htm

Kerr, C. (2001). *The uses of the university*, (5th Ed.). Harvard University Press.

Larson, S. (2000). *Captured in the middle: Tradition and experience in contemporary Native American writing*. University of Washington Press.

Miller, A. L., & Dumford, A. D. (2015). The influence of institutional experiences on the development of creative thinking in arts alumni. *Studies in Art Education, 56*(2), 168–182.

Noble, D. D. (1996). Selling the schools a bill of goods: The marketing of computer-based education. *Afterimage, 23*(5), 13–19.

Porter, R. (1891, April). Distribution of population according to density: 1890. *Extra Census Bulletin, 2*, 1–4.

Purdue University. (n.d.). Studio arts and technology. https://www.admissions .purdue.edu/majors/a-to-z/studio-arts-and-technology.php

Ruin, H. (2018). *Being with the dead*. Stanford University Press.

Singerman, H. (1999). *Art subjects making artists in the American university*. University of California Press.

Sismondo, S. (2020, August). Sociotechnical imaginaries: An accidental themed issue. *Social Studies of Science, 50*(4), 505–507.

Slager, H., & Wilson, M. (2022). Editorial. In *Expo-facto: Into the algorithm of exhibition* (pp. 2–3). Metropolis M Books.

Smith, M. L. (1994). Recourse of empire: Landscapes of progress in technological America. In L. Marx, & M. R. Smith (Eds.), *Does technology*

drive history? The dilemma of technological determinism (pp. 37–52). MIT Press.

Strauss, C. (2006, September). The imaginary. *Anthropological Theory, 6*(3), 322–344.

Turner, F. J. (1893). The significance of the frontier in American history. *Annual Report of the American Historical Association*, 197–227.

Conclusion

Our Pandemic Pedagogies and How We Continue

STACEY SALAZAR

The notification arrived late in 2019: "Accepted for publication!" Based on more than a decade of research and nearly 30 years of teaching, my proposal for a single-authored text, entitled *A Guide to Teaching Art at the College Level*, would be published. I was elated.

Still, it was just a proposal. Most of the book had yet to be written. I mapped out a plan to meet the deadline. With more than a year to write—including an earned sabbatical from my college—my plan was solid.

But then, everything changed.

I became vice provost for graduate studies when my supervisor left to take a position on the West Coast. Two months later, COVID-19 hit, and, like so many colleges, the decision was made to close our campus—shutting down student access to individual studios, communal fabrication spaces, classrooms, and in-person mentorship. An extended spring break was announced to afford us time to relaunch all residential graduate art and design degree programs, fully online.

Yet the dramatic shift to remote learning prompted by a traumatic global health crisis was only one of several cataclysmic events that spring—which together amplified long-standing issues of racial injustice, social inequality, political mistrust, and climate catastrophe. As the multiple shocks of 2020 unfolded, my life as a college administrator became a tsunami-like series of spontaneous decisions, provisional policies, and distanced convenings—navigated from my impromptu home office. Scholarly writing was pushed to the perimeter. My planned writing schedule was now obsolete.

At the same time, due to the global quarantine, conferences were canceled, gatherings suspended, and even visits with family and friends rendered impossible. Weekends and holidays became the space where my book took shape. Indeed, the parallel roles of author and administrator created an odd but fortuitous synergy: As I wrote about the need to change studio art education practice, contemporaneous conditions were realizing change in real time.

I sensed we were in the midst of a great turning point.

Immersed in these crises and their local manifestations at my art college, it was too soon to understand the implications for studio art education. I wrote, and my book was published as scheduled.

And so, this chapter serves as a postscript to my book—but also, and importantly, to the collection of essays in *Turning Points*.

A postscript is an additional statement providing further information. As a modifier, *post* means after, later, or subsequent to. For example, *postsecondary* refers to education that takes place subsequent to high school, and postmodernism is a philosophical stance arising after modernism. *Postmodernism*, it seems to me, is a useful analogy for the radically revised pedagogies that proliferated subsequent to the cataclysms of 2020. Postmodernism points to the provisional nature of knowledge and values by questioning or expanding modernist metanarratives such as objectivity, originality, linearity, and timelessness (Lyotard, 1984). Postmodernism did not mark the end of modernism, but rather became a counterpart to it.

Similarly, as professors responded to the global sequester by enacting new pedagogical methods—simultaneously disrupting longstanding assumptions about how studio art education is conducted—the new ways did not terminate earlier practices. Rather, like the postmodern condition of art, post-pandemic pedagogies exist alongside, interwoven with, and in resistance to pedagogies prevalent before 2020.

The publication of this collection of essays—a global assembly of aspiring students, visionary artists, and accomplished scholars—is situated to serve as a retrospective of that tumultuous time and a harbinger for how to continue.

Teacher

Thirty years ago, renowned education scholar Howard Gardner argued that "didactic training of adults toward more sophisticated understandings of art is destined to fail ... instead, new understandings emerge over several years of study as a result of regular, immersive interactions in artistic, physical, and social contexts (1990)." In *A Guide to Teaching Art at the College Level* (Salazar, 2021), I assert that the same is true for teaching art: New understandings emerge over time while professors are absorbed in the physical and social act of teaching art. Yet I never imagined global circumstances would contrive artistic, physical, and social conditions such that studio art professors around the world would be, at the same time and in nearly identical ways, immersed in new methods of teaching.

This abrupt move to virtual contexts was, for some professors, too much. Across the education sector, studio art educators resigned or hastily retired, finding the labor involved in adopting fully online pedagogical modalities exhausting, the challenges associated with navigating remote interactions with students disheartening, and the needs of family (sequestered at home) and art students (in their online

grid groups) conflicting. Other professors waded into virtual teaching by downloading software tutorials and forming online skill-sharing sessions in an effort to reconstitute, or salvage, some semblance of the educational experience they had provided when their classes were in person.

Still other professors, as suggested in the preceding essays, adapted sufficient skills to launch a virtual version of their studio art class, and then—some for the first time—led with participatory pedagogies that positioned students as central to the educational project. Professors began to consider the totality of students' lives (Chapter 1: Pedagogy as Mentorship) leading them to discover the value of building community in the studio art classroom (Chapter 3: Community and Relationships). Among other benefits, such pedagogical ventures seemed to begin to repair longstanding racial and social injustices.

When these professors Zoomed in from their studios and homes, modeling how to be an artist and adult took on new meaning. With their own art-in-progress visible in the background, a toddler bobbling on their lap, and a housecat ambling across their screen, the teacher's approachability became self-evident. The learning dynamic leveled as students and professors met as equals in the shared realities of balancing work and life, learning and making, success and failure. Differences—in age, geography, culture, and class—were eclipsed. As one contributor put it, teachers and students found ways to "fit into each other's lives." Such an intimate turn, occurring across many and varied contexts, might be indicative of how we continue.

Context

Art education scholar Elliot Eisner argued that context—the whole educational environment—teaches (2002). The history of studio art education suggests that pedagogical approaches develop, in part, due to differences in context: Artist-teachers craft educational programs based on the affordances and constraints of the culture in which they live, and their pedagogies reinforce or resist the prevailing norms of time and place (Salazar, 2021). Yet, in my experience, it is rare for studio art professors to consciously consider context.

In 2020, context could no longer be disregarded. The abrupt shift to online educational platforms in conjunction with mandates for social isolation created a profound change in the way studio art education had taken place for centuries: immersed in materials, tools at hand, in the presence of other artists at work, enveloped in the communal space of a studio art classroom. Art students and professors, displaced from those contexts, resumed studio education via remote means, working in distant and disparate contexts, as they viewed one another through screens and communicated by virtual means.

This disruption to context was magnified for art because in studio art education (in contrast to the teacher-lecture model prevalent in most disciplines), technical struggles and conceptual misunderstandings are visible to professor and classmates as the work develops, and holistic, deliberate, and intimate conversations take place between teacher and student as the work comes into being. Now, solitary students worked in their homes—their progress, struggles, or accomplishments rendered invisible to peers and professors. Formal and informal exchanges typical of the physical studio art class were erased. As Sandra Maxa, the Graduate Program Director for the Master of Arts in Graphic Design at the Maryland Institute College of Art, recounted after teaching her first online class:

> I left [the session] wondering, can I do this? The "room" was so quiet . . . I found myself missing the sounds, the sighs, the small laughs, the whispers, even the dinging of someone's cell phone. And I really miss the brief interactions like telling someone to have a good weekend as we both leave the elevator, or noticing a book on someone's desk and asking them about it. It's going to be tough to establish new rituals, but we will try. (personal communication, September 2020)

New rituals did emerge, as the essays in this book reflect. The online synchronous video tool turned out to be ideal for showing peers and professors around the bedroom-studio, basement work space, or backyard. Suddenly, the diversity of student cultural backgrounds moved to the foreground of studio art education. Teachers discovered that they could ameliorate student isolation by having a few peers Zoomed into the background; students talked and shared informally as they worked, developing keener understandings of one another. And materials and ideas for art making came from the physical surroundings of students' homes, in contrast to pre-pandemic times, when students relied more on the resources of the studio classroom the art supply store. These domestic explorations prompted questions about what *really* is necessary to make art (Chapter 2: Materials and Processes and Chapter 4: International Perspectives). We sense anew the ways life influences art and, reciprocally, how art transforms life. This reciprocity, surfacing on a global scale, is part of our turning point.

Learner

Research conducted before the pandemic suggests that art students find ordinary face-to-face conversation intimidating; they express a desire for their studio art education to provide opportunities for positive student-to-student interactions and meaningful peer dialogue

(Salazar, 2021). This is significant because pre-pandemic art making was assessed in a physical classroom with the professor and peers assembled for "critique." Such assessments can be psychologically fraught for the student whose work was being discussed, especially if that student's work explored issues of personal or cultural significance, or received only responses to formal issues, or worse, silence (Kushins, 2007; Sherrid, 2016). The (rarely recorded) in-person group critique tended to privilege extroverted or assertive students, students fluent in the same language and culture as the professor, and students with the ability to sustain their attention for several hours.

In this new video paradigm, the hours-long critique was no longer viable. As a result, new pedagogical possibilities developed.

Viewing work was no longer limited to a particular time and space. Instead, students submitted documentation of artwork to digital folders for asynchronous viewing hours or days before a class meeting. Each viewer, student and instructor, could look at the work on their own time, in their own way. Suddenly, there was time for reflections and connections before forming verbal responses.

Responding to work changed, too. The online studio classroom afforded many ways to engage. The chat tool, which students readily harnessed as an accessible space for peer-to-peer dialogue, was somehow less intimidating than speaking up in a "real" classroom and invited participation while the critique unfolded. A reluctant speaker could compose their thoughts in written form, and when ready, post them. Or, without typing a word, participants could click a reaction emoji. And there is the recording option, so readily accessible in the digital conference space. Classes could agree to record critiques for future reference and reflection.

Students suggested strategies for conducting critiques; professors, with students, experimented with a variety of ways to make critiques meaningful. As these few examples and the stories in the previous chapters suggest, the shift to remote learning offered an array of pedagogical possibilities for studio art education.

The digital life can be fraught, though. Prior to the pandemic, researchers discerned an empathy gap among those who grew up connected to digital technologies (Turkle, 2012; 2015). And studies conducted in the past 2 years suggest that, as a group, today's college students are the most anxious, depressed, and disengaged ever (McMurtrie, 2022). It may be that the multiple epidemics of 2020 (COVID-19, racial and social injustice, and climate catastrophes) in combination with the all-remote, all-digital education mandated during the global quarantine, exacerbated a youth mental health crisis that, in 2019, was just emerging. Recognizing the need to support learning, creativity, and a sense of belonging, contributors to *Turning Points* suggest critical assessment of digital engagement, self-regulation strategies, engaging

students with the world beyond the screen, and teaching art beyond the studio.

The pandemic impacts have wrought so much pain, and yet, as the preceding essays indicate, we have also been granted a period of colossal pedagogical experimentation.

Everyone wants to know when this will end. . . . That's not the right question. The right question is: How do we continue?

—Ed Yong, "Our Pandemic Summer," The Atlantic Monthly (2020)

The community of educators, artists, students, and administrators contributing to *Turning Points* demonstrate that we have already imagined alternatives to pre-COVID-19 studio art education because we have lived them for more than a little while. At this auspicious moment, we may be at one of the great turning points in human history as Grace Lee Boggs described it:

People are aware that they cannot continue in the same old way but are immobilized because they cannot imagine an alternative. We need a vision that recognizes that we are at one of the great turning points in human history when the survival of our planet and the restoration of our humanity require a great sea change in our ecological, economic, political, and spiritual values. (as quoted in AWTT)

With that recognition, it will take all of us, sharing our stories and documenting our insights, to harness the potential of this moment, as we turn, together, toward educational ecologies that are more democratic, more just, more generative, and more humane. We must be the change we have been waiting for.

References

Americans Who Tell the Truth (AWTT). (n.d.). Grace Lee Boggs. Retrieved November 14, 2020 from https://americanswhotellthetruth.org/portraits/grace-lee-boggs/

Eisner, E. (2002). *The arts and the creation of mind.* Yale University Press.

Gardner, H. (1990). *Art education and human development.* Los Angeles, CA: The J. Paul Getty Museum

Kushins, J. (2007). *Brave new basics: Case portraits of innovation in undergraduate studio art foundations curriculum* [Unpublished doctoral dissertation]. The Ohio State University.

Lyotard, J-F. (1984). *The postmodern condition: A report on knowledge* (G. Bennington & B. Massumi, Trans.). The University of Minnesota Press.

McMurtrie, B. (2022). *A stunning level of student disconnection*. The Chronicle of Higher Education. https://www.chronicle.com/article/a-stunning-level -of-student-disconnection?cid2=gen_login_refresh&cid=gen_sign_in

Salazar, S. (2021). *A guide to teaching art at the college level*. Teachers College Press.

Sherrid, E. (2016). The room of silence. Video created in collaboration with co-producers Olivia Stephens, Utē Petit, and Chantal Feitosa, and the organizing efforts of the student group Black Artists and Designers. https://vimeo.com/161259012

Turkle, S. (2012). *Alone together: Why we expect more from technology and less from each other*. Basic Books.

Turkle, S. (2015). *Reclaiming conversation: The power of talk in a digital age*. Penguin.

Yong, E. (2020, April 15). Our pandemic summer. *The Atlantic Monthly*. https:// www.theatlantic.com/health/archive/2020/04/pandemic-summer -coronavirus-reopening-back-normal/609940/

After COVID-19, the world changed and so the notion of arts education changed as well. Within the terror throes of the pandemic, the very real stuff of in-person art was inaccessible to us, as we had limited ability to engage in live performance, art museums and galleries were only partially open, and our literary readings were held online. The shock to our cultural activities forced us to adapt and so we did. And so in turn the very real stuff of arts education morphed into something that will likely change a generation of artists. We have just begun to see how potent the possibility of online education can be in times of crisis (even as it is in its current form wholly inadequate). Arts education through the lens of COVID-19 also forced us to strip away our attention to what projects we might have found sufficient to work on before and jettisoned our imaginations towards something more (hopefully) humane and crucial. We carry to our new classrooms the knowledge that our inward truths, found in the space of home, can be just as important as anything we might find elsewhere. And that arts education classrooms now must be places of kindness, empathy, and pressurized time, where we push our students to do the work that really matters to them and to the future. As Bernadette Mayer writes in her poem, "The Way to Keep Going in Antarctica," "Do not be afraid of your own heart beating / Look at very small things with your eyes / & stay warm." Post-COVID-19, our arts education classrooms must continue to be the spaces where we introduce the grand ideas, but also the holy places where we can begin again to look at 'very small things' and 'stay warm.'

—Dorothea Lasky

Afterword

The Immune System of Society: A Reflection on Art as a Defense Against Dangerous Ideas

SØREN OBED MADSEN

Just as an organism has an immune system, so too has our society. The system protects us against danger. And which role, if any, does art play in this immune system? How can art help our society to become better or shield it from dangerous viruses? This conceptual chapter taps into the research streams in organization studies and beyond that have made use of metaphor as a cognitive and heuristic device that can allow for new ways of seeing and provide groundwork and models for theorizing (Cornelissen, 2006). Morgan argued that "our theories and explanations of organizational life are based on metaphors that lead us to see and understand organizations in distinctive yet partial ways" (1986, p. 12). By using metaphors, we are able to enrich our language and expand our understanding of society (Alvesson & Sandberg, 2021). Using this metaphor, we can imagine our society as an organism, and an organism needs to be healthy to function and prosper. Hence, this chapter explores what virus theory is and how it can help us to better understand and battle the hidden diseases in our society, which threaten the cohesiveness of society by polarizing and creating an unsafe feeling of "us versus them." A crucial part of this is how our immune system works. Drawing on Røvik's virus theory (2011), virology (Cann, 2005), Cornelissen's metaphors as a method (2003), Lévi-Strauss' (1974) and de Botton & Armstrong's (2013) views on art, this chapter outlines and reflects how art is a part of the immune system of society.

Virus Theory

The idea of using the virus as a metaphor is not new. Kjær and Frankel (2003), Røvik, (2007; 2011), Obed Madsen (2012; 2021), Quist and Hellström (2012), and Madsen and Slåtten (2015) have studied how management ideas and tools behave as a virus. But exploring how the immune system of society works is new. Røvik proposes we understand ideas as viruses in how they behave and emphasizes that this metaphor is not meant in a negative sense, but just as a description of how ideas are behaving. However, this chapter wants to remind us that ideas are not neutral, and that the effect of ideas is also not neutral. Negative

ideas affect different people in different ways, and we need to be aware of the scope of that differentiation. There are good and bad ideas, which have performative effects and are currently affecting us—just like viruses. The idea-as-virus metaphor consists of four parts: a problem, a solution, expectations, and an object. The object, like a text, book, model, video, or sound clip, makes it possible for the virus to travel. It also defines a problem and proposes a solution to that problem, which means it anticipates what is going to happen, if indeed the solution is carried out.

Even though the virus metaphor is not new, Røvik (2011) contributes to it by describing six characteristics possessed by viruses:

1. Infectiousness
2. Immunity
3. Replication
4. Incubation
5. Mutation
6. Dormancy

First, a virus infects only a living host. In the same manner as an idea needs to interact with an organism, a virus requires cells that it can infect. Members of a society are like these cells.

Second, one can acquire immunity against a virus. This feature is particularly interesting when it comes to ideas. The resistance against certain ideas can be a response from the immune system that protects against the potentially damaging effects of the virus. When a new idea has similarities to an idea from the past that caused problems, there will be resistance. There are agents who remember what happened last time a similar idea was present in society, and these agents are trying to prevent the repetition of the damage or problems that the earlier idea might have generated.

A virus replicates itself. Hence, ideas can spread like a virus in an organism. The ambition of an idea is to define a problem and propose a solution. It is difficult to restrict the effect the idea has to certain areas of society. Problems and their potential solutions affect members of societies in different ways and to different extents. An idea will change when it meets individuals (or smaller groups within a society) because it will be translated into the terms that will specifically affect them. So, an idea fractures, develops, and morphs. New strains of an idea develop when it spreads to broader parts of the population, just as new strains of a virus evolve when more and more people are infected.

A virus can incubate. This characteristic refers to the perspective of time in the diffusion of an idea. An idea is just lying dormant until it is triggered into action by an event in society. Thus, the point of incubation is to understand that there might be periods where a

particular idea is inactive, and that the idea can suddenly break out and affect society when enough people start believing in it.

Viruses can also mutate, that is, experience changes in genetic structure. We know this from the field of virology where different strains of the common flu mutate. This means that the virus can spread to organisms which hitherto have not been in danger of being infected. Ideas can also mutate and combine with replication; they can penetrate previously untouched parts of society. As Røvik (2011) describes, this gives a virus the possibility of not being recognized by the immune system. In the societal context, this may materialize as a mutational change in a concept or concept name.

A virus can go dormant: It may no longer cause symptoms but remain present in the organism until suddenly there is an outbreak. This is reminiscent of ideas that still exist even though they have been defeated in the past, and sometimes pop up again, because nobody knows how to get rid of them. Examples of such ideas could be fascism, racism, or other ideas that reveal themselves in symptoms such as confusion, anger, hate, or fear.

What Is a Dangerous Idea? Just like a virus, a dangerous idea must be assessed on the damage it inflicts on its host. Some viruses give us a mild cold, while others can kill us in a matter of hours or have long-term negative effects on our health. The challenge is that it is difficult to judge a new virus, so we can only know if it is dangerous after an infection. However, our immune system has a memory, which helps to distinguish the harmful viruses from the safe ones, unless a harmful one has mutated and is not recognized by the immune system. In terms of dangerous ideas, racism, sexism, and other ways in which we might judge one another based on a single marker (such as age, body type, handicap, faith, or professionalism) are all examples that lead to dehumanization. This in turn leads to fragmentation and polarization in a society, ultimately justifying large-scale abuse and even war. As is the case with viruses, the danger of these ideas must be studied empirically.

The Immune System: An organism is surrounded by microorganisms, such as viruses, bacteria, fungi, and parasites that can infect it, just like a society is structured around many different types of ideas. Some ideas are good for society, while others are harmful. The function of the immune system is to protect the organism from these microorganisms, either to stop or kill any intruders that are dangerous for the host.

Røvik (2011) describes how the immune system has a primary outer defense, a secondary outer defense, and an internal defense. The primary outer defense consists of learned immunity, which is expressed in the fact that societies do not adopt certain ideas based on previous experiences that were destructive. They actively ignore, decouple, and speak out against these ideas in order to push them

away. The secondary outer defense consists of the ability to stop the adoption of ideas, which Røvik describes as logics and mechanisms that sometimes stop ideas in the early stages of the adoption process. These defense mechanisms can be agents or specialized agencies that examine the idea and sometimes decide that it should not be used in society. Examples of such agencies include scholars, universities, or public agencies that must approve an idea before it can be used or supervise which ideas are in circulation. As well, they may also have the authority to stop these ideas.

The internal defense starts when the idea is either technically or value-wise incompatible with the society by examining if the idea can potentially damage the fabric of society by undermining trust, hope, and care. If so, parts of the society will attack and reject the idea. However, a virus can counteract this attack by mutating, as we know from the coronavirus, which mutates and finds ways to bypass the immune system.

Even though we talk about one immune system, this actually consists of two systems: the innate and the adaptive (Cann, 2005). The innate system is nonspecific; it consists of physical barriers such as the skin and cells that can identify and kill unwanted intruders. The adaptive part of the immune system is specific; this is where the organism learns from interacting with microorganisms and creating antibodies. It is the part that we activate with vaccines. We are born with the innate system to protect us against microorganism in general. By contrast, the adaptive system is based in learning, which can differ from person to person depending on their history of interaction with microorganisms or vaccines. Education is a component in the adaptive part of the societal immune system.

The immune system can also malfunction by overreacting. This happens in two ways. The first is known as allergy, where the immune system responds to a nonthreatening substance. The allergic reaction can range from sneezing, to itching, to anaphylactic shock, where blood pressure drops and breathing becomes so difficult that one risks dying if they do not receive treatment. The second type of overreaction is autoimmune disease, where the immune system is attacking the body's own cells. The treatment in this case would be to suppress the overactive immune system through medication or to avoid drugs that trigger the overreaction.

The immune system can also have so-called immune defects, meaning that the organism can be more vulnerable to microorganisms. A person with immune defects gets infections more often, and the infection is more serious than in others. Microorganisms that do not infect others can make a person with an immune deficiency sick. Using the idea-as-virus metaphor, immune defects can function as the basis for reflections on the state of our immune system in society. Do we have a healthy societal immune system, or do we do things that stress

and impair it? And how do different societies react to the same idea? Because the immune system can be impaired by different factors, including long-lasting stress, alcohol, lack of sleep, poor nutrition, smoking, or obesity, certain activities must be prescribed to shore up the body, effectively increasing the probability that the immune system will not get triggered. Public health recommendations, such as social distancing, washing hands, and disinfecting common surfaces, function in this way. Vaccines are an additional precaution to make sure that the immune system is responding properly to dangerous viruses.

In terms of the societal immune system, it is relevant to understand how ideas function like viruses. Why are some ideas repelled while others pass through the system with little effect? And which ideas have a substantial impact on society when they do, indeed, infect the host? In addition, what are the mechanisms in a society that, as in the case of the body's outer immune system, namely the skin, provide a first defense against harmful ideas? To answer these questions, societies have developed legislation, systems, and behavioral models that can either calculate the effects an idea may have before it is accepted or serve as built-in resistance toward certain types of ideas. And, of course, art functions as one such preventative system for guarding against potential infection from bad ideas.

The Role of Art in Society

The structuralist Lévi-Strauss (Lévi-Strauss, 1974; Brenner, 1977) described how elements can be understood in relationship to a broader system. Art is any activity or artifact the purpose of which is to express emotions, thoughts, beliefs, and ideas. A partial list of these activities and artifacts includes painting, drawing, sculpture, literature, dance, spoken word, craft, music, and film. Following Lévi-Strauss' notion, art has multiple functions and may be used by societies as individual and group expression, ritual, entertainment, therapy, and in the communication of feelings, thoughts, knowledge, stories, and ideas.

As one can see, art has the function of impacting others in several ways, by inspiring, creating identity, provoking, entertaining, and providing relaxation or healing. These functions add to general education by influencing how we think about certain subjects, ourselves, and the world. De Botton and Armstrong (2013) argue that art is the cure for problems in relationships, work, and politics. In addition, art can repair the self, remove anxiety, and help us to rediscover creativity, passion, and playfulness. By looking at and producing art, we revisit memories as well as create emotions such as hope and courage. Art helps us to process negative feelings such as sorrow or bitterness, makes us grow by creating self-awareness, and helps us to create an overall balance when we are feeling lost. It makes us

contemplate our lives; it acts like a source of consolation and renewal. Inspired by de Botton and Armstrong (2013) and their notion that art contains the antidote to diseases in society, we can explore how art helps people fight dangerous ideas and how it can help with healing after the damage from such ideas is done.

The Immune System of Society

Just as in organisms, our society has an immune system. In society, this immune system protects us against danger. The obvious manifestations of such societal protections are the police and the military, which scan, seek out, and eliminate physical threats. However, additional aspects of society, which are invisible to the naked eye, protect us as well. Legislation, financial oversight, trust, and education are all components that determine which ideas, behaviors, and actions we should tolerate, and which we should prohibit. And just as in the physical immune system, the societal immune system is not perfect. Both are composed of two facets, the innate and the specific. The specific immune system is the facet that learns from interaction with dangerous ideas. The innate system can be found in most societies that are not infected by corruption. In society, this manifests as institutions and organizations whose very role is to supervise, control and accredit other organizations to make sure that they are not the breeding ground for dangerous ideas or that they comply with established rules. In this immune system analogy, humans are the cells within the organism we call society or organizations. Humans perform individual agency within the larger social arena; they are the specific component in the system that learns to distinguish between harmful, useless, and dangerous ideas.

So let us explore how these "cells" learn. Humans test if ideas are compatible with the existing societal practice. That means that they decide if ideas align with existing values, if they add value, or if ideas can help relevant groups or persons reach their goals (Røvik, 2011). Humans will assess new ideas by comparing them to past experiences, to figure out the relative advantage and consequences if an idea is adapted. This is where art comes into play. Art cultivates memory, hope, edification, critical thinking, openness, and curiosity. These all function as defense against dangerous ideas, in terms we have previously discussed: creating immunity, identifying harm, battling the virus of bad ideas once infected, and healing from the negative effects of that infection, as described subsequently.

How Art Is Helping Create Immunity

Art can help activate memories about previous infections of dangerous ideas. It can create curiosity and openness to what is different, create

acceptance of difference, and thereby build up resistance and immunity to ideas that seek to create fear and hate towards the unfamiliar.

Knowing about our history can help us to recognize which dangerous ideas spread before a conflict or war. Art can function as collective memory and at the same time educate us.

Art Helps Identify Dangerous Ideas: At the abstract level, art can embody and represent former experiences. This function of art is two-fold. First, it acts like a collective memory, in which the observers are reminded of the past. Second, art is a teaching tool, which hands down wisdom by reminding and educating new generations of what the past has taught us. In this way it helps us like the cells in the adaptive immune system, which identify past viruses and remember interactions with them. The physical artifacts we call art, including paintings, plays, sculptures, and films, travel through time and place. In this way, art reminds us of our former experiences.

Art can help us by examining and comparing different ideas before we adopt them. It can give us inside knowledge and experience with the many micro cosmoses that exist in the world without being a part of them. Art enlarges the domain of our experience (Caws, 2000). By looking at and experiencing art, we, as explorers, can visit new worlds and leave them when we have learned something new. Art opens up these micro cosmoses, where we can visit future, past, and present events through the specific artifacts, be they films, theatrical productions, books, songs, or paintings. Art can show us war, in which we see the conflict through the eyes of the aggressor or the defender; it can give us insights into another culture or another age. We can see, feel, and imagine how things were, how they are, and what they might become. In other words, art expands our worldviews, perspectives, and possibilities. In this way, art acts as the cell in the immune system that investigates ideas before deciding how to engage with them.

At the concrete level, art can help us connect to ourselves and others, thereby preventing ideas that alienate us from each other and make us look at each other as enemies or as inferior. Art can prevent these ideas from entering into our communities. To illustrate this process, De Botton and Armstrong use the example of standing in front of Rembrandt's *The Night Watch*. In their story the viewer becomes irritated because others are blocking their view of the work; the viewer would rather enjoy the magnificent painting alone. But instead of supporting the wish that other viewers disappear, *The Night Watch* reminds us of the value of company; it suggests that we could engage with those around us, discussing what we like about the painting. In this way, art creates community and builds bridges to strangers by focusing on what we have in common. This in turn prevents us from

reducing others to obstacles we must overcome, barriers to our own goals or opposites of our own interests.

Unfortunately, some harmful ideas will still infect parts of our society. Certain groups will subscribe to ideas that are proven to have a damaging effect on society but will nevertheless hold those ideas dear. In addition to preventing bad ideas from taking hold in the first place, art can also help in battling these infections.

How Art Helps Battle Infection: When a dangerous idea has infected a group in society, other groups must mobilize to fight the spread of that idea and its consequences. This mobilization manifests as organizations taking counter measures to fight extremism, crime, or the prelude to war. However, art can also help in these instances. When a dangerous idea has infected our society, art can help us mobilize resistance, fight ignorance and prejudice, or challenge authorities that are abusing their power.

One example of such a case comes from Tolstoy's *War and Peace.* What seems to be about the French invasions of Russia can be read as a magnification of failed self-image and its consequences, which helps to fight delusions of grandeur (Caws, 2000). Or put more simply: Freedom is the reward for suffering, and you need to suffer (to go to war) to become free (to achieve peace). The main character, Pjotr Bezukhov, is imprisoned by his ideas of the good life, but regeneration takes Pjotr through a journey of depression, anger, and resignation until he arrives at inner freedom. *War and Peace* is more than mere entertainment. It is a tool for training your mind so you can become free from the ideas that entrap you.

Art can show us alternatives by expressing views, activating feelings, creating new thoughts, and mobilizing others.

Art helps us to appreciate what is different. Many dangerous ideas, at their core, want us to be afraid and hateful toward what is not familiar or does not look like us. Art shows us alternatives to existing options, problematizing those options and coming up with new solutions.

So, art is a space for defining problems, exploring solutions, and finding consensus. The popular resistance to the current war in Ukraine is an example of this. By showing and promoting the colors of their flag, we are communicating with each other and with the Ukrainians. The proliferation of the flag clearly identifies the problem, indicates that we share a common view of this problem, and invites others to join us in solidarity. This solidarity facilitates talks about solutions. In this case, art is used to express common cause with Ukraine; this action reminds us that we are not alone, it makes visible those who share our feelings about the invasion. The two colors of the flag, blue and yellow, become a universal symbol of unity and a silent but visible resistance against injustice.

How Art Is Helpful in Healing: As De Botton and Armstrong (2013) argue, art can act as therapy. By giving examples of how art can help us to heal the cognitive and emotional sicknesses that all humans suffer from, they also show how we can be well. In the book *Art as Therapy*, they show how art can generate new ways of looking at our lives and get new thoughts and perspectives on what causes us pain. For example, we may feel lost in the great expanse of the world, but by looking at a model of a ship we can imagine exploring new worlds from a distance; we can tame this world, which seems overwhelming, by changing the scale of it, making ourselves bigger and our problems smaller by comparison. When we are suffering, we often feel disconnected from ourselves, others, and the world, which causes us to feel lonely (Alberti, 2019). Art can show that we are not alone by experiencing others' pain or liberation, and we can feel part of a larger community. Art reinforces connections; it reminds us that we are connected to others, things, and ourselves.

Art Can Help Us Process Feelings: The term *catharsis* describes the process of cleansing emotions by looking at art (Scheff, 1979). Because our brains have mirror neurons, we can look at something and feel like we are experiencing it ourselves (Stamenov & Gallese, 2002). We use this feeling in art to process emotions that are heavy or deal with past traumas (Nichols & Zax, 1977), whether it is through viewing paintings, watching films, listening to music, or experiencing other art forms.

Art Can Give Us Hope When We Have Lost It: It can remind us of our strengths and past victories, mobilize our feelings, and show how others have succeeded in dealing with adversity. For example, what can art teach us about pandemics? There are paintings that illustrate the experience of former pandemics as well as films about how they have affected society. These works of art explore a pandemic's consequences, battles, and victories. There are also works of music, literature, and theater that deal with pain, fear, and loss, which can help us process feelings and give us temporary hope. By looking and listening to these art forms, we process feelings of fear, helplessness, and rage; we come to know that ultimately, we will get through it.

Conclusion: Art as a Part of the Societal Immune System

Just as our biological immune system helps us avoid and fight infections, and if infected, helps heal where we have been attacked, art can have the same function in society. Ideas are the viruses in our society: some are good for us, others are neutral, and some are dangerous, compromising the cohesiveness of society. Ideas can

mutate, so a good idea can become harmful or a dangerous one can become harmless. Ideas can also hibernate, so past dangerous ideas that we thought were gone can suddenly come to life again and cause infections. Art, if it is used as such, is a vital part of the societal immune system, since it works as collective memory, makes us reflect, educates us, and makes us ask fundamental questions, like "What is a good life?" or "What does it mean to be(come) human?" Art serves a utilitarian function in society by fighting harmful ideas in the following ways:

- As collective memory
- As a space to creatively manage future possibilities
- As a way of defining problems and solutions and managing consensus
- As a space for empathy, for sharing feelings and experiences
- As catharsis

And by creating art, we play a crucial role in shoring up the immune system of our society. Because when we make and consume art, we are helping to either explore and confront dangerous ideas or heal the damage they have done.

Implications

First and foremost, we need to heighten the status of art in our educational systems and in society as a whole. We need to build in resistance to dangerous ideas at the core of society by equipping individuals to function in the societal immune system, as individual cells resisting infection. Doing so will create immunity toward dangerous ideas and develop our ability to identify dangerous ideas before we get infected. In this way, art is not an adornment to society but a necessity for society to function.

Second, as we are all a part of the broader societal immune system, we should be aware if we become infected by dangerous ideas, if we are, in fact, spreading diseases. And if so, we must consider how we can cure ourselves by producing and consuming works of art.

Third, artists can use this perspective to reflect on their own creative production: Which ideas do I wish to promote? And which ones am I fighting against or trying to heal? A lot of artists are already doing this, but by using the concepts from virus theory, it might sharpen their attention on certain aspects of their own creative production. Art lovers and others who are touched by art can also reflect on these questions as they read books, watch films, listen to music, or look at works of visual art.

References

Alberti, F. B. (2019). *A biography of loneliness: The history of an emotion.* Oxford University Press.

Alvesson, M., & Sandberg, J. (2021). *Re-imagining the research process: Conventional and alternative metaphors.* Sage.

Brenner, A. (1977). The structuralism of Claude Lévi-Strauss and the visual arts. *Leonardo, 10*(4), 303–306.

Caws, P. (2000). Moral certainty in Tolstoy. *Philosophy and Literature, 24*(1), 49–66.

Cann, A. J. (2005). *Principles of molecular virology* (4th Ed.). Elsevier Academic Press.

Cornelissen, J. P. (2003). Metaphor as a method in the domain of marketing. *Psychology & Marketing, 20*(3), 209–225. https://doi.org/10.1002/mar.10068

Cornelissen, J. P. (2006). Making sense of theory construction: Metaphor and disciplined imagination. *Organization Studies, 27*(11), 1579–1597.

De Botton, A., & Armstrong, J. (2016). Art as therapy. Phaidon Press Limited.

Kjær, P., & Frankel, C. (2003). The Virus of management: A viral perspective on bureaucracy and scientific management. Paper presented at The EIASM Workshop of Management Knowledge in Time and Space, Istanbul, Turkey.

Lévi-Strauss, C. (1974). *Structural anthropology.* Perseus Book Group.

Madsen, D., & Slåtten, K. (2015). The balanced scorecard: Fashion or virus? *Administrative Sciences, 5*(2), 90–124. https://doi.org/10.3390/admsci5020090

Morgan, G. (1986). *Images of organization.* Sage.

Nichols, M. P., & Zax, M. (1977). *Catharsis in psychotherapy.* Gardner Press.

Obed Madsen, S. (2012). En historie om strategi som en virus. *Økonomistyring & Informatik, 28*, 13–31. (In Danish).

Obed Madsen, S. (2021). Managementideer som en virus–hvad består det organisatoriske immunsystem af? *Samfundslederskab i Skandinavien, 36*(3), 140–160. (In Danish).

Quist, J., & Hellström, A. (2012). Process management as a contagious idea: A contribution to Røvik's virus-inspired theory. *International Journal of Public Administration, 35*(13), 901–913. https://doi.org/10.1080/01900692.2012.686034

Røvik, K. A. (2007). *Trender og translasjoner. Ideer som former det 21. Aarhundrets organisasjon.* Universitetsforlaget. (In Norwegian).

Røvik, K. A. (2011). From fashion to virus: An alternative theory of organizations' handling of management ideas. *Organization Studies, 32*(5), 631–653. https://doi.org/10.1177/0170840611405426

Scheff, T. J. (1979). *Catharsis in healing, ritual, and drama.* University of California Press.

Stamenov, M., & Gallese, V. (Eds.). (2002). *Mirror neurons and the evolution of brain and language* (Vol. 42). John Benjamins.

Index

Index

Index

About the Contributors

David Bogen is an educator and an academic leader whose work centers on arts advocacy and a vision of arts-based institutions as catalysts for economic and cultural development within the cities and the regions that they serve. He is currently the executive vice president for academic affairs and provost at Berklee in Boston, Massachusetts.

Rébecca Bourgault is a visual artist, educator, scholar, and community art worker. An assistant professor of art education at Boston University, Bourgault holds an EdD from Teachers College, Columbia University, an MFA from the University of Calgary, Alberta, and a BFA from Concordia University, Montréal, Quebec. Bourgault's artistic and scholarly research has been exhibited and published in the United States, Canada, and the UK. Her research interests include socially engaged art practices, multimodal forms of research-creation, arts research, and associated pedagogies.

Judith M. Burton is Macy Chair of Education at Teachers College. She researches the artistic-aesthetic development of children, adolescents, and young adults and its implications for teaching/learning and the culture in general. She is a fellow of the Royal Society for the Arts, a distinguished fellow of the NAEA, and distinguished visiting professor at the Central Academy of Fine Arts Beijing.

Lane Cooper is an artist, curator, and educator. Born and raised in northwest Alabama, that fact has shaped her professional interests. Primarily a painter, she occasionally produces video and performance works with a focus on questions of reality and/or gender. She has taught at the Cleveland Institute of Art since 2001, teaching in painting and art history. She is currently an associate professor. Her academic interests include painting as practice and shifting worldviews in relation to art and culture. https://lanecooperart.com/home.html

Tracie Costantino, PhD, is a teacher educator and arts leader who serves as the provost at California Institute of the Arts. Her research in aesthetic education focuses on the nature of cognition in the arts, creativity, and the transformative potential of aesthetic experience. She has also published numerous articles on interdisciplinary and transdisciplinary curriculum, including in relation to STEAM (science, technology, engineering, arts, math).

Iman Djouini is an assistant teaching professor at the University of California Santa Barbara. Often employing print media, placemaking, and typography, Djouini's art practice explores themes of gender and postcolonial spatial relations. Her teaching and research interests include decolonial pedagogies through theory, research, and practice-based art making.

Martinez E-B is a multidisciplinary artist working out of the Chicago, IL area and a studio arts instructor at William Rainey Harper College. His art practice simulates the cultural/social/political fog of his upbringing and fuels his research and efforts for clarity in equitable practices at the college level. E-B is a co-founder of Equity Literacy Project, an online publication that offers education to those who wish to build opportunities and resources for students of all kinds. http://martinezeb.com

Aimée Ehrman is a New York–based ceramic artist and educator who teaches at Teachers College, Columbia University. With creative practices rooted in experimentation and focused on processes of making, she is interested in exploring the fully embodied ways that we engage with our environments and how we think with and through material.

José Galarza is an educator, designer, fabricator, and theoretician focused on community engagement and noncolonial pedagogies. He is the founding director of the Center for Teaching Innovation and Exchange (C/TIE) at the Maryland Institute College of Art, where he realizes its mission to provide training and resources to faculty to make teaching and learning more accessible, collaborative, and responsive to the challenges of higher education in art and design.

Jun Gao is an assistant adjunct professor of the Art and Art Education program at Teachers College Columbia University, where he teaches painting courses. He also lectures at art schools in China. His diverse art practices include painting, drawing, photography, graphic design, and digital art. A philosophical inquiry of time in visual culture and education centers his artistic and scholarly research.

Bill Gaskins is an interdisciplinary artist exploring the myths and realities of American life through the depth and breadth of his work in photography, video, and nonfiction writing. He is the author of the groundbreaking monograph *Good & Bad Hair: Photographs by Bill Gaskins* and the inventive short film *The Meaning of Hope*. He is founding director of the MFA Program in Photography + Media & Society at MICA.

Jeremy Gilbert-Rolfe, professor/chair emeritus Art Center College of Design, is a painter who also writes about art. His paintings have been shown in New York and elsewhere since 1970, and he has published four books and quite a lot of essays over the same period.

Carlos Arturo González-Barrios is an animator and multidisciplinary artist based in Tampico, México. He currently works as an art educator at the Monterrey Institute of Technology and Higher Education, Tampico Campus. His animation has been featured in gallery exhibits, advertisements, music videos, and visuals for educational purposes. He also provides consultations on teaching methods for animation to teenagers and children. https://arturogb.com

Michelle Grabner is chair of the Painting and Drawing Department at the School of the Art Institute of Chicago, where she has taught since 1996. Grabner is an artist, critic, and curator. In 1999 Grabner and the artist Brad Killam started The Suburban, an artist-run project space. In 2008 they established The Poor Farm, a not-for-profit residency and exhibition space in rural Wisconsin.

Samuel Hoi is president of Maryland Institute College of Art (MICA) in Baltimore, Maryland, and formerly president of Otis College of Art and Design in Los Angeles, California. He is an experienced and innovative higher education leader and an advocate for art and design education and creative professionals as drivers in social, economic, and cultural advancement.

Gi (Ginny) Huo is an artist and educator exploring the intentions of people's beliefs and the legacies of religious systems. Huo's work has recently been exhibited at places such as Baxter St CCNY, CANADA Gallery, Socrates Sculpture Park, and The Smithsonian Archives of American Art. They are currently the interim director of education and public engagement at the New Museum and an adjunct professor at Parsons School of Design. They believe art and education are powerful tools for liberation.

Sangbin IM is an artist working in the domains of photography and painting. He is also a professor at Sungshin University in Seoul, Korea and a writer and lecturer with multiple published books. He obtained his MFA in painting and printmaking from Yale University as a Fulbright scholar and earned his doctorate from Teachers College, Columbia University.

Megan Irwin is a graphic designer and educator at East Carolina University. With a focus on typography and publication design, her

current practice examines the role of the designer as an archivist. Her work draws from material culture, using analog methods and found imagery to tell stories. Megan recently received her MFA from the Maryland Institute College of Art.

Rabeya Jalil is a visual artist, art educator, and Fulbright scholar based in Lahore, Pakistan. Jalil's creative practice includes painting, curriculum development, teacher education, and writing. Currently, she is associate professor and head of painting in the Department of Fine Arts at the National College of Arts, Lahore, Pakistan.

Richard Jochum is associate professor of art and art education at Teachers College, Columbia University. He has received his PhD in philosophy from the University of Vienna and an MFA in sculpture and media art from the University of Applied Arts in Vienna. His artistic work focuses on video, performance, and installation. His scholarly interests include artistic research practices, studio art teaching and learning, as well as new media and media art education.

Dorothea Lasky is an Associate Professor of Poetry at Columbia University School of the Arts, where she currently directs the Poetry Concentration. She is the author of six books of poetry and one book of prose, including Animal and The Shining. She is also the editor of Essays, a book on the idea of the poet's essay.

Dina Lutfi is an assistant professor of graphic design and multimedia at Imam Abdulrahman Bin Faisal University in Saudi Arabia. In addition to being an educator, she is an artist and designer. Her academic degrees include a BS in visual communication, MA and EdD degrees in art and art education, and an MFA in graphic design. Lutfi's research interests include dialogues about form, multiculturalism, semiotics, and visual communication. Her academic focus encompasses art and design history in addition to contemporary perspectives.

Steven Henry Madoff is the founding chair of the MA Curatorial Practice program at the School of Visual Arts in New York. He holds his PhD in modern thought and literature from Stanford University. Among his publications are, as editor, *Art School (Propositions for the 21st Century)* (MIT Press, Cambridge, MA, 2009) and, as series editor, *Thoughts on Curating* (Sternberg Press, Berlin, 2021–ongoing).

Søren Obed Madsen is an associate professor at the Department of Business, Strategy and Political Science at the University of South-Eastern Norway. His research is focused on different ways of understanding implementation and leadership.

Sabrina Marques is a Cuban/Portuguese American artist and educator. Her artwork focuses on narrative, utilizing storytelling, memory, cultural commentary, and humor. She is an associate professor of studio art at Western Connecticut State University, where she engages students in the art of creativity as a pathway to meaning. Her research involves an international interdisciplinary collaboration with neuroscientists and psychologists addressing the science of happiness and creativity, and how the two intertwine.

Carina D. Maye is an educator, researcher, and artist from Marietta, Georgia. She is a doctoral candidate in the Doctor of Art and Art Education Program at Teachers College (TC), Columbia University in New York. As a researcher, Maye is studying the complex ways Black artists' personal experiences intersect with their educational and professional experiences.

Jen Mazza is a New York–based artist who makes paintings and teaches at the Pratt Institute and Parsons School of Design. Her often collaborative teaching integrates reading, art making, and research across a range of disciplines. Her work has been exhibited most recently at Ulterior Gallery in New York.

Arzu Mistry is an educator and artist who maintains a high level of dedication and enthusiasm for the arts as mediums for pedagogy, advocacy, transformation, and intervention for building sustainable, inclusive communities. Arzu teaches at the Srishti Manipal Institute for Art Design and Technology in Bangalore, India. She runs the Art in Transit and Accordion Book Project and coauthored Unfolding Practice: Reflections on Learning and Teaching. She is currently a doctoral student at Teachers College, Columbia University.

Amanda Newman-Godfrey is an assistant professor of art education at Moore College of Art and Design in Philadelphia. Her research and publication interests focus on working with diverse learners in the art room, differentiated assessment practices, and critical disability studies in art education. She is also a photographer and jewelry designer. Her work in the creative field extends to her company Spotted Horse Provisions, where she makes artisanal and sustainably minded pantry provisions.

Kate O'Connor is a professor at Ferris State University, where she coordinates 4th-year studio and teaches in the 1st- and 2nd-year design curriculum. She received a bachelor of architecture from The Catholic University of America and earned her master of architecture from Tulane University. With the goal of creating substantive and

responsible architecture, her studios focus on composition through analog and digital craft in making spaces. Her pedagogy explores how form is studied as it acts in service to space.

Neil Daigle Orians is an artist, curator, and educator living and working in Cincinnati, Ohio, the native homeland of the Indigenous Algonquian speaking tribes. They received a BFA in studio art from the University of Nebraska-Lincoln and an MFA in studio art from the University of Connecticut. They are currently assistant professor and area head of printmaking at the University of Cincinnati. https://neilmakesthings.com

Lynn Palewicz is an associate professor at Moore College of Art and Design and currently serves as chair of Foundation. Her professional work includes elaborate still-life drawings in charcoal depicting fabric and nature alongside reflective surfaces. She is also a published writer whose work explores research and pedagogy in art and design higher education. https://lynnpalewicz.com

Jess Perry-Martin is a secondary visual arts educator at ArTES Magnet in San Fernando and a lecturer in art education at California State University at Northridge. Her work centers around mentorship and collaboration within arts education, advocacy and equity for Title I students, and bringing contemporary art into classrooms. She embodies these practices through her teaching and additional work as a National Board Certified Teacher, AP reader, and Art21Educator.

Kaitlin Pomerantz is an artist, writer, educator, and land/water worker whose practice considers ecological histories, matter-into-material, transitional landscapes, ecosocial preservation, time as connective material, and place-based learning. Pomerantz is the founder of MATTERS, an educational initiative connecting art and design learners to land and labor, laying groundwork for creative practice rooted in social and ecological awareness, repair, and care. kaitlinpomerantz.com

Linnea Poole is a Baltimore-based community educator, art practitioner, and professor at the Maryland Institute College of Art. Aside from teaching, Linnea's art making includes autoethnographic writings and proposes open discussions surrounding the topics on Black women, community, mourning, and healing. https://linneapoole.com

Ernesto Pujol has served as an instructor at numerous graduate art programs worldwide. Pujol was the founder and director of *The Listening School* performative project, 2015–2020. Self-described as a social choreographer, he is the author of two seminal titles: *Walking Art Practice, Reflections on Socially Engaged Paths* (2018), and *Sited Body,*

Public Visions: Silence, Stillness & Walking as Performance Practice (2012). More recently, Pujol has been pursuing design and horticulture, working as an eco-artist creating hybrid, wild spaces for healing.

Sreshta Rit Premnath is a multidisciplinary artist and founding editor of the serial publication Shifter. Premnath teaches at Parsons School of Design in New York, where he co-directs the BFA Fine Arts program.

Emma Quintana is a sculptor, interactive installation and multi-media artist, and professor. She teaches a variety of 2D, 3D, and 4D art and design courses and is the digital fabrication coordinator at the University of Tampa. Her studio practice and pedagogy focus on a multifaceted approach to art making and boundary pushing.

Seph Rodney, PhD, is a former senior critic and opinions editor for *Hyperallergic* and is now a regular contributor to *The New York Times*. He has also written on art for CNN, NBC, *American Craft Magazine*, and other publications. In 2020 he won the Rabkin Arts Journalism prize and in 2022 won the Andy Warhol Foundation Arts Writers Grant. Seph can be heard regularly on the podcast *The American Age*.

Jessica Rohl is a Buffalo-based artist who works within the photographic medium. She finds answers through her lens—Rohl's work heavily focuses on the art of gathering and what it means to gather. She finds inspiration not only in the people around her, but also light and music.

Stacey Salazar is a Baltimore-based art education scholar, who, after teaching at a community college, a public university, a private college, an art college, and a public high school, now serves as the vice provost for graduate studies at the Maryland Institute College of Art. Stacey's single-authored book from Teachers College Press (2021), *A Guide to Teaching Art at the College Level*, has been adopted as a primary text for graduate seminars and faculty workshops across the United States.

Sara Schneckloth is a professor of drawing at the University of South Carolina. Her studio practice centers on intersections of biology, geology, and architecture as understood through body, material, and mark. She co-curates the *Seed Cultures Archive*, a digital project in conversation with the Svalbard Global Seed Vault, and directs *Drawing Canyon, Sage and Sky*, a program for artists seeking to integrate field drawing and natural materials into their studio practices. https://.saraschneckloth.com

Kimberly Sheridan is an associate professor at George Mason University with a joint appointment in educational psychology and art and visual

technology. She is cofounder and codirector of Mason Arts Research Center, a National Endowment for the Arts research lab: http://masonarc.gmu.edu. She is an author of the book *Studio Thinking: The Real Benefits of Visual Arts Education* (Teachers College Press, 2022).

Paul A. C. Sproll is Professor Emeritus at the Rhode Island School of Design and for nearly 30 years led its Department of Teaching + Learning in Art + Design. His longstanding commitment to engaged practice within K–12 contexts was inextricably linked to his college teaching. Throughout his career, he maintained an enduring dedication to issues of social justice and access to quality art and design education, and he displayed a passion for work at the intersection of formal and informal education.

Jessica Stockholder lives and works in Chicago, where she is a professor at the University of Chicago. Her work sits at the intersection of painting and sculpture and orchestrates an intersection of pictorial and physical space, often incorporating the architecture in which it has been conceived.

Robert Storr is an artist, critic, and curator. He received a BA from Swarthmore College in 1972 and an MFA from the School of the Art Institute of Chicago in 1978. Storr was senior curator in the Department of Painting and Sculpture at the Museum of Modern Art, New York, from 1990 to 2002. He was professor of painting/printmaking and dean of the School of Art at Yale in 2006.

Veronica Thomas is an entrepreneur whose practice is helping educators design courses in digital contexts. She is the founder and CEO of It's Edumentary (https://www.itsedumentary.com/), an educational consulting company that aspires to improve learning impact and preserve teaching legacies. Thomas is motivated and energized by bringing out the best in others and describes herself as a persistent visionary who is always asking, "How can we do this better?"

Jason Watson is a New York City-based artist and educator whose studio practice combines investigations of the figure, found objects, and architectural forms as engines of potential meaning. He has taught at universities, community colleges, public K–12 schools, and nonprofits and is currently pursuing a doctorate in art and art education at Teachers College, Columbia University. https://jasonwatsonart.com/

Rainer Wenrich, PhD, is professor and chair of art and education at the Catholic University of Eichstaett-Ingolstadt. He studied art history at the Academy of Fine Arts in Munich, and art education and psychology at the Ludwig-Maximilians-University in Munich. As a visiting scholar,

he conducted research at Project Zero of the Harvard Graduate School of Education, Cambridge, and at Teachers College of Columbia University, among others. His research integrates art and education, design and fashion theory.

Mick Wilson is director of doctoral studies and professor of art at HDK-Valand Academy of Art & Design, University of Gothenburg, Sweden. He is also guest professor at the Art Academy of Latvia and visiting faculty at the MFA Curatorial Practice program at SVA, New York. His teaching and research interests center on the political imaginary and contemporary art, addressing questions ranging from exhibition and the nature of publicness to the possible forms of political community with the dead.